The
Professional
Communications
TOOLKIT

To Mom
and to Tina,
the first and last women in my soul.

The
Professional
Communications
TOOLKIT

D. Joel Whalen

DePaul University

With
Tina M. Ricca

SAGE Publications
Thousand Oaks ▪ London ▪ New Delhi

For information:

Sage Publications, Inc.
2455 Teller Road
Thousand Oaks, California 91320
E-mail: order@sagepub.com

Sage Publications Ltd.
1 Oliver's Yard
55 City Road
London EC1Y 1SP
United Kingdom

Sage Publications India Pvt. Ltd.
B-42, Panchsheel Enclave
Post Box 4109
New Delhi 110 017 India

Printed in the United States of America

Library of Congress Cataloging-in-Publication Data

Whalen, D. Joel.
The professional communications toolkit / D. Joel Whalen.
 p. cm.
Includes bibliographical references and index.
ISBN 1-4129-2716-1 or 978-1-4129-2716-1 (pbk.)
 1. Business communication. I. Title.

HF5718.W468 2007
658.4'5—dc22 200602155

This book is printed on acid-free paper.

06 07 08 09 10 11 9 8 7 6 5 4 3 2 1

Acquisitions Editor:	Al Bruckner
Editorial Assistant:	MaryAnn Vail
Production Editor:	Diane S. Foster
Copy Editor:	Bill Bowers
Typesetter:	C&M Digitals (P) Ltd.
Proofreader:	Scott Oney
Cover Designer:	Candice Harman

Contents

Preface

"What we have here . . . is a failure to communicate."

—The chain gang captain to Cool Hand Luke Jackson

Cool Hand Luke had a big problem with communication when he was on that Florida chain gang—that and trying to win a bet by eating 50 eggs—and communication is a problem for professionals too.

This book is designed for professionals who must navigate through an obstacle course of communication every day. Think about all the audiences you must reach: clients, patients, staff, your colleagues, and countless vendors, from pharmaceutical salespeople to Web page designers. Each person you encounter during your day presents a new communication hurtle you've got to climb. The obstacles are many and complex:

The person—The person's knowledge and education, the mood the person is in, your relationship with the person, and how well the person understands his or her role. I'll show you how to bridge the communication divides between yourself and others.

Fear and anxiety—Many times you've faced the onerous challenge of talking with someone who is afraid. Physicians care for patients who are fearful at facing surgery, pain, death, and loss. Business managers deal with angry customers, feuding employees, and internal political brush fires. Tax accountants encounter their clients' fear when it's time for an IRS audit. Top engineers know well a complex and intense, albeit submerged fear, given the engineer's ethos, when they present a design or analysis solution to their engineering colleagues.

Influencing your peers—Seasoned professionals know that their professional peers are the most difficult audience. I can speak well, even brilliantly, before a wide variety of audiences, but when it's time for me to present a paper to a group of professors—or worse, deans—at an academic conference, I have to pull out every anxiety management technique I know. It's intimidating to present your discoveries to an audience of experts. It's nerve-racking, as you know.

I'll show you how to manage fear in others, and in yourself, and communicate brilliantly.

Message complexity—You derive your message from your profession's models and terminology. It can be complex and highly precise. Of course, your client does not have the education or experience to understand this complexity. You've learned that you have to communicate using the layperson's terminology, simple metaphors, and examples. However, as you talk, you get a feeling you're being duplicitous. You sense, to some extent, that you're misleading your patient because you're leaving out important information. Your message is important to him, he has a right to know what his diagnosis is, but you can't fully explain it to him because he can't understand. So, you have to reassure yourself that you're doing the best you can, given what the patient can understand and absorb. It's frustrating.

You'll learn how to maximize your communication with less knowledgeable people.

Technology—Today, your complex, important, meaning-rich, and at times emotionally laden messages have to be communicated electronically, via e-mail and voicemail. You can't see your patient's facial expression or hear your client's tone of voice. She can't see and hear you. While technology has instantaneously connected you to the planet, e-mail strips you of 90% of the communication that makes you powerful, compelling, effective, and unique. I'll show you how to communicate effectively using technology.

Why Communication Is Important

Did you ever think about how common communication is? We all communicate, right? Communication is the fabric from which society

is cut and bound together. At the core of your being, you have a deep need to communicate with others. Think about it: through communication you choose how to spend your valuable time and money. You decide what is virtuous, beautiful, and desirable. Through communication, you know what to fear. **Communication is the central and most important part of human activity.** The vehicle that gets you what you want is communication. As independent as you are, the good things in your life have come through the communication you've had with other people.

Little help from science

For thousands of years, people have stumbled about, communicating often and poorly. We've received little help from communication science. Advice offered by communication coaches and speech teachers was either intuitively obvious, or just plain wrong. The good news is that over the past three decades, communication science has made vast strides in understanding human communication.

This book presents discoveries and techniques that really work. I've worked for more than 20 years with thousands of professionals, conducted research at DePaul University's Kellstadt Graduate School of Business, and traveled the world studying how people communicate.

So you think you're not understood?

Have you ever had the feeling you're not understood? I know your answer is "yes." For over 20 years, I've worked with thousands of businesspeople from a variety of countries and dozens of industries. At one time or another, each person has told me, "Joel, I just don't feel like people understand me." And it's not just their colleagues in the workplace who don't understand them. They feel their spouses, their children, their friends, and their aging parents don't understand them. We're islands unto ourselves. It's hardwired in the way we communicate.

I've discovered that people have unrealistic expectations for communication. Communication can't give them everything they want. And people are unaware of the power that communication can give them, **because they don't know how communication works.** This book is an operator's manual for human communication. You'll see how communication works and what you can do to be a better communicator.

Communication's essence

We earnestly perform the act of communication through surrogate representatives of our inner thoughts and feelings—we send each other not the actual feelings and thoughts, but abstract symbols of our feelings.

I believe oral communication is the most powerful form of professional communication for shaping ideas, for influencing people, and for the process of discovery. In close communication between two people, rich, complex meaning can be transmitted directly through tone of voice, facial expressions, body posture, and that magical energy we get from each other. Ironically, the words we choose to use are poor, pale outlines of what we mean.

It's not just professionals who have communication problems. To some extent, communication has been cited as the root problem in a galaxy of human relationships. Every day you see stories on the TV news and in the newspaper about conflict in marriage, race relations, employee/employer relations, international relations, and intergenerational communication . . . it may even affect you and your parents.

When communication is working, it's like love . . . nothing's easier. And, like being in love, nothing is worse when it goes wrong. It can ruin your day, your week, your job, and your marriage.

The good news is that business communication, as practiced in the United States, is far easier to master than the other communication forms you use. One reason the United States continues to be a world leader in the global marketplace is our facile business communication system. I am not talking about faxes, telephones, and fiber optics. I refer to the system of codes, symbols, behaviors, and rules that dictate how, when, why, and with whom business communication takes place. Compared with learning how to communicate with your spouse, your relatives, and your government, learning to be an effective business communicator is a piece of cake (low-carb, no-fat cake for the constantly slimming you, of course).

Read this book, then practice what you learn, and I promise you will become a better communicator.

Acknowledgments

Tina Ricca—my life editor, consultant, confidence builder, partner, and a hot-looking babe.

Robert Whalen—master communicator, whether in the guise of Storm Roberts or as his own self.

Al Bruckner, for launching, then elegantly keeping this book afloat till it docked. The Sage Publications reviewers, who e'er ye may be, for good advice. The talented, hardworking folks at Sage—MaryAnn Vail, Diane Foster, and our word-meister, Bill Bowers. Michael Millican for designing the tables and graphs.

David Hoffmeister—bringer of many gifts, the best of which is his friendship. My partners in DePaul's Sales Leadership Program: Sue Fogel, Dan Strunk, Clancy Ryan, Jeannie Sticher, and the always amazing Sarah Laggos.

The clients and friends who added to this book by adding to me: Brooks Boyer (yes, you are the World Champions), Craig Callahan—for getting very rich and staying nice—*In Hoc*, Bruce D'Agostino, Hugh Daubek, Andrea Goldberg—a world-class salesperson and superb friend, Irv Grant—for showing me *how to win friends and influence people*, Zafar Iqbal, Frank "Duke" Loftus, and Lisa Miller—for showing that you can have that much love, talent, and energy and not explode. The Gamma Theta Chapter of Sigma Chi. David "Dr. DISC" Drehmer and the EBC instructors: Sheri Buergey, Mike Foster, Mark Gershman, Mike Saporito, Bill Sullivan, Kate O'Brien—who brought me into the world of NCAA Athletics—and Margaret "Master Marketer" O'Brien.

Om Huvanandana, Harold and Carolyn Randall, Sherryl "The Grand" Tanian, and Ray and Pauline Thomas (good on 'ya, mate)—for opening more of the world to Effective Communication.

Pamela Stroko—one of the smartest people I've ever worked with, constantly pointing me to new ideas, while praising my own.

Mary Ellen Whalen—giver of life and lessons in humor, style, and compassion. Denny Whalen—living life with courage and discipline, while speaking with poetry and integrity.

People who flat-out know how to write: Nancy Atherton, James Lee Burke, Dan Jenkins, Dean Koontz, Steve Martin (never read Steve Martin when you're trying to write a book of your own), and John Steinbeck. For Jimmy Buffett, John Hall, Carl Hiaasen, and Randy Wayne White—saltwater writers, all of who keep John D. MacDonald's voice alive.

Theodore Clevenger—they didn't call him Major Professor for nothing.

Professionals who role-modeled this book: Dale Carnegie, Bill Clinton, Benjamin Franklin, Jim Jenness, Don Nichols, Marion Parker, Bruce Perry, Will Rodgers, Eleanor Roosevelt, Oprah Winfrey, and Paul Harvey: *Good Day*.

There is only one way to make people talk more than they care to.
Listen. Listen with hungry earnest attention to every word. In the
intensity of your attention, make little nods of agreement, little
sounds of approval. You can't fake it. You have to really listen. In a
posture of gratitude. And it is such a gratification of self, to find a gen-
uine listener, that they want to prolong the experience. And the only
way to do that is to keep talking. A good listener is far more rare than
an adequate lover.

—John D. MacDonald

1

Effective Communication

It's Not About You

Communication takes place in the mind of the other person, not in yours.

Think about this: Effective communication happens in the mind of the person who receives your message, not in your mind. Here's how it works:

> You get an idea you want to tell your colleague. She listens as you speak; her mind drinks in your meaning. In a flash, in the theatre of her mind, the words you say trigger a projection of images, sounds, and feelings. It's as if she has a screen in the front of her head. From her memory of past experiences comes a cavalcade of sensory images.
>
> You know you did not mystically transmit your thoughts into her mind, right? The message came from inside her mind, from her memory. All you did was induce it. That's communication.

In this chapter, you'll explore what communication really is, and how it works, and most important, you'll learn what you can do to be more effective.

What kind of communication do you need?

As you navigate through your world each day, without even thinking, you switch between two types of communication. One is simple; the other is more complex. Both are important. Each requires vastly different techniques to be effective. They are

1. *Checklist Communication*

2. *Convincing Communication*

(See **Table 1.1**—*Checklist Communication* and *Convincing Communication*.)

Checklist Communication—best done quickly

When you just need to drop off some information, or tell people something they need to know, you're doing *Checklist Communication*. You don't need to speak directly with the person. All you need is voicemail or e-mail to send this kind of message.

Here's a sign you're doing *Checklist Communication*—You call some-one and expect to get their voicemail, but instead the person answers the phone. You're slightly surprised and mildly disappointed, because you don't need to speak with them; you'd rather do voice-mail. As the comic Bill Engvall says, "Here's your sign." You're engaging in *Checklist Communication*. You probably did not spend any time planning or mentally rehearsing your call; you picked up your phone and called. What you said came off the top of your head. You probably experienced no anticipation and little to no anxiety. That's *Checklist Communication*.

Convincing Communication—requires more preparation

When you have to engage in *Convincing Communication*, you want to see your listeners face-to-face, or at least speak directly with them. If you phone them and get voicemail, you probably leave a "call me back" message. You might want to warm them up and take their temperature before making your pitch. You'll want to sense their

mood and try to gauge their reaction to what you're going to propose or request. You spend time thinking, preparing, and strategizing about the call before you make it. You can expect to have some anticipation, and perhaps anxiety, before you make that call. You're doing *Convincing Communication*.

Table 1.1 *Checklist Communication* and *Convincing Communication*

Communication Type

Checklist Communication	*Convincing Communication*
• Simple message	• Rich meaning
• Checklist of items to share	• Abstract/vague
• Short time to deliver	• Listener not trained/experienced
• Concrete message	• Listener not engaged
• Listener understands	• Listener cynical
• You have credibility or authority	• You don't have high credibility
• Clear channel	• Cluttered, noisy channel

Example: *Checklist Communication*

Picture this—You pick up the phone to leave a message for your coworker. At the beep you say, "Hi Tina, just calling to let you know that the Beta Development Team meeting has been moved to next Tuesday, same time, in conference room E-23." That's it; you're done. It's simple, direct communication. You're confident your meaning will be understood.

You've just done some *Checklist Communication*. Look at **Table 1.1—** *Checklist Communication* **and** *Convincing Communication*. Your message is important, but it is **simple**; your listener is **knowledgeable**—she knows about the meeting and where conference room E-23 is. The **listener knows you** and **believes you**, you had **sufficient time to compose** (reflect, incubate, and edit) your message, and you did **not need face-to-face communication**. The **message is simple and easy to deliver**, and the **chance that you'd be misunderstood is small**.

Example: *Convincing Communication*

Here's your situation—It's Friday afternoon and you've been out of town at corporate headquarters since Monday. You're ready to fly the

friendly skies home. You check voicemail and get a message from your vice-president. She asks you to stay over the weekend. She wants you to attend a meeting early Monday morning with her and a project team. You consider this a hassle, but at the same time you realize it's a great opportunity. You're excited at the prospect of joining this team and flattered the VP wants you to be there. It's a good sign for your career.

Here's your message—You want to convey your eagerness to work with the team and appreciation of the recognition it implies. You also want to send a subtle "you owe me" message to your VP for extending your trip. You want to "push back" because you need her to approve reimbursement for the rather lavish meal you're planning to have Saturday night; and you'll need to buy a new shirt for Monday's meeting; all the shirts you brought need laundering.

Using **Table 1.1**—*Checklist Communication* and *Convincing Communication*, let's look at this message and see why it's *Convincing Communication*.

The **message is complex**. You're not just saying "yes"; you want to build some obligation. **You don't have a peer relationship** with the vice-president, the **communication is one-way**, and you have to respond promptly—you only **have 30 seconds of voicemail time**.

Convincing Communication **will be the center of attention in this book.**

Dominant and subordinate roles

When you send a message in *Checklist Communication*, you're the *source*. (See **Figure 1.1**—**Features of** *Checklist Communication*.) You are in charge and responsible for the communication. It's important that you say it right, that you have your facts in order. Your listener (*receiver*) plays a more passive role. The listener is like the catcher in baseball. You're the pitcher. The listener has to catch what you throw. While the listener can provide feedback during voice-to-voice communication (non-e-mail/voicemail message), the feedback is usually limited to asking a clarifying question. The listener's communication is restricted to asking more about your message.

Sure, your listener's response may cause you to modify your message so he or she "gets it right." What the listener says will not influence or change your point of view. Feedback is largely unnecessary—that's why you use so much voicemail and e-mail in *Checklist Communication*.

Figure 1.1 Features of *Checklist Communication*

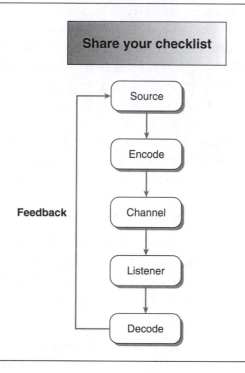

Convincing Communication

When you do *Convincing Communication,* you are working with a collection of more complex and thorny variables: mood, emotion, and meaning.

You also have more multifarious goals: You want to shape someone's opinion, you may need support, or if you're a subordinate, you may need permission. When you tell your colleague, Barney, the meeting will be at 4 p.m. on Thursday, Barney will believe you. He probably won't use his mood to color and plumb greater meaning from your *Checklist Communication.* He will not try to wring meaning from your straightforward, bare-bones message. However, if this is the fourth time you've had to move the meeting, you may well expect Barney to cop an attitude. His mood may become a factor. Your relationship with Barney, how flexible and patient he is, and how much the meeting means to him are at risk. The meaning of a 4 p.m. meeting on Thursday can become complex. He may need some gentle persuasion. Now, you're engaged in *Convincing Communication.*

Look at **Figure 1.2—*Convincing Communication*—Rich and Complex**. The two circles represent your and your listener's frames

of reference—the sum total of your life experience. For example, where did you grow up, in a big city or in a small farming town? Was your family big, with lots of brothers and sisters, or were you an only child? Did your family speak more than one language at home? Were there lots of hugs? Did you travel outside the United States? Were you good at sports, or was reading more your thing? You get the idea. The objects inside the circles (the squares, circles, and triangles) represent the symbols and memories of your life.

For example, imagine the meaning of your message: "the meeting has been moved" is a square for you, and for Barney, it's a triangle. You have three choices in your communication strategy:

1. **Accept conflict**—stick to your square (not a good idea).

2. **Accept Barney's point of view** that the meeting has been moved too many times, and it's a real hassle for him—move your point of view, accepting his triangle. If you select this strategy, you won't get *Felt Sense* (see ***Felt Sense:* your body knows** below), but Barney will.

3. **Move your and Barney's point of view** to a circle: Convince Barney that moving the meeting is your boss's idea (authority), and that it's better for everyone attending (group consensus). You'll both get some *Felt Sense.*

Figure 1.2 *Convincing Communication*—Rich and Complex

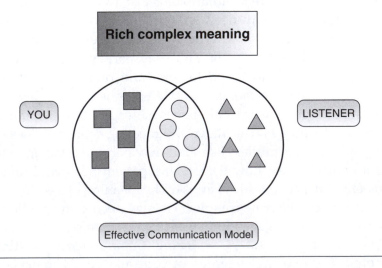

Nothing in common

When you were young, did you play hockey? Go cross-country skiing or ice-skate outdoors? I never have. I was reared in Florida. If we want to share our childhood experiences, we will have to find similar symbols that we both have experienced.

I've been in hundreds of television and radio commercials; I love to sail, skin dive, and scuba dive. Have you ever pulled a lobster from under a reef? Have you ever reefed your mainsail, so you could sail in and out of a line-squall storm? I've never ice fished. I've never met your spouse or your parents. I've never visited your high school. Communication is a challenge when you want to share your experience with someone else.

More on the *Convincing Communication* diagram (Figure 1.2)

The circles in the *Convincing Communication* diagram represent everything you and I have experienced in our individual lives.

In the diagram, you'll see some things you have experienced, and I haven't, represented by the triangles. Each triangle is a symbol/meaning that has a unique meaning to you, because you have experienced it (and I have not). At the intersection, the little circles are the symbols/meanings that we share in common. The squares in my area are the symbols that have meaning only to me, because you have not experienced them.

If I wish to communicate with you—I mean really engage you, your brain, your feelings, and give you strong understanding and *Felt Sense*—then I will be wise to pick symbols from your frame of reference (triangles), or from our commonly shared frame of reference (circles). If I select symbols from my frame of reference (squares), I am making you work too hard to receive my message. I am also creating a real barrier between us. Try as we might, and as motivated as we both are in trying to communicate—you just have not been there and can't understand. At best, I can try to build bridges to communication by selecting symbols/experiences derived from your frame of reference.

Simultaneous feedback

When you are engaged in *Convincing Communication*, you feel the need to see and speak directly with your listener. You want to read

his mood, his state of mind, as you communicate with him. You can see the shifts in his body tension and energy; you watch his eyes and body posture, you see him flex his hands. All this rich information tells you how your listener's mood and emotions are being shaped, or not shaped, by your communication, and how well you are changing the meaning between you and your listener . . . how well you are moving toward the center position of green circles and expanding that space (see **Figure 1.3—Sharing Experience—Expanding Meaning**).

How the message you send gets meaning

What is your prior experience? Are you afraid of dogs? Do you love math? Is Chris Isaak one of your favorite singers? Think that French is a romantic language? Feel more comfortable with shorter men? All your complex (and not so complex) attitudes, beliefs, and orientations about the world have come through your experience. People's reactions to the symbols you communicate come from their prior experience with that symbol, and the thing(s) it represents.

In **Chapter 3—The Power and Limitations of Speaking,** you'll see how symbols became meaningful to you through your life experience. You'll also see how society defines symbols through its common agreement between people (consensus), from the environmental/social context in which the symbol operates, and from the object/concept it represents.

Figure 1.3 Sharing Experience—Expanding Meaning

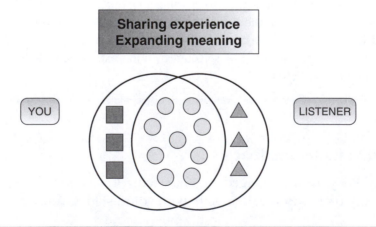

Leadership: communicating your vision

The challenge of communication is to relate experience and vision from your past. When you communicate, you relate what you see, hear, and feel as you look back into your memory. Your vision for the future lets you become a leading professional, a successful person who can heal, create value, build organizations, and gather people about you. It comes from the bedrock of your experience. To lead, you must share your vision in (through) powerful, meaningful, and truthful communication. Later in this book, we'll talk more about how your listener decides if what you're saying is the truth. By truth, I don't mean *not a lie.* We seek a far more powerful truth in persuasive business communication. We seek the truth of a shared experience from our past and a shared vision for the future.

Seek to share understanding

If you wish to lead, persuade, and share your vision with others, one sure-fire goal will make you successful as a communicator: Work to share understanding with your listeners. Seek to create a feeling in your listeners that they understand. It's not enough to have your listeners agree with what you're saying—to know the facts. Persuasion and understanding are the results of an interaction between mind and body. Your mind and body work together, helping you decide if what you're thinking is accurate, is the truth. You might think of your body confirming your cognitive judgment as a "gut feeling" or "instinct"; psychologists call it *Felt Sense.*

Felt Sense: your body knows

How do people decide if they believe what you're saying? When you're thinking to yourself, engaged in self-talk, how do you decide which thoughts you like best? Of all the things you have thought about, how do you know which has the greatest appeal to you?

The answer to this important question is this: You use *Felt Sense.* Your body and mind work together, determining the degree to which the things you're thinking about are good, true, important, and real (Gendlin, 1976, 1978).

Example of Felt Sense

Imagine you're at home in the morning and about to leave for work. You grab your briefcase and bag; you head to the door. Just as

you reach for the doorknob, you get this feeling you're forgetting something. You know just how that feels, don't you? It's a rather unpleasant sensation in your body, perhaps a grab in your stomach, a tension running through your shoulders; it's a tight feeling in your upper back; a persistent sensation that "you've forgotten something."

You know from experience that these body sensations are a warning that you should go back and double-check. So, you begin to run a mental inventory of all the things you could be forgetting: File folders? Wallet? Keys? Suddenly you get a surge of feeling in your gut. You think to yourself, "That's it, it's the keys; I left them on the bureau." How did you know this was the right item on your checklist? Your body told you with a feeling, a rush of energy, that you forgot your keys. As you visualized the bureau, and perhaps saw your keys on top, you got the feeling. This feeling is called *Felt Sense.*

How *Felt Sense* works. When you get a meaningful thought, a part of your brain called the limbic system activates (Gershon, 1999). A surge of neurotransmitters is produced that resonates with cousin-receptors residing in your gut. Literally, your gut—from the back of your throat, down your esophagus, through your stomach and intestines—is lined with the same type of receptors that compose your brain. So, when what you are thinking is true, your *Felt Sense truth detector* goes off. You feel it in your gut. When you trust your gut, you'll rarely be wrong.

Everybody has this capability. Some people are able to tune into *Felt Sense* **with greater facility than others.**

Giving *Felt Sense* to others: great communication

When you make a superior presentation, or you're involved in a wonderful conversation with somebody you really like, you and your listener are getting lots of *Felt Sense.* As you share your past personal experiences, or relate your vision of the future, you create a *Felt Sense* in your audience.

Your listeners believe what you're saying is important and true, not just because they think you make "sense." Their bodies work with the cerebral cortex to form *Felt Sense.* The *Felt Sense* feeling tells them that what you're saying is the truth. That, my friend, is shared understanding, and what we call persuasion.

Monkey see, Monkey communicate—*Mirror Neurons*

If you thought *Felt Sense* was interesting, you will love *Mirror Neurons.* Have you ever been in a sports bar and watched your favorite team play a game? Imagine that the score was tied, the bases

were loaded, and your team hit a home run. Did you find yourself yelling and cheering? Remember how you felt? You were excited, and felt powerful, energized, and happy. That's the effect of your *Mirror Neurons* going to work (Gallese & Goldman 1998; Keysers et al., 2003; Kohler et al., 2002). How do you think the player who hit the home run felt? He felt the same thing. Through your mirror neurons, you experienced the same thing as the player.

Another example—Have you ever had your heart broken? Of course you have. Remember the time you watched the movie where the characters' marriage was breaking up? How did you feel? Did your eyes fill with tears, did your throat get thick, and did a warm flush run up the side of your head? As you reached for a tissue, and the actor reached for a tissue, you both experienced the same emotion.

Discovery of mirror neurons

Here's the story. A team of Italian scientists was mapping the brain, just as geneticists have mapped the human genome. Their goal was to identify which specific neurons were responsible for specific body functions and behavior. It was a huge task; it boggles my mind that they would attempt it. Anyway, they were working with monkeys to develop their laboratory techniques.

Picture this: The scientists have a monkey hooked up with telemetry, sitting in a child's high chair in their lab. On the tray, they've placed some raisins for the monkey to eat. You see, they were trying to find the specific neuron that fires when the monkey reaches for a raisin: the monkey's "raisin-reach neuron." You know that "raisin-getting" is an important event in a monkey's life, so it produces a profound reaction in the monkey's brain. The sensors were hooked up to a speaker, so that every time the monkey reached for a raisin, the speaker would go *SCRICH*. Well, after many attempts, they succeeded; they found the neuron. Every time Mr. Monkey reached for a raisin, the lab was filled with a loud and satisfying *SCRICH*.

The scientists went wild, celebrating and congratulating each other. Then, without thinking, one of the scientists reached over and took one of the monkey's raisins—and the speaker went: *SCRICH*. **The monkey's neuron fired when the monkey reached for a raisin, and—and this is very, very important—when the monkey saw someone else reach for a raisin. The monkey experienced the same thing when he was reaching for a raisin or when he witnessed someone else getting a raisin.**

The scientists named this momentous effect *Mirror Neurons*: neurons that fire when you do something and when you watch someone else do something.

Talk about your communication: That's communication

Thanks to *Mirror Neurons* and *Felt Sense*, humans have a great capability: We can experience something by doing it ourselves, or by watching someone else do it. Think about what this means to your effectiveness as a communicator: Just by watching someone else's experience, that experience becomes our own. When you want to be successful with *Convincing Communication*, your two best allies are *Felt Sense* and *Mirror Neurons*. You can depend upon them to produce great results for you.

In **Chapter 3—The Power and Limitations of Speaking**, you'll read about using *sense messages* to raise *Felt Sense*, and to ignite your listener's *Mirror Neurons*. You'll find that your power and capability as a communicator will take a huge leap forward. People will understand you, and as important, you will come to understand other people, as you never have before.

Chapter 1 Summary

Effective Communication: *It's Not About You*

Key Ideas

- Communication does not happen in your mind; it materializes in the other person's mind.

- Each day you switch between two types of communication: *Checklist Communication* and *Convincing Communication.*

 Checklist Communication is simple; you can use voice and e-mail to send *Checklist* messages. *Convincing Communication* is more complex; you have to expend the effort to speak face-to-face, or voice-to-voice by phone. *Convincing Communication* has more subtle variables: mood, emotion, and meaning. *Convincing Communication* comes from *Felt Sense* and *Mirror Neurons.*

- *Felt Sense*—Your mind and body are a truth detector (gut feeling).

2

Message Strategies—
What to Speak &
What to Write

Attitude Is 90 Percent of Speaking

Speaking: *The words you say are less than 10% of the message.*

What is the more important kind of communication: oral or written? Think about which type of communication will make you more influential, more respected in your organization—the reports and memos you write, or the hundreds of casual hallway conversations and off-the-cuff remarks you make at meetings? What type of communication do you think your colleagues and clients consider more valuable: oral or written communication?

Certainly, a well-written report, or a one-page memo, is a powerful communications instrument. To be successful, you must master this skill. However, **speaking is inherently more powerful than writing**. And, for most people, effective oral communication is far easier to master than writing.

Power of Speaking: Oral Communication

The essence of communication: meaning

Communication is meaning. When someone gets your meaning, you're communicating. When your listener doesn't get what you mean, you're not communicating. Remember, communication takes place in your listener's mind. So, even if you say it clearly, if your listener does not get your meaning, or gets it wrong, you're not communicating. When I say "meaning," I'm not referring to what you said, but rather, to what you *meant:* Your ideas, your passion, the goodness of your heart, and the impact of what you say on your listener. Meaning is not solely what you say; it's what you intend.

Figure 2.1 Factors Driving Meaning

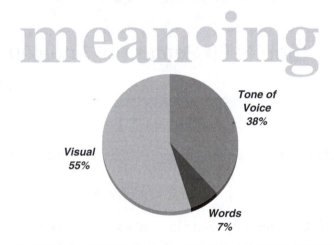

SOURCE: Mehrabian, Albert, *Silent Messages: Implicit communication of emotions and attitudes.* Belmont, CA: Wadsworth Publishing Company, 1971, p. 65. (currently distributed by Albert Mehrabian, am@kaaj.com)

Look at **Figure 2.1—Factors Driving Meaning.** When you're speaking, and someone gets your meaning, three things are at work:

- 7 percent words
- 38 percent tone of voice
- 55 percent visual

Poor communication teaching

Over the years, communication teachers have tried to help you become a better speaker by advising you on how to stand and when to gesture. They encourage you to make lots of eye contact. They tell you not to say "um," not to fidget, and to take your hands out of your pockets. Teachers make these recommendations because they know that 90 percent of your meaning comes from your tone of voice, how you stand, and your gestures. In their sincere effort to help, they might give you vocal exercises to shape your voice and sharpen your articulation. The sad news is that, given the short time most communication teachers have to work with their students, all they do is make their students feel self-conscious.

Here's the problem—You can't focus on how you're standing, how your voice sounds, and what gestures you're using while you're trying to speak. If you do, your audience will think you look distracted, phony, and robotic; and worse, they'll think you look like a total geek.

Attitude is the engine—The good news is that the engine driving your tone of voice and the way you move is your attitude. When you speak, 90 percent of what you communicate is the way you feel.

Before you speak, set your attitude

Your attitude is the engine that drives how well you communicate. To be a great oral communicator, first you must manage your attitude. It's the way you say your words that makes you persuasive, not the words themselves. In fact, the words you say are only minor parts of the message your listeners get. According to communication research, 93 percent of the information your audience receives comes from your tone of voice and the things they see you do (Raudsepp, 1993). Later, in **Chapter 3—The Power and Limitations of Speaking,** we'll talk about the rich tapestry of symbols we use in communication.

First, people see the way you look, your personal grooming, and how you're dressed. After their initial inspection, they judge you, and assign a credibility rating to you. Then, they begin to listen to you, watch your movement, and hear your vocal tone to get your message. What they hear is shaded by their initial evaluation of you.

Speaking delivers less content

How fast can you talk? No matter how big a motormouth you are, your listener can absorb words faster than you can transmit. Look

at **Table 2.1—Listening Faster Than You Can Speak**. Did you know that announcers on radio and TV read at the standard broadcast rate of 120 to 130 words per minute? If you spoke at twice that rate (260 words per minute), your listener would still gobble up the words and be hungry for more—360 words per minute more. Nonverbal symbols rush in to fill the 360 wpm gap in speaking. Obviously, your skill in manipulating nonverbal messages will be important to your success as a persuasive business communicator.

Early learning to fill talking/listening gap

When you were an infant, you learned to seek information beyond the words people cooed at you. You actively looked for additional symbols from other people that would give meaning to the world. You learned nonverbal communication first: the tone of your mother's voice, facial expressions, and more.

Nonverbal Communication

The fastest way to improve your communication is to stop trying to regulate the **Five Effective Speaking Tools** while you're talking (see **Table 2.2—Five Effective Speaking Tools**). The most effective way to boost your communication effectiveness is to work on your

Table 2.1 Listening Faster Than You Can Speak

Oral communication bottleneck: Your mouth

Listener receives	480 wpm

You speak	120 wpm

Deficit	360 wpm

wpm = words per minute

Convincing Communication takes place in the mind of the other person and in the intersection between your two minds. It does not take place in your mind.

Table 2.2 Five Effective Speaking Tools

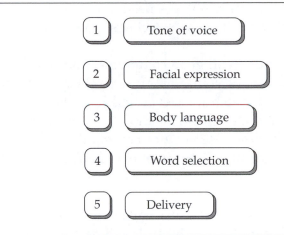

attitude. Later in this book, you'll learn how to directly improve your **Five Effective Speaking Tools**. First, let's work on your attitude.

When you talk, you show how you feel

Delivery is how you put it together: your superb vocal tones shape your perfectly selected words, accented by wise and animated facial expressions, all housed in a powerful, confident body posture, punctuated by strong and assured gestures. That's delivery. Does it sound hard? It's not. Making a great delivery is easy. Learning how to develop a skilled speaking manner is quite simple. You don't try. Don't even think about how you look—**you focus on how you feel about your message and your audience. You look into your memory and describe what you're seeing. Remember, successful communication begins with your desire to deliver messages you've mastered and have a passion to deliver.** Without a passion to share, and mastery of message, you'll be another average executive as you work your way through the material, boring the audience and communicating only half your ideas.

During great communication, you disappear

Think about the last time you enjoyed a truly great conversation. You talked forever and time flew by. When you looked at your watch, you were amazed at how much time had passed. "Oh my gosh, look at the time." That's one of the signs of good communication: The participant loses a sense of time and a sense of "body." When you speak

well and are really into your conversation, you see only your listener's eyes and mouth. Your consciousness flashes on the visions projected in the theatre of your mind (sounds, feelings, smells, and tastes, too).

The same thing is true in all good communication—You don't even exist; you're not aware of yourself. You're too busy looking at your audience's faces. You watch their eyes and read their reaction. You think about what you're seeing in the theatre of your mind, and then, you describe what you see. **Remember, communication is a two-way dance as the speaker and listener move together toward understanding and consensus**. Your facial expression, vocal tone, body posture, and gestures are best regulated by your internal autopilot: **your attitude**. If you try to actively manage these elusive elements, that is, if you work hard to look dynamic and paste contrived expressions on your face, you'll look artificial and stilted. Your audience will know you're a phony. Your credibility will crumble to dust, and you'll fail to get what you want.

Meaning starts in your mind and flows to your body, and then— through symbols of gesture, tone, and expression—to your audience.

You can't force this process. You can, and here is the good news, directly regulate these important communication tools. Vocal tone, facial expression, and body language are orchestrated by the interaction of your mind and your attitude. Attitude is critical. It is your attitude that you must control.

Deep-dived communication

"There is a time in all such things when eyes look into eyes. With vision narrowing and intensifying until there is nothing left but the eyes, searched and searching. This is a strange and tingling thing that narrows the breath—but it is a communication, and once it has happened there is an awareness beyond words."

John D. MacDonald, 1964

Here's what great attitude feels like

When you've got a great attitude toward your topic and your listener, it's a distinct and positive feeling. You feel powerful and centered, while at the same time, you take risks; you hang it out over the

edge. You know if you try to express an idea and fail to find the words, your audience will understand, and they'll be drawn even more into your presentation, as they work with you to find meaning. Because of your positive attitude, you don't have to deliver a flawless presentation. Actually, the audience prefers a slightly flawed presentation. You're more credible.

As you speak, you become filled with feelings of pride and joy for your ideas. You let your pride flow from you to your audience. It's your confidence that sells.

Most motivating emotion = enthusiasm

Of all the emotions that will move your audience to embrace your point of view, enthusiasm is the most important. Enthusiasm should be your primary tool in communication. Remember, persuasion is not just facts; it's emotional messages too.

Communication Toolbox

Telephone and Voicemail Techniques

Yo get a lot of voicemail. The North American Telecommunicators Association says that 50 percent of phone calls made today are one-way (voicemail, answering machines). And messages are chopped short. In 1982, only 22 percent of phone calls took less than one minute; today it's 52 percent. Consider the number of times you have to communicate important business information to others' voicemail, or in phone conversations.

First rule: You're intruding—ask for permission to speak

You wouldn't walk into someone's office and just start speaking, would you? You would knock first, wait for an invitation to come in . . . all the while you'd use your people sense to see how busy the person was, what their mood was like. You'd say, "Can I ask you a question?" or "Have you got a minute?" That's what you do, right?

You should use the same courtesy on the phone. When you call someone, ask if he or she has time to talk. You'll be amazed at how often the answer is, "No, you caught me at a bad time. Can we speak later?" So, you set a time to talk later.

Imagine if you just started talking, compelling the other person to engage in a conversation. He or she would do so grudgingly. At best, you'd get half an ear's worth of attention. The person would rather do something else than talk with you, and probably feels as if he or she is doing you a favor, and you owe them one. Of course, the person will never say that to you. He or she will absorb the frustration and feelings of being used. You've spent relationship capital and you didn't even know it.

Ask for permission. If you ask for permission to talk, you won't be intruding. If the person you've called is busy and can't talk, and you let him go—he'll owe you. Now, that's what you want.

Win win: So, next time you call someone, tell him or her who you are and what you want, and say, "Is now a good time to talk?" Either way you'll win. If the person says "yes," you get your conversation. If the person says "no," he or she owes you one.

Telephone: You've lost 55 percent of your ability to create meaning

Move around, gesture, and use facial expressions—You've got a huge communication handicap on the phone: You and your listener can't see each other. And, you know that 55 percent of meaning comes from visual information (see **Figure 2.2—Source of Meaning**). Here are some steps you can take to overcome that gap.

Your movements and facial expression are easily heard in your

Figure 2.2 Source of Meaning

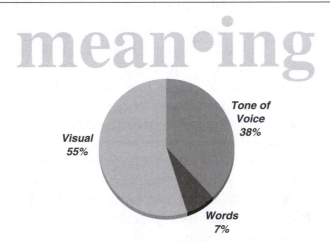

On the phone you lose 55% of your meaning that comes from visual information

SOURCE: Adapted from Mehrabian, A. (1971). *Silent Messages,* p. 65. Belmont, CA: Wadsworth. (currently distributed by Albert Mehrabian, am@kaaj.com)

voice. Your smile, your frown, your gestures can be heard in your voice. When you're on the phone, you can give your communication effectiveness a big shot in the arm if you vary your facial expression. Smile big to convey power, love, and confidence.

Test it yourself—Next time you're on the phone, use the opportunity to test the power of vocal tone in communication. Listen carefully

to the person on the other end of the line. See if you can visualize the expression on the speaker's face. You'll probably notice that you can tell when the other person has a smile or a frown, looks curious, and so on, through the broad range of human facial expressions. The part of your brain that regulates vocal tone and the part that controls facial expression are located near each other. It makes sense, in the grand scheme of things, that these two powerful communication devices should be coordinated and work together.

If the other person's voice does not have vocal inflection, you can't imagine his or her facial expression. The person's face will appear bland and uninterested, in your mind.

Use a headset—Free up your hands and body to gesture, move around, and express yourself—the added dynamism from your movement will translate into a more effective oral presentation.

Stand up—You'll move more if you stand than if you sit.

Visualize your listener—imagine your unseen listener

Professional radio and television announcers use a technique that can help you on the phone. Imagine how hard it is to sit alone in a soundproof room and speak into a microphone to thousands of people you don't know and can't see. To make their listeners more real, announcers create a vivid image of a person in their mind. They picture this person as they are speaking. Writers use this trick, too. As I write this book, I picture you answering my questions and reacting to the things I write. Of course, I don't know what you look like, so I don't really see you. The face I see, the voice I hear in my imagination, is that of a little old lady. She's been with me since I was a 15-year-old disk jockey on WWIL-AM/FM in Fort Lauderdale, Florida. She joined me at my first broadcast, and has served as my surrogate audience ever since. I never gave her a name, but she definitely has a personality. She's a coldhearted, cynical, small-minded, old grouch. And her nastiness makes me a better communicator. If I can communicate with her, nice people like you are easy.

I want you to do the same thing. Picture somebody in your mind. It doesn't have to be anybody real. In fact, it's probably better if the person isn't real. If you select one of your friends, you could create a problem. You might confuse your friend's interests, knowledge, attitude, and personality with those of your true, intended audience. Your stand-in must change attitude, profession, and job title to fit your audience.

My little old, grouchy lady takes on the characteristics of each audience I address. Today, as I write, she is standing in for you. So far, this year, she has helped me prepare my communications with my students at DePaul University, a senior advertising executive, a marketing professor, high school student leaders, Gap Incorporated managers, a ton of insurance executives, various business executives, a team of financial services salespeople, and, unfortunately for me, an IRS auditor (who turned out to be a nice person).

Why should you imagine that your stand-in listener has a bad attitude? If you write and/or plan your oral presentation to deal with the biggest cynic, or the most ignorant person you can imagine in your audience, everyone else will be overwhelmed. You may not choose to deal directly with the issues your imaginary cynic raises, but you'll have plenty of ammunition ready should you need it later, in a meeting, or when you make a presentation.

Make notes before dialing—When you write down key ideas, you package your message. Say new and difficult words out loud to rehearse them. With notes and rehearsal, you'll dramatically cut back on repetition, hesitation, and time. Your message will have real impact.

When to leave your name and number

How many times have you received a voicemail from someone you didn't know? It probably happens several times each day. The callers say their names and give their phone numbers at the start of the message. Then, they proceed to tell you what they want and why you should call them back. They've got it backwards. Why should you write down their names and phone numbers when you don't know them and have no motivation to return their calls? After they tell you who they are and give their numbers, they proceed to say why you need to call them back. Fine and dandy, but you haven't got their names or numbers. Now, you've got to rewind the message and listen again to learn the name and get the number. Nice way to begin communication: frustrate the person from whom you want something. Ouch.

Who really wants a message? Think about how you check your voicemail. How often do you sit at your desk, pen poised, with a fresh sheet of paper before you? Your answer is probably *seldom* or *never.* When people check their voicemail, they usually hope there's not a message to call someone. Often, they don't have a pen handy; sometimes they only have a scrap of paper. Many times, people aren't able to write easily because they're standing in an airport concourse, driving their car, or eating lunch.

You've got to make it easy for them

Tip ✓ **Got a pencil?**—Before you give your number, say: "Got a pencil?" This old radio technique breaks listeners out of their autohypnotic stasis and into action.

Tip ✓ **Repeat your number**—Radio announcers know that people don't hear numbers well at all. So, they always repeat the sponsor's phone number. You should repeat your number, too. Another reason to repeat your number is the ubiquitous use of cell phones. Just as you're about to give your number, your listener, also on a cell phone, drives between cell towers, loses the signal, and hears, "so call me. My number is 312–7 (**silence**) 21.

Tip ✓ **Tone of voice**—Too many business communicators use a monotone voice when speaking. Your attitude—angry or elated, sad or confident—is communicated by your voice. Your vocal tone conveys your meaning when people can't see you—for example, on the telephone.

Visualize your listener. Avoid communication breakdown.

Sometimes communication gets tangled, and the reason is hard to fathom. At other times, the cause of the miscommunication is easy to find. Read the following paragraph and see if you can diagnose what went wrong. When you figure it out, you've learned an important lesson in becoming a better communicator.

"Your Food Stamps will be stopped effective March 1992, because we received notice that you passed away. May God bless you. You may reapply if there is a change in your circumstance."
From a letter to a dead person from the Greenville County, South Carolina Department of Social Services.

Newsweek, 1992

 Miscommunication is a great source of laughs. Next time you're watching Comedy Central, notice how many jokes are about misunderstanding and misuse of words. Comedy is the flip side of tragedy. Miscommunication can be tragic . . . and funny.
 I've shown this tangled letter to hundreds of people and asked them to tell me what the communication problem is. The first answer I usually

get is: "They're writing to a dead person." That's right, of course. Look closer and you'll see that the writer is addressing the deceased *and* writing to the survivor. The letter writer is addressing two people, while not communicating well with either one.

This is the first lesson to becoming a more powerful and effective communicator. When you begin to plan your communication, and as you proceed to communicate, you must have your listener/audience clearly in mind. The bureaucrat writing from the office of the Greenville County, South Carolina, Department of Social Services seems like a nice person—he or she is trying to be helpful, even keeping the door open to further assistance, "if there is a change in (the) circumstances." But the person made the mistake of trying to hold two different audiences in his or her mind at once: the survivor and the dead person. What made the letter so confusing was that the survivor and the dead person have two different sets of needs and should be addressed with two different message strategies. The strategy for reaching the dead person is either (1) Hold a séance; or (2) Don't try; the person is dead. You can visualize the poor writer, sitting at a gray, metal, government-issue desk, surrounded by an ever-growing mountain of paperwork, taking the time to craft an individual, customized letter to the client. But, as the Social Services clerk began writing, the two disparate audiences began to shift in the writer's head. One moment the message was being addressed to the survivor, and the next minute to the dead person.

As you plan your communication, remember always to have a clear picture of your audience in mind. I recommend you actually picture them in your mind as you are writing. Work to talk with them as you set down your ideas and words. Communication is a conversation between two people. You'll never address a crowd. Even if you're given the opportunity to address ten thousand people in a stadium, you'll be talking with only one person at a time. When I go on television or radio to speak, whether it's to hundreds of thousands or millions of people, I imagine I am speaking to one person.

Chapter 2 Summary

Message strategies—What to Speak & What to Write: Attitude is 90 Percent of Speaking

Key Ideas

- **Speaking is more powerful** and easier to master than writing.

- **Communication is meaning.** Meaning is not just what you say; it's what you intend. Three factors drive meaning: 7 percent words, 38 percent tone of voice, and 55 percent visual. Your audience can listen faster than you can talk—360 words per minute faster.

- **The Five Effective Speaking Tools** are your

 1. Tone of voice
 2. Facial expression
 3. Body language
 4. Word selection
 5. Delivery

- **Don't look like a robot.** Don't focus on the **Five Effective Speaking Tools** (above) as you're trying to speak. You'll look distracted and phony. **Attitude is the engine** that drives your body language. Ninety percent of what you communicate is how you feel. You want to show your ideas and passion. Don't think about yourself: During great communication, you disappear.

The most motivating attitude is enthusiasm.

Telephone and Voicemail Techniques

Key Ideas

- When you phone someone, you're intruding—ask for permission to speak.

- You lose 55 percent of your ability to create meaning when you use the phone.

Communicator's Checklist

- ❑ Use a headset.

- ❑ Stand up, move around, and gesture.

- ❑ Visualize your listener.

- ❑ Make a note or two before dialing.

- ❑ Leave your name and number at the end, if the person does not know you.

- ❑ Ask: "Got a pencil?" before you leave your number, or other important facts.

- ❑ Repeat your number.

3

The Power and Limitations of Speaking

Complaint: "Nobody understands me."

Answer: "You're right."

As you begin to try these communication techniques, you'll be amazed at how little people remember of what you tell them. You will work for hours creating the most perfect presentation imaginable. You'll pack it with interesting and important facts and deliver it smoothly and confidently. Perhaps you will even use overheads with keywords, graphs, and charts. Yet, when you talk to some of the brighter, more highly motivated people you know, they will remember little of what you say.

Miscommunication is common

The most typical result of communication is miscommunication. Each communication results in a different meaning in the speaker's mind and the listener's mind. So, if you're thinking "people don't always understand me when I need them to," you're in good company.

You can become far more adept at packaging your communication, and thereby optimize its impact. The first step is to master the power, and respect the limitations, of speaking.

What to write/what to say?

One of the biggest problems in professional communication is that people speak when they should write their messages, and they write when they should send voicemail. An essential skill you will learn in this chapter is the ability to analyze a message and decide which parts are best spoken and which parts should be written.

The power of speaking

Did you play the *telephone game* when you were a child? The teacher would whisper a message to the first student, who would then whisper it to the second, and so on, until the last person in the class received the message. The teacher told the first student, "It's Darma's birthday today, and we're going to have cake." After 25 kids had passed it on, it came out from the last student as, "Frogs are green." "Where did that come from?" you think to yourself.

If you took one of my classes, you'd witness an experiment based on the telephone game. I've done this exercise hundreds of times, so my students could see what kind of message is best sent by speaking, and what kind of message should be written. You must learn to avoid this most common communication error: Speaking when you should write, or writing when you should speak. Let me tell you about it, and you will see what thousands of people have learned in my workshops and classes.

Story time

Here's how it works: I read a brief story to one person, who tells it to a second person, who then tells it to a third (see **Figure 3.1—Content Loss as Message Is Retold**). Now, the story I read is especially designed to contain message elements that are ideal for speaking, and it also contains parts that should be written, not spoken.

Here's what happens—The first person tells the second person a story that is different from the story I read her. **Now, here's the key:** The second person tells the third person a story almost identical to the story he was told by the first person. Then, the message the third person tells the audience is the same as the message she was told by

Figure 3.1 Content Loss as Message is Retold

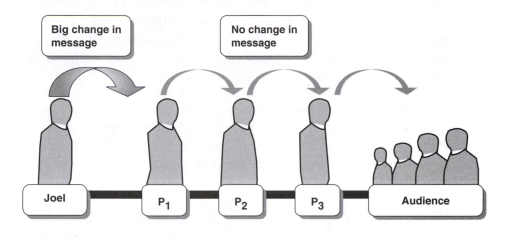

the second person. The message remained intact after it had been filtered and processed by the first person's mind. What you may call forgetting, I call *refining*. The first person's mind acted like a miniature communication processing plant. Her brain filtered out all the things that should have been written, and what was left was pure, perfect oral communication.

What was remembered and what was forgotten

People remember the first thing they hear and the last thing said. They forget the stuff in the middle of the story (see **Table 3.1— Remembered in Speech**). You'll learn more about how to use this scientific fact in **Chapter 7—Message Packaging—Strategies for Formatting Presentations:** *How You Say It*.

Table 3.1 Remembered in Speech

Oral message

What you'll remember:

- First and last things said
- Pictures and stories (events)
- Repetition—things said 3 times (sort of)

The parts of the message always remembered are *sensory-rich* pictures and events that are told. This happens even when the sensory-rich message is said in the middle part of the message. Sensory-rich messages pop clear pictures into people's heads. In the theatre of their minds, sensory-rich messages give them recollections of sounds, tastes, smells, and body feelings.

Repetition does not work—You may have been taught that repetition aids memory. Advertising people are advised to repeat their ideas three times in a commercial. I've learned that repetition does not get your listener to remember. What does aid memory, every time, is things said first, last, and *sensory-rich messages.*

What is always forgotten—The demonstrators forget numbers, names, and other details. They also don't remember any sequence of events. If a story has four steps, people forget the order of when things happen. When you speak, you create a sense that things happen simultaneously, in flashes (see **Table 3.2—Forgotten in Speech**).

Table 3.2 Forgotten in Speech (Should Be Written)

Oral message

What you'll forget:

- Names
- Numbers
- Details
- When things happened
- Sequence of events
- Will tend to create and add

When you talk to people, or give a presentation, do you ever wonder what they will remember? People will reliably remember the strong sensory messages you send them. You can try it. After you've spoken, ask your audience to write down five things they remember. You'll see a consistent pattern of sense memory:

- The pictures you shot into their minds.
- The sounds you suggested.
- The smells and feelings you talked about.

Your "self" was formed over time

The brain is essentially blank at birth. Recently, we've discovered that significant learning occurs when you're *in utero*—you were active

in your mother's womb, in the last trimester. It was a time of great growth, and perhaps, a time of learning. However, for practical purposes, vast regions of your brain were blank at birth. In fact, the first two to three years of your time on earth were characterized by an explosive growth in the numbers and types of brain cells. Did you know that you had more brain cells at age two than you have now? And it's not just because of those undergraduate keg parties. After birth, the brain expands vastly; soon after, it begins to determine which brain cells you'll need. It then reduces the number of cells you will have throughout your life.

Some brain patterns are on-board at birth

We've learned that parts of your brain are "hardwired." You have genetically determined traits that play an important role in your life. But by far, the larger aspects of you—your skills, worldview, knowledge, disposition, and temperament—are the result of the patterns of cellular interconnection in your brain.

Brain programmed through sensory information

All that you are came from your interaction with the world. Think about it. All the information you have taken in, all the experiences you have had were delivered to you through your sensory organs. If you had no sensory contact with the world, your brain would lie fallow and undeveloped. Through the things your eyes see, the sounds your ears hear, and the sensations of pain, pleasure, heat, and cold that your skin senses, your brain communicates with the outside world.

Table 3.3 Sensory Modality

Our senses: Gateway to the mind

Sense	Sense Organ
• Sight	• Eyes
• Hearing	• Ears
• Touch	• Skin
• Smell	• Nose
• Taste	• Tongue
• Emotions	• Viscera

The only way your mind can connect with the world is through your sensory organs. The same is true of the messages you send and receive from other people. You communicate through sensory organs (eyes, ears, skin, tongue, and nose; see **Table 3.3—Sensory Modality**). The senses are the only gateway to communication with other people (due respect to those individuals skilled in psychic communication—I don't know how to teach that skill).

A little bit of sensory memory stimulation works wonders

When you work with sensory memory, you don't have to become the master storyteller. It's not necessary to weave a tapestry of words, sights, sounds, and celebration to use sensory memory. In business, if you overdo the description and become too verbose, you'll turn the audience off. It's like cooking with spice: You need a pinch of oregano, not a fistful, to spice up the dish you're serving.

Secret behind using sense memory

St. Augustine said, "God is in the details" (popularized by the great architect Ludwig Mies van der Rohe). You activate your audience when you pick a few sensory-rich details and plant them in your message. If you want to bring home the impact of company layoffs, all you have to do is paint a single, vivid picture. Make it a small picture that illuminates a detail.

> "It's in their eyes . . . the shocked look in a man's face as he picks up his last paycheck. You know he's thinking, 'What am I going to do now?' . . . and you know he thinks we've betrayed him."

It's easy; we live in a sensory-rich world. You'll find examples all around you:

> "Waking up Saturday morning to the aroma of fresh-brewed coffee someone else has already made."

> "It's the sinking feeling you get in the pit of your stomach as the elevator starts down too fast."

> "You'll see it in the early morning mist on a mirror-flat lake."

Table 3.4 Verbal Clues to a Listener's Preferred Sensory Mode

Listener's preferred sense

Preferred Sense	Things the Listener May Say
Visual	"I see what you mean." "I get the picture." "That's very clear."
Aural (hearing)	"I hear you." "Sounds good to me." "That doesn't ring true."
Visceral (body/emotions)	"I can't get my hands on it." "I can grasp what you mean." "Things are well in hand."

Determine a listener's preferred sense by the things they say.

"It's a child's laugh, the ring of the cash register; it's the excitement in their eyes."

Make sure your important points are communicated by sensory memory. What you say will be remembered.

Sensory preference—
different senses for different people

Some people, in fact, most people are visually oriented—they prefer messages that let them see. They want messages in pictures. They receive and decode what you say primarily with visual sense memory.

Probably because of the years I worked in radio, I tend to be more acoustically oriented. You'll find that each individual you deal with may have a different orientation from your own.

Sometimes people give you clues to their preferred mode of sensory communication. They'll tell you if you listen (see **Table 3.4— Verbal Clues to a Listener's Preferred Sensory Mode**).

Symbols

Introduction to Symbols

Skillful technicians, like surgeons, know their tools; they spend hundreds of hours learning how to make tiny, perfect cuts with a scalpel, or tying intricate surgical knots with one hand. As a skilled communicator, you'll want to know more about the tools you can use. The most fundamental tool we have in communication is the symbol. A symbol is something that stands for something else.

Humans are symbol-seeking, symbol-seeing, and symbol-sending critters. As you read this section, you'll begin to appreciate what a symbol-loving culture we live in, and how much of what you want in life comes your way because you use symbols with skill.

The basic element of communication: the sign

The most basic element of communication is the sign. A sign is a symbol. A symbol is something that stands for something else.

For example, a map is a symbol that represents an actual physical, geographic territory. Look at this map of my home state, Florida and Lake Okeechobee (see **Figure 3.2—Map of Florida** and **Figure 3.3— Lake Okeechobee**).

Here is where you go to play with the mice at Disney World. This is a Mouseketeer hat, in case you didn't recognize it (see **Figure 3.4— Mouse Hat: Disney World**).

These are the Florida Keys, and here is Key West. When you visit Florida, be sure to make the trip to Key West. Get there in time for sunset—it's one of the most magnificent shows on earth. And be sure to rent a convertible: You'll look marvelous with the top down (see **Figure 3.5—Florida Keys**).

Figure 3.2 Map of Florida

Figure 3.3 Lake Okeechobee

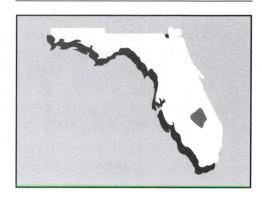

Here is Lake Okeechobee

Figure 3.4 Mouse Hat: Disney World

Figure 3.5 Florida Keys

Symbols are not the object they represent

Look at my beautifully handcrafted maps of Florida. They are not really Florida, are they? You knew that, but you agreed for a moment in time, and for the sake of communication, that we'd use my inarticulate squiggles to represent Florida. What did you receive from my communication? Did you see a real Rand McNally map of Florida, or did your mind see an overhead satellite photo of the state? When you looked at the Mouse Hat, did you see Mickey or Disney World? Have you ever been to Disney World? If you have been, then your interpretation of these symbols would be different than if you had seen only Disney World commercials. What sunset did you see in Key West? If you have not seen a Key West sunset, whatever your mind conjured was a pale, inadequate substitute. (You must see a Key West sunset—it's amazing, soul-shaking, and can't be captured on film or video. You have to be there in person. Promise me you'll go.)

Theatre of the mind

The magic of communication is that **you agree to suspend reality for a moment and enter the theatre of your mind.** I cannot force you to do it—to invest the mental effort necessary for a communication event to be shared. If you're pressed for time, or if you find this text unimportant or boring, you may have skimmed quickly, and not expended the mental effort necessary to receive the message I sent you in those maps. See, I did not really send it. I merely offered it to you, held it out for your consideration. If you wanted to take it, you had to bring something with you from your experience, your memory.

Types of symbols

Human beings are symbol-seeing critters. Everything in our world we can visualize or sense has symbolic meaning and can be used in communication. The more able and facile you are at summoning, selecting, and sending symbols, the better a communicator you'll become. (See if you can say that last sentence without slobbering.) Now, come with me on a little road trip, as we explore some symbols, and see what they mean to us.

Types of meaning

As you may suspect, communication scientists have decided that symbols are so important to the world that they should be given different names and assigned to precise, functional categories. Two of these symbolic categories have important information that will help you deliver more effective messages.

Denotative Symbols

Businesspeople love using *Denotative Symbols*. As Gil Grissom, from TV's *CSI: Crime Scene Investigation,* is fond of saying, "We let the evidence speak for itself." When you present hard data, you use Denotative Symbols. A Denotative Symbol is a concrete object and the sign attached to it, for example, the **Grand Canyon**.

As you read the words *Grand Canyon,* little error is produced when that symbol is shot into your mind. The chance is good you've pictured the huge natural wonder in the American West. The only chance for miscommunication is if you had never seen or heard of the Grand Canyon, or if your brain had slipped a synapse, and you had

thought of Grand Cayman Island—another natural wonder like the Grand Canyon, only much more moist. The communication is accurate, and the probability of error in transmission and reception is low. When you want your message to be accurate, you select Denotative Symbols from your lexicon. Businesspeople need to send many accurate, factual messages loaded with Denotative Symbols. **Denotative Symbols are popular with businesspeople, but poor persuaders. Denotative Symbols are easy to remember.**

The problem with Denotative Symbols is that they are not persuasive. If you build your message with mostly factual, accurate symbols, you'll inform your listeners, but you may not move them. If you want to be persuasive, you must mix in the right dose of Connotative Symbols.

Connotative Symbols

As you may suspect, because Denotative Symbols are accurate and easily remembered, the other major category of symbols, *Connotative Symbols,* will be inaccurate and easily forgotten. You're right. The inaccuracy comes from the rich constellation of meaning that surrounds Connotative Symbols. The meaning of a Connotative Symbol varies from person to person. For example, the meaning of the symbol *excellent meal* will change from person to person, and event to event. An *excellent meal* to some people is measured by the quantity of food served; for example, *country buffet* or Shoney's *All-You-Can-Eat Breakfast Bar* would constitute an excellent meal to a group of fraternity boys after a beer party. Compare the meaning of an *excellent meal*, in the context of entertaining a senior executive: selecting a restaurant that furnishes a large bib, a bucket, and big spoon to each diner might not be an appropriate choice. You and the executive might seek an *excellent meal* at one of the city's elegant dining establishments.

The meaning of a word can change from person to person based on their experience. For example, the word *mother* brings to mind a warm, feminine, nurturing person. However, among the lessons society has learned in the past 5 years is that the word *mother* can also signify an alcoholic and/or drug-addicted, abusive, pain-inflicting source of despair. In another dimension, think about other Connotative Symbols, such as "love" or "fairness" or "success." Compare the meaning of "love" for a newlywed couple and for a recently divorced mother of five children. Or compare the meaning of "success" between a business major and a student of philosophy, or the fine arts. Who would tend to equate dollars and cents with success?

I am sure you are aware that Connotative Symbols are imprecise. Senders must be aware of the impact of these symbols on their listeners. The meaning will vary from listener to listener, and from time to time for the same listener. The power that Connotative Symbols deliver is their ability to arouse emotion in the speaker and the listener. These are the words that inspire us. When Franklin Roosevelt wanted to stir the souls of the American people during the Great Depression (1929–1940), he selected the simple, but rich, Connotative Symbol "fear." Roosevelt told the American people, "The only thing we have to fear is fear itself." Certain Denotative Symbols can arouse emotion, but they must be linked to a strong sensory modality. For example, when Winston Churchill appealed to the people of Britain in 1940 to rally behind him through the Blitz bombings, he selected a set of Denotative Symbols: "blood, toil, tears, and sweat." As they affect our emotions, Denotative Symbols can produce a reaction. "I've torn my guts out over this presentation." "There was blood all over Wall Street today."

Figure 3.6 Persuasion = Facts & Emotion: Denotative and
 Connotative Symbols and Meaning

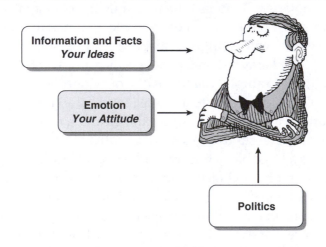

Think of Persuasion as *Facts wrapped in Emotion*

Persuasive messages contain both Denotative and Connotative Symbols

Accurate Denotative Symbols appeal to listeners' heads. They allow you to reason with them. But reason will not move most people.

You can't depend upon people to act on facts alone. Often, the facts don't have meaning without a context for analysis: their impact upon the firm, its employees, and customers. This impact is best presented—given meaning and salience—through Connotative Symbols that arouse the listener. It's not enough to present the facts for decision making. You must also provide the motivation for action. Providing facts for consideration is a staff-level function. Motivating people to action is leadership, an executive quality (see **Figure 3.6—Persuasion = Facts & Emotion: Denotative and Connotative Symbols and Meaning**).

Contextual meaning

We give symbols meaning based on two types of context:

1. The physical and social environment in which the symbol is used.

2. The symbol's semantic context with other symbols, i.e., words modify the meaning of other words.

For example, the physical/social environment will change the meaning of the meaning-rich symbol of a bathing suit. Visualize yourself in a bathing suit on the beach. You're standing with volleyball players, sun-soakers, and people whizzing by aerobically on skates, on bikes, or jogging. What symbolic meaning does your suit have? Perhaps positive messages such as "dressed appropriately" or "with-it fashionable" or "athletic" or "sexy" or "summertime" or "fun"? Or perhaps, negative, shameful messages such as "human stick" or "beached whale" come to mind. Now, visualize yourself wearing your bathing suit on the floor of the New York Stock Exchange. There you stand, in that huge open room with hundreds of frantically active people each wearing a multicolored barber jacket, symbolizing their firm affiliation. What messages come to mind: "nut" or "embarrassment" or "exhibitionist" or "lawbreaker"?

The physical/social environment changes the meaning and the impact of your language on other people. Think of the meaning and impact of using profanity in church versus saying those same words during a softball game. A more subtle change takes place in the impact of your words when you use the full extent of your considerable vocabulary and skill with technical words—in a business meeting, or talking with the car mechanic. In the business meeting, you'll be accepted and probably effective. The same use of your expansive vocabulary, when you speak with a mechanic or other blue-collar worker, may create a distance. You'll emphasize the difference in your

social group and relative status. You might alienate the mechanic and cause your bill to increase.

Words also take on meaning as they are nested together in sentences. Remember how you learned to read? You discovered the meaning of new words, as a detective would, by studying the other words in the sentence. You did not have to go to an adult to find the meaning of new words you encountered. This was an important step, as you became an independent learner.

Color

Colors are rich in symbolic meaning. What does the color red mean? (See **Table 3.5—Meaning of the Color Red.**)

Consider the color green. (See **Table 3.6—Meaning of the Color Green.**)

Do you ever think of business dress as a costume? Would the costume you wear to a first job interview be different from the way you might dress after you get the job? It might not. Would you wear the same outfit to a meeting with your banker, to present a business plan seeking a loan, as you would to a meeting with the creative group at your advertising agency?

Imagine you're walking down a public street at 9:30 p.m. You see Harry coming the other way. Now, you don't know Harry, but he starts walking toward you and says, "Hold it right there." What do you do?

Table 3.5 Meaning of the Color Red

Blood, violence, death

Stop sign

Anger

Hot

Communist

Table 3.6 Meaning of the Color Green

Scene One Harry is 5'10" tall and weighs approximately 175 pounds. He is about 35 years old. Harry is wearing an old, soiled, army-issue, olive drab field jacket. His shoes are ancient, nondescript, and shabby. He is wearing a black watch cap.

What do you do? How would you treat Harry?

Scene Two Harry is 5'10" tall and weighs about 175 pounds. He is about 35 years old. His shirt is light blue. He is wearing black pants, and on his feet are bright, *spit-shine* black shoes with rubber soles. The hat he wears is a peaked military type, with an interesting badge on the crown. What really commands your attention is his accessories. Harry is wearing lots of chrome with leather accents, including hand-cuffs, truncheon, badge, mace, and most impressive, about 5 pounds of gunmetal blue pistol in a worn leather holster.

What do you do?

The only difference between the Harrys is what they are wearing. A business costume is as important as any public safety officer's uniform. It helps identify us, and helps us take command. Just as a police uniform increases the power and authority of an officer, the correct business clothing will send out the right signals about you.

Lines

Here are two people (see **Figure 3.7—Person A and Person B**).

Figure 3.7 Person A and Person B

Person A Person B

A	B	
☐	☐	Which person would you like to sit next to on a four-hour plane trip?
☐	☐	Which one would you like to dine with?
☐	☐	Which one would you like to have as a project team member?
☐	☐	Which one do you want to handle your lawsuit against a bungling, substance-abusing surgeon who has mutilated someone you love?

Now that you've made these important decisions, consider what you've just done. You made decisions of varying importance—issues from your travel comfort to the future care of a disabled loved one—from two different lines on a sheet of paper. Your ability to get deep meaning from symbols is a tribute to your intelligence and experience. It's one of humans' greatest and most valuable capabilities.

Space

Countless messages are communicated by how people use the space about them, how they claim that space for themselves, or how they share it.

Researchers, led by Nancy Henley, director of the University of California at Berkeley Women's Studies Center, traveled the world taking hundreds of candid photographs of people in public places: as subjects sat on park benches, walked in malls, and dined in restaurants. The people were not aware they were being photographed, so they

were captured in their "natural state." Among the many interesting things Dr. Henley noticed in the photos was how men and women use space differently.

Dr. Henley noticed that men sprawl and take up lots of space, while women tend to be more compact and hold themselves in. Men sit back with legs splayed and form a tent over their heads with arms and hands folded behind their necks. Women sit with their hands placed in their laps, legs tucked inward and held near the body. According to Dr. Henley, men communicate superior power or dominance in a group by taking up more space and making themselves appear bigger. Women show less assertiveness, even submission, by making themselves appear smaller. Next time you are seated at a conference table, watch how men and women tend to use space, including how they place their papers and other materials on the conference table, and on adjoining chairs. You might find that men and women are still occupying different amounts of space, not indicated by relative rank in the group, or in the organization.

Subtle symbols: power and confidence

You must effectively communicate your status and power to others. People, particularly men, feel comfortable when they know where they stand in the pecking order (Tannen, 2001). You can push the envelope of your power by subtly using power symbols less obvious than a raised voice or accompanying physical gesture. For example, the way you enter a room can communicate your confidence and power. The next time you attend a meeting in a large room—for example, a hotel ballroom or large conference room filled with people—notice how the less confident people enter the room. They move quickly through the door and find a seat. Or if they are at a cocktail party, less powerful people immediately try to find a part of the room where they can feel comfortable. They make little, if any, eye contact with others. They act as if they want to be invisible.

Now watch the more powerful, confident people. You'll notice that when they enter a large room they pause just inside the door, scan the room, survey the layout, notice the people within, and then select where they want to go. They take a moment to decide where they want to be. They stand in the entrance and allow others in the room to look at them. Their power and confidence are conveyed by their attitude that they belong in the room; and they select the part of the room and/or the people they will join. Less powerful people, rather, try to enter unnoticed, to avoid making any impression.

Space = relationship

Next time you're in a public place with a few minutes to observe people, notice how couples (male and male, female and female, female and male) walk and stand with each other. You will be amazed by your ability to guess the nature of their relationship by noticing how much space they maintain between each other. You will be able to discern if they are business associates or lovers. Their use of space will tell you if they are just beginning the relationship, for example, on a first date, or if they are in a long-established union. You'll also spot those having a fight, or feeling the flames of love. As you study these couples, describe what you see in words. You'll find that the way they use space has great symbolic meaning to their relationships. If you were to ask them how they decided to set the distance between each other, they would look at you blankly. Most of the time, we don't make this decision consciously—but if the space is not correct, you know it and adjust.

Touch

Like space, touch says volumes about the relationship. When you touch someone, you can communicate understanding, joy, friendship, or power and dominance. For example, imagine you and I were to meet in an Effective Communication workshop. What do you think it would feel like to reach out and touch me on the shoulder? You would probably feel an invisible barrier preventing you from touching me. I'm a senior, Caucasian, male professor. Because of our relative ranks and roles within our professor/student relationship, you would be aware that touching me would not be appropriate—even though you know it would be just fine with me if you did. Now, I don't feel the same barrier with you. I would feel comfortable touching you, in a neutral area, of course: top of arm, hand, or top of back on the shoulder.

Between equals, touch has a different meaning than it does between people of different rank. When people of the same status touch each other, it communicates comradeship. However, the appropriate amount of time must have passed since the initial meeting, or the friendly touch may be interpreted as an attempt at dominance and communicate the wrong message.

When a relationship is forming, and you want to take dominance or communicate friendliness, measure the time you've spent and determine the dynamics of your relative status. Then, go ahead and try a cordial touch (on a neutral body part such as the forearm), or give a pat on the back; you'll communicate lots of good things. If the

person jumps, as if touched by a live electric wire, you'll know that your good-natured touch was made too early in the relationship.

Smells

Olfactory sense memories are among the most powerful we have. Our minds recall things we have smelled with maximum clarity. Scent is able to kindle volumes of other memories. When you recall the smell of pine, you might remember a forest with the hushed rush of air through the trees or the soft, loamy feel of the pine needle carpet beneath your feet.

Smells can have symbolic meaning, too. Realtors suggest that if you want to sell your home, you should put cinnamon sticks in a pan of boiling water. The homey scent will communicate just the right message to potential buyers. I coached a homebuilder client to have his salespeople bake cookies in the model home's kitchen. The scent of fresh-baked cookies sent the same signals as the boiling cinnamon. The cookies gave the salespeople a chance to share food with prospective buyers, and thereby build a closer relationship.

A theme that runs through all I've told you about symbols is meaning. Have you noticed that symbols and meaning have an important relationship? Is the color red really more active than green? Is cinnamon really a homey smell? Tell me, what is inherently homey about cinnamon? That spice's meaning comes from your prior experience growing up with that smell: Your memories of kitchens, cooking, families, and holidays give cinnamon the rich meaning it has today.

Emotions and Fear

Persuading angry people

When you see someone who is angry, what you are witnessing is largely defensive behavior: Angry people want to protect themselves; they are afraid. Before you can persuade, you must get them to lower their defensive shields. They will not listen to you with their shields up. They can't think with so much noise in their heads. In this defensive state, they will filter everything you try to say to them through a thick fog of anger. You can't communicate your ideas to a person in this agitated psychological state. You'll waste your time and just make them angrier. But angry people can be managed.

Here's how to manage people who are in fear

Fear transmits and spreads like disease. Other people's fear will cause you to become afraid, too. Different people show their anger in different ways. Some people are quite demonstrative; they communicate their anger with loud talk and an angry tone. Their face might be contorted into a hateful expression. Angry people's gestures might be choppy, as they move their hands in fast, short thrusts.

Other people—particularly managers—try to hide their anger, and may even deny to themselves that they are angry. These types may behave in a manner opposite to the angry person described above. They will speak quite softly and not move at all. Their facial expression may be passive, but their eyes will contain a spark.

When you deal with the demonstrative types, you must manage your fear. Their raw, emotional energy will tumble across the air space between you, making you fearful, and perhaps angry. It's okay to feel it, but you must not communicate your rising fear to them. It will only pour gasoline on their raging fire. You must remain calm.

Step one: Let them talk it out.

People might have a great fear—usually based on experience—that you will interrupt, disagree, and not let them talk. Most people do interrupt angry people. People might have fearful expectations that you will not listen to them. As you listen, you remove that fear. When you encourage people to talk and air their complaints, you may gain information that will help you find resolution. If angry people hear themselves speak, they may realize, as they listen to themselves, that the source of the fear is not quite so threatening. Don't interrupt, except to help them find the right words, or to show you're listening. People must talk it out to get a handle on their anger.

Step two: Show they are safe with you.

You may be a threat to them. It's important that you do not present any threat. Keep your voice level, soft, and reasonable. Focus intently and show you are listening.

Step three: Provide them with feeling words.

You may find that people have difficulty expressing what they think and feel. Many people have a limited vocabulary of emotional words to describe how they feel. If you say, "You look angry," or "If I were you I'd feel discouraged," and then shut up and let them talk, you may find that people will begin to bond with you, and trust you a bit more. They may find that giving their feelings *words* helps them understand the problem and be less fearful.

Step four: Communicate to them that their feelings are normal.

After emotions begin to abate, people might become concerned that you'll think they have behaved foolishly. Their shame can cause more emotion and defensiveness. People might not feel comfortable with anger in a formal business setting. When you say, "If I were you I'd feel exactly as you do," you help remove this source of shame, and thus reduce the chance of further anger.

Handling angry supervisors and customers

The above steps do apply if you wish to handle angry supervisors or customers. However, you are in a more delicate position when handling complaining customers or supervisors than you are when dealing with peers, because your power over management and customers is limited. Supervisors hold legitimate power over you. Your customers can freely take their business elsewhere, and complain to management about you.

You can handle people who have authority and power over you if you apply a little psychological judo. In judo, people's superior force can be used against them. After you've gone through Steps One through Four, and people have a chance to calm down, continue to empathize with them. Use your imagination; try to think of all the negative ramifications and problems the situation has created for them. Feed back this information to them. As you describe the problem, they will begin to agree with you and, perhaps, take back the floor because they want to talk more and continue with their complaint. That's great—this is just what you want people to do. Let them air it out. Soon they will reach a point where they are satisfied with your understanding. However, at this moment, you must continue to escalate and exaggerate your description of the problem and its impact. You make it bigger and bigger until they say, "No, it's not that bad." "You've done everything that could be done. It's okay." You keep describing the negative, fearful outcomes until you exceed their perception of the situation. At that point, people will shift position—they will no longer be angry and will tell you, "It's okay, it's not that bad." As in all persuasive business communication, you must be sincere and honest in the things you say. If you try to blow smoke at people who are in this state, and they realize you're patronizing them, you're dead meat. If you wish to be persuasive, you must develop the ability to see things from other people's perspective.

If you'd like to learn more about how to deal with fearful people (and business is full of them), Dale Carnegie's (Carnegie, 1981) excellent book, *How to Win Friends and Influence People,* offers good advice on how you can handle angry people and win them over to your way of thinking.

Using fear to persuade

Compared with *love messages, fear messages* are far more powerful. People react far more extremely to fear messages. It makes sense that

we would rather avoid harm than seek gain. Our primary instincts are directed at survival. The human brain is designed first to protect us from danger. The cerebral cortex shuts down when the brain stem detects sufficient danger (see **Chapter 4—When You're Afraid to Communicate:** *Understanding Anxiety and Fear*).

In experiments, people have eagerly spent 2.5 times as much money and effort to avoid *fear* than they would to achieve a *gain. Fear* motivates people 2.5 times more than *gain* (Kahneman & Tversky, 1979; Tversky & Kahneman, 1992; Brooks & Zank, 2005).

Fear messages can backfire—watch out: *Fear appeals must be handled carefully*

Research has shown a strong negative correlation between the effectiveness of a fear message and the audience's education and intelligence. Simply put, the higher the audience's education and intelligence, the less fear appeals work. Less educated people and children are more responsive when they are threatened, but managers are not.

With a manager's higher education and intelligence (not compared to yours, certainly; I'm comparing managers to the general public), an ill-conceived fear message will be transparent—they'll realize that "they're just trying to scare us." If you try to scare management into action, and your appeal is seen as a ploy, it will backfire; you'll not be credible or persuasive.

Fear appeals can work with management, *but* the peril you predict must be plausible. **There must be a real danger, the potential for real loss.**

Buyer's Four Big Fears©

All people have four basic fears when they make a business decision or a personal purchase. The bigger the decision or purchase, the bigger the potential fear.

Fear one: I won't get what you're promising.

Buyers frequently view persuaders skeptically—our desire to sell may cause us to exaggerate, or worse, lie to get our way. Sales and advertising have a great tradition of acceptable exaggeration called *puffery*. People are well aware that persuaders tend to inflate their promises. For example, when you eat at Denny's, does the food ever taste as good as it looks in the photos on the menu?

Fear two: I'll pay too much for it.

It's not solely the loss of money that makes this fear so big; we don't want to be fools. Is there anything worse than making a major purchase, such as a DVD player or giant-screen TV, and then finding it on sale? Cost-cutting strategies, currently rampant throughout corporate America, make "paying too much" a form of fiscal treason. Beyond monetary cost, buyers may be concerned that they'll pay too much in terms of psychic energy; for example, they'll have to undergo training before they can use your plan. Consider the time cost for evaluation and installation, from the buyer's point of view.

Fear three: My significant other(s) will say I was crazy to have bought it.

Most people buy with someone, real or imagined, looking over their shoulders. Significant others include supervisors, spouses, in-laws, professional associates, and even nosy neighbors and golf partners.

Job Interview Tip—Remember, when you interview for that next great job, that the person who interviews you is afraid of making a mistake. They don't want others in the firm, especially the boss, to say, "I can't believe you hired him."

Tip ✓ Be sure to tell the interviewer how well your previous interviews went with others in the firm. "I've met some nice people at this firm; Mr. Friendly (the interviewer's supervisor) and I had a wonderful conversation."

Fear four: I won't like my self-image; it's not for people like me; firms like ours.

Self-image may apply more to consumer products, and the things we buy for ourselves, than to corporate decisions. But companies have images too. A corporation holds a market position, and it seeks to define and regulate its corporate culture. So, your plans must be right given the firm's ethos. I recall an MBA candidate who wanted to sell a new computer system to his supervisors at an old and well-respected bank's trust department. He asked for my advice as he prepared his presentation. He planned to begin his pitch by emphasizing the computer's features that appealed to him: high speed, the latest equipment/hardware, plus advanced, high-tech performance. I pointed out that the attributes of his proposed computer system might frighten his conservative, risk-averse supervisors. He was successful. He

emphasized the system's fail-safe redundancy, the error-checking features, and how it would protect the customers.

Another important message is that "this idea or product" is used successfully by firms like yours (or ours) and by firms you admire (or we admire). You can counter each of the **Buyer's Four Big Fears** and be persuasive (see **Table 3.7—Message Strategies to Counter the** *Buyer's Four Big Fears*).

Fear one: I won't get what you're promising.

Message Strategy—Remind buyers, subtly of course, of your credibility (expertise, trustworthiness, and goodwill). Credibility lets people believe what you predict and promise them. You can rely on your trust relationship with people (see **Chapter 6—Making People Believe You**: *Persuasive Communication*). A list of satisfied customers and performance data objectively shows that others have received what you have promised. When you offer objective data, you allow buyers to evaluate the potential outcomes—not solely your opinion.

Table 3.7 Message Strategies to Counter the *Buyer's Four Big Fears*

Buyer's Four Big Fears	
Fear	*Message Strategy*
I won't get what you're promising.	**Credibility** • Satisfied Customers • Performance Data
I'll pay too much for it.	$Value = \dfrac{Benefits}{\$\,(Costs)}$
My significant other(s) will say I was crazy to have bought it.	**Inoculation:** Build set of anticipated objections and anwers
I won't like my self-image; it's not for people like me; firms like ours.	We have satisfied customers *just like you.*

Fear two: I'll pay too much for it.

Your message strategy is a sales classic. When buyers have objections about price (monetary, psychic effort, time, risk, costs), your message is to sell value; that is, increase the buyers' perception of the good things they'll gain. People want to maximize their return for the costs

they pay. **Figure 3.8—Source of Value** shows the two fundamental strategies you can use to increase *value*. Value is the *benefits* people will gain when they follow your plan, divided by the *costs* incurred to buy the *benefits*. To increase *value* and get people to adopt your recommendation, you can increase the *benefits*, or lower the *costs*.

Figure 3.8 Source of Value

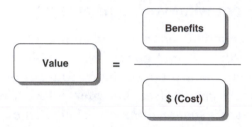

People buy the alternative idea or product that has the greatest level of Value. Value is determined by the Benefits people will receive, divided by the Costs they must pay. Persuaders can raise Value by lowering the Costs, or by raising perception and awareness of the Benefits.

Fear three: My significant other(s) will say I was crazy to have bought it.

It's best to anticipate the players who may be in the "decision group"—the group of deciders, influencers, recommenders, gate-keepers, and evaluators who have some say or influence in the decision to adopt your plan. Know what their needs, prejudices, and viewpoints are likely to be. I always recommend that you take time to establish a relationship with all members of the *decision group*. As you make mini-presentations, you can establish a strong support base and learn, in advance, of any objections or problems they may have with the plan. With this intelligence, you can formulate your "Inoculation Strategy."

Inoculation Strategy—The idea behind an *Inoculation Strategy* is, if you know your buyers will hear negative comments from the opposition, then give the buyers a dose of those negative opinions *before* they hear them from others. Like a medical inoculation, a *message inoculation* is a weakened strain that allows buyers to develop antibodies, in this case, counterarguments that will resist the negative influence of others. You give buyers "what they may hear from others," or "some misconceptions that others may hold."

Be a two-edged knife—One of the great 19th-century orators, U.S. Senator Theodore Gillmore Bilbo (a noted sleazeball), was called the Two-Edged Knife, for his ability to debate any issue, from either side, with equal zest and skill. Bilbo was a shifty guy who did not stand for righteousness and good; however, I know you do. You must know the reasonable and fearful arguments against your ideas. You must build a set of anticipated objections that other people may raise, and develop counterarguments. Be wise; touch on both sides of the issue. It makes your presentation more balanced, and shows that you have considered other viewpoints, as well as your own, and that you've looked at the downside as well as the upside of your plan. Thus, you demonstrate the level-headed decision making that people want and demand of business leaders.

Fear four: I won't like my self-image; it's not for people like me; firms like ours.

The best solution is to offer evidence that "we have satisfied customers just like you," that firms like yours, whom you admire, use it and have benefited from this approach. People you respect have embraced this idea.

Dr. Jekyll becomes Mr. Hyde during your presentation—When the stakes are high, and rational, level-headed people are asked to make a decision, they frequently become a bit nuts. **Figure 3.9—The *Emotional Buyer*** shows the psychological change **the buyer undergoes** during the decision, or buying, process. The figure represents your buyer's state of mind, from the start of the persuasive process until the end, when buying takes place. Look at the left-hand side of the diagram (where the buyer evaluates your ideas), and compare it to the right-hand side (where buying takes place). As you begin the persuasive process, the buyer is in a more rational than emotional state. However, when it becomes time to decide, you can see that the ratio of rational to emotional thoughts has reversed. You now have to deal with an emotional, and only slightly rational, person. The nice, intelligent executive you first met has become a different person. Businesspeople might not show their emotion by action or tone of voice: Executives are great poker players who know how to maintain a blank face. However, one clue that something is going on is when the person says things that make no sense. Suddenly the buyer decides, "It costs too much," when you've demonstrated the cost-effectiveness, and earlier the executive agreed the price was right. The buyer

might say, "I've got to think it over." This makes no sense because all the facts are laid out, the thinking is over; it's time to do. You now must contend with a fearful buyer. One or more of the big fears are probably at work.

Strategies to persuade Mr. Hyde

Your first task is to help turn Dr. Jekyll into Mr. Hyde. The diagram in **Figure 3.9—The** *Emotional Buyer*© is axiomatic; it has to happen. If buyers don't get emotional, they don't buy. When you ask executives to make decisions that involve significant consideration and risk on their part, you must be prepared with persuasion and message strategies. On the emotional side, a buyer must become excited at the prospect of obtaining the benefits you're offering. A buyer will undergo some form of emotion that will reduce the mental space for rational thought. You have to prepare for this.

To turn Dr. Jekyll into Mr. Hyde, you must reduce rational thoughts and raise the emotional state. First, you make more emotional (connotative) statements than rational (denotative) statements.

Figure 3.9 The *Emotional Buyer*©

The figure shows the change in the buyer's mental state, from the time he or she begins to evaluate a product/idea, to the time he or she decides to buy. The buyer passes from a mental state dominated by rational thought into an emotion-driven state of mind.

Look for the physical signs—After buyers are excited and see the benefits, you'll often notice that they begin to slow their thinking through their physical movements. Another sign that listeners are undergoing the shift—from mostly rational thought to emotional thought—is that they distract themselves. They may pick up something and read it, or pick up the phone and make a call. They might change the subject abruptly. This type of behavior is an unconscious effort on the buyers' part to reduce the uncomfortable mental state they are in. Remember, their perceived risks give rise to their fear. With this non sequitur–type behavior, they gain some form of relief from their fear.

Turn down their emotions

Now that they have become emotional, it may be necessary for you to reduce the buyers' emotional state, and raise the rational thoughts. Continue to tell the buyers to accept the plan, and remind the buyers of the reasons why they wanted it. Review and show rational facts that support why your idea is sound. Use objective cost and performance data. Rely on your credibility and relationship. Follow the recommendation of the master sales trainer, Frank Bettger, and say, "If you were my own cousin, I'd tell you what I'm about to tell you now: 'Adopt the plan; it's right for you.'" If you want to persuade people from outside your department or outside your firm more effectively, read Bettger's (Bettger, 1986) *How I Raised Myself From Failure to Success in Selling.* That book is worth every minute you spend reading it.

Manage your own fear—Remember, fear transmits like a disease, and you're likely to get it. Tell yourself: "Stay cool." Take a deep breath. Make an effort to relax as much as possible. Fill yourself with positive feelings. You can help the buyer relax with your calm, positive manner. Remember, when you get to the emotional part, you stand at the threshold of success. If you have carefully studied the buyer's needs, and believe to the best of your professional judgment that the plan is wise, you have a professional obligation to help the buyer make the right decision.

The professional loser

A common, but undesirable, type of salesperson is called the *Professional Visitor.* This type is a nice, friendly, well-mannered individual who may be knowledgeable about his or her products and how they can help prospective customers. The *Professional Visitor* does

make some sales, but not enough to be outstanding. This salesperson has a big problem dealing with people when they become emotional. When it comes time for the buyer and the *Professional Visitor* to sign a contract, the salesperson's emotions and fears rise because he or she doesn't have coping or self-management strategies. *Professional Visitors* can take prospective customers to the edge of the decision, but in the face of the customers' fears, they are not equipped or trained to help customers make the decision. When *Professional Visitors* do sell, the buyers are unafraid, or can make fearful decisions on their own.

Persuasion Ethics

I believe that you, as a seller or persuader, have two primary, ethical obligations. First, you must be professionally trained to diagnose other people's needs, and make a determination if the prospective buyer does, indeed, need your product or service. Second, if you determine, in cooperation with the buyer, that the product or idea will benefit the buyer, you have a professional, ethical obligation to help the buyer overcome fear and make the decision to adopt your idea, product, or service. The fact that you made an effective presentation and "let the buyer decide" is not enough. I believe that if the buyer is fearful, you must help him or her through that difficult period.

Professional emotional management—You must work to regulate your emotions if you are to help your buyer make a decision. You must be able to turn up your emotions to help the buyer become activated and excited, to anticipate and see the benefits your ideas offer. And you must be able to turn down your emotions so you can help the fearful buyer.

Decide to be persuasive—After you read this book and begin to practice its ideas, you can be more persuasive, and thus more successful—if you want to. The fact that you know how to persuade is not enough. You must have the courage to try to persuade other people. You may not have that courage. With all due respect to you, my reader, I have seen too many intelligent, well-trained, charming, and dynamic businesspeople fail at persuasion. They failed because of one thing: They were not willing to take responsibility for the outcome of their own ideas. I believe they were cut short in their careers because they did not have the courage and character to make a commitment to another person—to promise another person, based on strong faith, that their ideas will come true. You must commit yourself to help the deciders through the difficult, emotional process they have to undergo.

If you make that emotional, ethical commitment, and if you continue to study and practice persuasion, you will find the success you want. You will not stop until you reach your goals.

Waiting for "Yes"—For example, research, and my own experience, show that you may have to ask the buyers to adopt your plan after they have said "No" three times. The fourth time you ask, they will probably say "Yes." The first three "No's" were part of their decision process, part of thinking it over.

Feel love; feel positive—The key to persuading the emotional buyer is your attitude; how you feel when you talk. If you feel love and not fear, or more accurately, love in spite of the fear that runs through you, you'll win.

If you're a guy, you may have a tougher time—I've noticed often that men can't deal well with emotion. Their emotional circuits are too simple: They are either "on," and they experience anger, or they're "off," and they are cool. Persuasion requires a more complex range of emotions than anger or cool.

I've noticed that, for whatever genetic, biological, or social/learning reasons, women handle their emotions well in difficult business discussions. I've seen many men frightened to their core; they want to fight and go to court ("I'll sue the SOB."). Then, I've seen a woman step into the same troubled situation, cool, calm, with no fear, and prevail.

Perhaps this emotional sophistication has helped women to take the lead in many sales categories, particularly in the sale of intangible goods, like advertising, meeting and convention services, telecommunications, and public relations. Men largely dominated these fields until women entered. Women have rapidly risen to the position of market dominance in these sales categories.

I believe that women have succeeded in selling complex products and plans because they manage emotion better than men. I also believe that men can learn to deal well, be persuasive, and lead others through emotional conflict.

Key: Emotional management is a vital skill for successful persuasive communication.

Chapter 3 Summary

The Power and Limitations of Speaking

Key Ideas

- Miscommunication is common. Each communication results in a different meaning in the speaker's mind and the listener's mind.

- **A big communication problem is:** People speak when they should write, and they write when they should speak.

People remember:

- The first thing they hear
- The last thing that is said
- Sensory-rich messages: recollections of sounds, tastes, smells, and body feelings

People forget:

- Numbers
- Names
- Details
- Sequence of events

- Visual sense is most people's favorite. When you send messages designed to stimulate people's senses, you give them "Felt Sense."

- Your past experience with symbols gives them meaning. A symbol is something that stands for something else. Symbols include colors, costumes, lines, spaces, touch, and smells. Persuasive messages have both Denotative (factual) and Connotative (emotional)

symbols. A Denotative Symbol stands for a concrete object, is easily remembered, and is *not persuasive*. A Connotative Symbol represents an abstract concept whose meaning varies from person to person, is hard to remember, and *arouses emotion*.

Emotions and Fear

Key ideas

🗝 Angry people are afraid and will try to protect themselves. You can expect them to hide this and deny that they are angry. You must get them to lower their defensive shields, or they will not listen to you.

Fear transmits and spreads like disease. *Fear* is 2.5 times more motivating than *gain*. Fear appeals must be handled carefully.

Less educated people and children are susceptible to a threatening message, but managers are not.

Buyer's Four Big Fears

1. I won't get what you're promising.

2. I'll pay too much for it.

3. My significant other(s) will say I was crazy to have bought it.

4. I won't like my self-image; it's not for people like me; firms like ours.

🗝 As you begin the persuasive process, people start in a more rational than emotional state. When it is time to decide, they become more emotional and less rational. Emotion is good; if people don't experience emotion, they will not be persuaded. Facts and emotion combine to form the persuasive experience.

Persuasion ethics

Persuaders have an ethical obligation to determine if the prospective patient, client, or buyer needs their product or service. The persuader has an obligation to help the patient, client, or buyer overcome their fear and make the best decision.

Communicator's Checklist

❑ Deal with angry people

Step One *Let them talk it out.*

Step Two *Show they are safe with you.*

Step Three *Provide them with feeling words.*

Step Four *Communicate to them that it is normal to feel as they do.*

❑ Lower anger and build trust
 • Fully explore the anger.
 • Talk about the cause of the person's anger.
 • Consider all the negative ramifications and problems that the situation has created for the angry person.

❑ Persuade using emotion
 • To persuade, you must reduce the rational thoughts and raise the emotional state of mind.
 • First, you make more emotional (connotative) statements than rational (denotative) statements.
 • After the buyer becomes emotional, you reduce the emotional state and raise the rational thoughts.

❑ Manage your emotions
 • Work to regulate your emotions.
 • Turn up your emotions to help the buyer become activated and excited.
 • Turn down your emotions so you can help the fearful buyer.
 • Take responsibility for the outcome.

4

When You're Afraid to Communicate

Understanding Anxiety and Fear

I hope to convince you that communication anxiety is common and normal. It's an ugly feeling that everyone gets at one time or another. Let me repeat that: Everybody gets communication anxiety at one time or another.

A good sign—The more chances you take and the more you extend yourself beyond your communication comfort zone, the more communication anxiety you will experience. So the more you try to improve your life, the more you get communication anxiety.

Think about this—The greater the risks you take, the larger the rewards you will get. The finance jocks will tell you: *risk = reward*. On the other hand, if you never get anxiety, I know you're stuck in the rocking chair hiding within your safety zone. It's much better for you to get an occasional dose of anxiety, so you can grow and gain. Don't you agree?

Safe behind the wall

You see we all have a wall about us. We feel no anxiety inside that wall. Inside that wall are people we're comfortable with, social settings that don't threaten us, and a job that does not intimidate us. It's nice and safe, and the only world you can know unless you're willing to face anxiety. The sad thing is that outside the wall awaits a world of people, opportunity, money, and recognition that can be yours. But to step outside that wall, you have to feel some fear.

You will realize that you can tap into a power that lies dormant within you—a positive power that actually comes from the same biochemical source that causes your communication anxiety. This power will transform you into an effective communicator: You can be yourself, someone who can think and speak well under pressure.

Why must you manage your speech anxiety?

Have you ever avoided speaking in front of a group? Have you ever "stepped aside" so another person could take your place as speaker? If not, I say good for you. Many of us have avoided opportunities to speak because we have a real or imagined fear of making fools of ourselves.

If you are among the courageous people who accept speaking opportunities, let me ask you a question. While you take the responsibility to talk, have you ever actively and aggressively sought out speaking opportunities? If you're serious about success, I strongly recommend that you do everything you can to become a skilled, popular, and frequent speaker.

Très cool: good talkers

People rate good speakers as superior to less able communicators on a number of important dimensions:

- More intelligent (not explained by IQ)
- Better looking/more attractive (not supported by photo judging)
- Better candidates for leadership

A fact of success—I can't tell you how to take risks and grow without experiencing anxiety. I wish I could, but I can't. However, I can

show you how to manage anxiety, how to lessen it, and how to turn it to your advantage. As I tell my students, "We may not get rid of your butterflies, but you'll get them flying in formation." While I can't, nor will I guarantee that you can train yourself never to get communication anxiety, I am confident that you can learn to manage the symptoms and turn them to your advantage.

In this chapter, I'll show you how to

- Predict when you'll get communication anxiety

I'll show you how to know when and where you're likely to get this unpleasant body feeling. Forewarned, you'll be ready to take action and get things under your control.

- Recognize the nine major symptoms (see **Table 4.2—Communication Anxiety Symptoms**)

The body feelings you get during communication anxiety are part of your fight-or-flight protective mechanism. This physiological response is critically important to your survival if you're in combat or lost in the Amazon rainforest. But if you wear a business suit and try to win friends and influence people, fight-or-flight really gets in the way. You'll learn where these feelings originate in your body and why they feel the way they do.

If you never get communication anxiety, you're a rare bird

Over the past 20 years, I've worked closely with thousands of professionals and students to help them become better communicators. Not one person has told me he or she *never* gets communication anxiety. I've yet to meet anyone who has never experienced it. I've heard some wild symptoms described, and some unusual occasions when people get communication anxiety. For example, some students and clients have told me they don't feel any symptoms before or during the speech, but after the presentation the symptoms hit as if the space shuttle landed on them. Communication anxiety is common. You're not alone.

Communication anxiety: silent enemy of success

Few of us experience a career-capping opportunity of addressing thousands of people. And rarely, if ever, will your career be built upon this type of venue. More likely, your success will come from

communications in more informal, smaller meetings, telephone conversations, and one-on-one sidebars with supervisors and colleagues. If you're like most businesspeople, anxiety over a communications event may inhibit your success. You may artfully avoid communication by not attending a meeting, or if you go, by not speaking up. Or you may speak timidly, hold yourself back, corral your ideas, and hood your passion and intelligence—all due to fears we call communication anxiety.

If you're like most people, this type of "speech anxiety" may limit your career, because it makes you avoid certain business conversations (as well as social and family life, too). For example, have you ever avoided or postponed making a telephone call? You knew you had to make it, but as you thought about what you'd say, or imagined the other person's reaction, you began to have second thoughts, and perhaps decided to "do it later." This is a subtle, more insidious form of speech anxiety.

Americans' greatest phobias

Phobias are irrational fears, such as fear of tall people, open spaces, and examinations. Each of us has experienced a fear that another person would consider irrational. An often-cited study asked people what their greatest fears were.

Look at **Table 4.1—Ranking of People's Greatest Fears**. You can see that most people would be terrorized if they had to: "fly over deep water in an airplane filled with insects, while giving a *fasten-your-seat-belts speech* when deathly ill. I hope it never happens to you. But if it does, after you read this book, you'll do a great "fasten-your-seat-belts" speech.

Table 4.1 Ranking of People's Greatest Fears

Top eight fears

1. Public speaking
2. Fear of heights
3. Insects
4. Financial difficulties
5. Deep water
6. Illness
7. Death
8. Flying (or crashing; not-flying)

How people ranked their fears

When it's your turn to speak, do you get these symptoms?

Fear of speaking produces a distinct set of physical feelings in everyone. For example, when you're speaking before a group of 15 coworkers, or perhaps when you're sitting at a conference table and the chairperson opens the meeting with, "Why don't we begin by introducing ourselves," you get a rush of uncomfortable feelings.

Look at **Table 4.2—Communication Anxiety Symptoms** and identify the feelings you have had.

Table 4.2 Communication Anxiety Symptoms

Check the ones you get:

- ❏ Increased heart rate
- ❏ Pounding heart
- ❏ Sweaty palms
- ❏ Butterflies in stomach
- ❏ Tunnel vision

- ❏ Dry mouth
- ❏ Neck & shoulders tension
- ❏ Cold, clammy hands
- ❏ Mind "blanking out"

When you'll get it

To prepare to deal with communication anxiety, you'll want to know how to predict when you'll get it. For most people, the type of audience and the purpose of the talk are critical to when they will get communication anxiety. Four factors can cause communication anxiety (see **Table 4.3—When You'll Get Nervous**).

Table 4.3 When You'll Get Nervous

When you communicate that you're nervous

- Important people
- Important requests
- Important setting
- Not master of message

Nervous

Factor one—important people

- The audience is composed of your professional peers.
- The audience is composed of people who have authority over you.
- You speak to people whose esteem you desire.

Factor two—important requests

- The outcome is important. You want to do well for personal or professional reasons.
- Your plan is on the line.
- Your reputation is on the line.
- Your self-esteem is at risk.

Factor three—important setting

- Your boss's office
- Boardroom
- Large hotel ballrooms
- Television studios
- First tee on any golf course

Factor four—you're not a *Master of the Message*©

This is the worst catalyst to communication anxiety. If you don't know what you're talking about and you have any risk of failure, for example when speaking before people you care about, you're almost sure to get communication anxiety.

Strategies when you're not a *Master of the Message*

I recommend that if you're asked to speak on a topic you haven't mastered, and the audience is familiar with the material, you should refuse the opportunity to speak. Your risk is too great.

If you can't refuse—for example, if the boss says you have to give the talk—a good strategy is to talk only about what you know well. You can find some area related to the topic that you could comfortably address. The standards of logic are far looser for oral than for written communication. You may get away with it. But remember my first advice: Refuse to talk; weasel your way out of it. Get somebody to take your place.

If you can't refuse, and can't find a way out of having to talk about a topic that you know nothing about, I have only one piece of advice left to give you: Fake it. You'll find more advice about putting on the stiff upper lip and brave front in **Chapter 8, Message Delivery—Performing the Presentation**.

I believe that the key to anxiety for most of us is fear of losing face.

Anxiety is normal; we all get it. Today's world is full of stress producers: job, family, school, children, taxes, and the dangers, both physical and psychological, surrounding us.

Anxiety is okay in speaking circumstances. It's a problem only if it causes you to avoid opportunities to speak with people, if it keeps you from expressing your vision to others, or if the physical and psychological experience is so intense—or so unpleasant—that you're uncomfortable. **Chapter 5, Managing Communication Anxiety:** *Action Steps You Can Take* offers proven techniques for managing communication anxiety that have been used successfully by thousands of executives.

Communication Toolbox

The Thinking Person's Approach:
Understanding the Psychophysiology of Anxiety

Anxiety attacks us. Sometimes it sneaks up and pounces. At other times, we feel it creeping up slowly from the background—a nagging, unpleasant sensation. However, if you ask people, "Where does anxiety live in your body?" they are hard-pressed to answer. I've found that smart people like you can better manage their anxiety when they know more about how it works. When you get a clear picture of how anxiety is created inside your brain and body, you'll be able to recognize anxiety's sensations and take action with more purpose and a greater sense of control.

Anxiety begins in your brain. The body feelings we call anxiety are created in your brain's chemical factory, called the *locus coeruleus* (LO-CUSS CO-RULE-US), located in your *brain stem.* Chemicals flowing from your brain through your body create what you feel.

Anxiety manufacturing plant: your brain stem

Your brain stem is called the alligator brain, because it was the first brain formed. It sits beneath the large cap of thinking tissue called the cerebral cortex. As you read this, you're using your cerebral cortex. Your brain stem is not directly aware of what you're reading. It's busy running your body's respiration, cellular reproduction, sleep, digestion, and other important functions not controlled by thinking. Besides running your body's metabolism, the brain stem is in charge of sensing danger. When your locus coeruleus senses that your safety is threatened, it overrides the thinking brain (cerebral cortex) and takes over the operation of your body and mind (see **Figure 4.1—Locus**

Figure 4.1 Locus Coeruleus: The Anxiety Factory

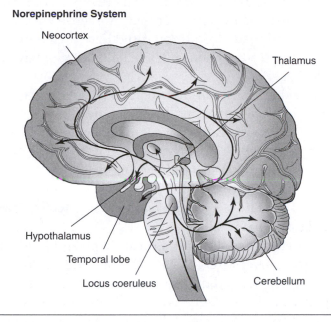

Coeruleus: The Anxiety Factory). One of the first things it does is create and distribute a master chemical (catecholamine) to direct the sympathetic nervous system. **Table 4.4—Sorting Out What You're Feeling** lists the physical changes in your body and what they feel like. It's the biological source of your communication anxiety feelings.

Table 4.4 Sorting Out What You're Feeling

Brain stem feelings	
Alligator Brain's Action	*Your Symptoms/Feelings*
Increases blood flow to major muscle groups	Heart races; heart rate increases
Sends sugar to muscles	Shaky and lightheaded feeling
Increases adrenaline	Butterflies in stomach; dizzy and feeling of nausea
Ignites fighting muscles	Upper body tense
Lubricates grasping appendages	Palms sweaty; hands cold
Diverts control from thinking brain to alligator brain	Mind "blanks out"; tunnel vision

The brain stem-caused body response to communication anxiety, and the accompanying physical feelings.

Your heart is racing; your blood pressure's up. You have lots of sugar in your muscles, and adrenaline is revving your metabolism. The fighting muscles in your upper body are tense with anticipation. You're primed and ready to kill. You could fight off a room full of savage invaders, or rip a telephone book in half, but you have to be cool. Wow! It's tough.

Imagine taking a walk in the woods on a lovely day. You notice the pleasant sights of leaves and trees; the ground is soft and loamy under your feet. You breathe crisp, pungent air filled with ozone, earth, and chlorophyll. Suddenly, as you look 10 feet down the path, you see a slim, cylindrical shape about four feet long. At this moment, let us slow time. What we describe now takes place in milliseconds (see **Figure 4.2—The Psychophysiological Mechanism Behind Communication Anxiety**).

Your eye detects the slim, cylindrical shape and sends that signal to the amygdala (AH-MIG-DA-LA). ① The amygdala is a pattern recognition device handed down from our ancestors. It contains sensory templates of all the dangerous things our predecessors encountered, things that looked, tasted, smelled, and felt dangerous. The amygdala compares your eye's report of the slim, cylindrical shape and finds that the shape matches a dangerous template (snake!).

Figure 4.2 The Psychophysiological Mechanism Behind
 Communication Anxiety

Warning Will Robinson, Danger—a trip through your brain's fight-or-flight machinery

② ③ Your amygdala acts on the potential danger and splits the signal: one impulse travels on a slower path to the cerebral cortex for higher-order analysis. ④ The other signal flies on a lightning-fast pathway to the locus coeruleus, a part of the brain stem that produces neurotransmitters that trigger other metabolic responses (Kalin, 1997).

When the signal arrives at the locus coeruleus, the first thing it does is take over the brain's activity. It shuts down the cerebral cortex. It begins sending out the master chemical catecholamine (CAT-AH-COAL-AH-MEAN), to direct the sympathetic nervous system. ⑤ A corticotropin-releasing factor (CRF) (COURT-E-COH-TRO-PIN) induces the pituitary to secrete adrenocorticotropin (ACTH) (A-DREE-NO-COURT-E-COH-TRO-PIN). ACTH then instructs the triangle-shaped adrenal gland atop each kidney to release cortisol. Lots of sugar-laden blood pumps into your muscles, and adrenaline speeds up your body systems—your heart races, and your blood pressure shoots up. The fighting muscles in your upper body (neck, shoulders, and arms) are tense with anticipation. You are primed and ready to kill—or run. You leap back, and land 10 feet away—your heart pounding like a rabbit's. By this time, your cerebral cortex has performed higher-order processing, and reported to you that it was only a vine on the path, not a snake.⑥

More on butterflies

Remember the feeling you experienced when having dental work that required Novocain? Dentists give adrenaline along with the injection of Novocain, because adrenaline acts as a vasoconstrictor. It causes the capillaries to squeeze down, reducing any bleeding that might occur. It's great for the dentist, since it makes the operating field easy to manage. The dentist leaves, saying, "I'll be back in a few minutes to see if you're good and numb." You're sitting there trying to relax, and fighting a losing battle. You're trying to think positive, and minimize your fears, but all along you've got a tremendous flock of butterflies in your stomach, and that slight nausea that signals fear. You don't realize that the butterflies are caused by the adrenaline injection; you think you're scared. Psychologists call what you're thinking an internal attribution. We'll discuss attribution theory later.

Mental self-management is vital to professional communicators. You are what you think. You create and control your own state of mind and sense of well-being. The following section on attribution theory will give you a thorough understanding of how your mind and body work together, and how you can learn to exercise superior control over your state of mind.

Chapter 4 Summary

When You're Afraid to Communicate:
Understanding Anxiety and Fear

Key Ideas

◖━ Fear of speaking is a normal feeling that everyone gets. Communication anxiety is a problem if it stops you from speaking when and where you want.

You can expect to get communication anxiety when it's important that you do well, when the listeners can judge you, when you're at risk, and when you're not a master of the message.

The more frequently you get communication anxiety, the more you are trying to improve your life. *Risk = reward.*

◖━ You get anxiety when speaking with important people, making important requests, in important settings, and when you don't know what you're talking about. This anxiety comes from fear of losing face.

You've got a wall about you. Inside that wall, you feel safe—there is no anxiety. Outside that wall is a world of people, opportunity, money, and recognition waiting for you. But to step outside your wall, you've got to feel some fear.

◖━ You can't completely eliminate speech anxiety. Communication anxiety is caused by your brain stem trying to protect you from physical danger. Communication anxiety symptoms are caused by chemical reactions in your brain stem and include

- Increased heart rate
- Pounding heart
- Sweaty palms
- Butterflies in stomach
- Tunnel vision

- Dry mouth
- Muscle tension in shoulders and neck
- Cold, clammy hands
- Mind "blanking out"

People rate good speakers as more intelligent, better looking, and better candidates for leadership.

Communicator's Checklist

❑ When you're not a master of the message, don't speak. If you must talk, speak only about what you know well. Relate to things you do know.

5

Managing Communication Anxiety

Action Steps You Can Take

With Corey Goldstein, M.D.

In this chapter, you will learn six action steps you can take to help manage stressful communication:

Action steps you can take

Action Step One	Ride it out, it will pass.
Action Step Two	Say, "I'm excited."
Action Step Three	Manage your metabolism.
Action Step Four:	Fill your mind with positive thoughts.
Action Step Five:	Know your topic.

Action Step One: Ride it out, It will pass

A picture of communication anxiety—Your pulse rate is a good measure of communication anxiety. Researchers—led by the internationally recognized communication scientist Dr. Theodore Clevenger—measured hundreds of speakers' pulses: executives, students, and top television performers. Speakers were evaluated in business meetings, in classroom speeches, and on nationally broadcast television shows. A clear, consistent pattern emerged.

The picture of a speaker's physical change during communication anxiety is shown in **Figure 5.1—Speaker's Pulse Rate While Presenting**. As you can see, the pulse first soars to levels usually associated with intense physical exercise; then, after 3 to 5 minutes, it lowers to 90 to 100 beats per minute (bpm).

Figure 5.1 Speaker's Pulse Rate While Presenting

In the graph (see **Figure 5.1—Speaker's Pulse Rate While Presenting**), the speaker's pulse rate is on the vertical axis, and time is represented on the horizontal arm. The first thing you notice is that, even before they get up to speak, speakers begin their presentations with an already elevated pulse rate of 90 to 110 bpm. The typical resting pulse rate is 50 to 60 beats per minute (bpm) for trained athletes, and up to 70 bpm for average people. You can see that most speakers

start their presentations with an elevated heart rate (90 to 110 bpm). Your heart rate will begin to increase in the minutes before you speak. After they start talking, the pulse accelerates rapidly. Similarly, when it's your turn to speak, as you walk before the audience, or when you are ushered into the boss's office, your pulse might climb as high as 170 bpm.

In these initial minutes, you may feel as though you're temporarily insane, because catecholamine is released into your body and brain. You hear your pulse pounding in your head from a major artery passing near your ears. Your body is demanding lots of oxygen to service your runaway metabolism. Even though your body badly needs more oxygen, you can't take a deep breath, because the intercostal muscles between your ribs are tense and tight. You get lightheaded. Your "fighting muscles," used in hand-to-hand combat, become tense, making it hard to move your upper back, neck, and arms. Your field of vision may narrow. You feel slightly nauseated from the adrenaline flowing in your blood. This adrenaline is causing the butterflies you feel in your stomach. But now, as all this is happening, you need to appear poised and cool, and deliver a smooth presentation. Good luck!

A short ride that's soon over—Notice that after 3 to 5 minutes, your body begins to settle down and your pulse drops dramatically. It doesn't return to a normal resting rate, but it feels more normal compared to the runaway freight train you've been riding. Your task is making it through the first few minutes of your presentation, when you'll experience the most intense communication anxiety.

When to take control of your body and mind

When you're waiting to speak, feeling anxiety surge through you, take positive steps to manage your metabolism and reduce your anxiety. Remember the graph of how your pulse rate changes during a presentation? The most challenging part happens at the beginning—right before and immediately after you're introduced—when your initial pulse rate is the highest. As you begin to feel your anxiety growing, it's time to work on a plan to lower your pre-talk metabolism. Controlling your metabolism, at this stage, will make the opening of your talk much more enjoyable for you and your audience—and reduce your feelings of anxiety.

Some anxiety is good

The right amount of anxiety can be a good thing. It makes you feel alive and sharpens your performance. If you don't care about your listeners, if you have insufficient passion for your message, your communication will be flat and passionless, too.

Of course, too much anxiety reduces your ability to think, and causes your audience to feel uncomfortable. They will confuse the fear they're feeling from you with your message. "Her ideas make sense," they'll think, "but something feels wrong." "She doesn't seem confident." Your anxiety becomes the listeners' concern and doubt.

You can see a compelling demonstration of how too much, or too little, anxiety will inhibit performance in **Figure 5.2—Some Anxiety Is Good: Performing Under Pressure**. In the NCAA Basketball Championship games, the Final Four, players make the most free-throw points when the score is moderately close, and their anxiety is moderately high. Notice what happens to their shooting percentages when anxiety is high because the score is close. Notice too that when the score between teams is lopsided, and anxiety is lower, the players miss more shots.

Figure 5.2 Some Anxiety Is Good: Performing Under Pressure

SOURCE: Center for Performance Enhancement

Action Step Two: Say, "I'm excited"

When you feel that surge of body energy as you're introduced to speak, or you walk into an office to start your job interview, or you're about to meet your beloved's family, tell them right away you're excited to

- Be there.
- Meet them.
- Work on this project.
- Share these ideas.
- Join their lovely family.

Decide: Is it fear or excitement?

Think about it. If you have butterflies in your stomach, the thing you're probably feeling is excitement. You're certainly not afraid. What is there to be afraid of? Probably nothing. You will do well in that meeting: You're prepared, and you know your stuff. This is a special moment for you, so it's only logical that what you're feeling is excitement.

Say you're excited, and people will believe you. And why shouldn't they? You look alive, your eyes are sparkling, you appear to be dynamic. It's one of the gifts adrenaline gives you.

When you tell people you're excited to meet them, and you look excited, it's a high compliment. You'll find that most people are flattered and begin to like you more.

What if you're really afraid?—On the other hand, if you give your feelings and the situation some honest thought, and decide you're really afraid and not excited, then you have a bigger problem.

Problem—You're afraid because you're meeting with nasty people. You expect they will be supercritical of you, demean you, and treat you in a cruel manner.

Solution—Don't go. Why take the meeting? Why do you want to work with nasty people? Life is too short, and the world is filled with really nice people who will appreciate you. Don't take the meeting, or if you do, don't take what they say seriously. Their nastiness says volumes about them, and not a thing about you.

Problem—You're not prepared; you don't know what you're talking about.

Solution—Don't take the meeting. If you do take the meeting, don't set yourself up to lose by pretending that you're an expert when you're not. (Please see **Chapter 4—When You're Afraid to Communicate:** *Understanding Anxiety and Fear.*)

Don't try to be cool—you won't look confident

If you try to act cool, as if you're not excited, it's not going to work. People will look at you and think, "Something's wrong with him." Your eyes might dart around; you move awkwardly, your voice sounds funny. You might move too quickly, or the opposite: You may freeze. Unless you explain your odd behavior, your listeners have to decide for themselves what's going on. When you tell them "I'm excited to be here," you make sense, in a positive way. Your audience will like the explanation of your dynamic behavior. You've flattered them.

Burn up the energy juice—Remember, you have lots of chemicals flowing through your body: blood sugar and adrenaline saturate your body and brain. Unless you use it, that stuff floats about causing those rotten, shaky, nervous feelings. If you move, if you say, "I'm excited," and you let yourself act excited, you'll begin using up those chemicals rapidly. You'll return your body to a more normal state. You'll lower your pulse. You'll look and feel more confident. And, as my favorite domestic-goddess felon says, "That's a good thing."

Is it fun or scary?

Think about the first time you went downhill skiing, or skin diving, or rode a roller coaster (or pick your own sensory-rich, rush-producing experience). Did you like it? Was it exhilarating or scary? Were you challenged, or did you feel like a prisoner on a freight train to hell? Did you feel powerful and alive, or frightened and in physical danger? What you thought was fun, your friend may have experienced as scary.

During the first few moments of these experiences you make a decision, an attribution for the profound set of body feelings you're having. If you thought downhill skiing was exciting—one of the most exhilarating experiences you've had—then, when you got to the bottom of the run, you couldn't wait to get on the lift and go again. On the other hand, if you were frightened by the feeling—felt you were out of control and in danger—then, when you finally made it to the bottom of the hill, you

probably kicked your skis off, headed to the lodge, and planted yourself at the bar, vowing never to let yourself be trapped in a situation like that again.

Business communication is like that. You can convince yourself that you like the feeling, that the body rush of adrenaline and the accompanying sensations are the result of power and excitement, rather than uncontrolled danger. You are what you think.

Action Step Three: Manage your metabolism

As you read in **Chapter 4—When You're Afraid to Communicate: *Understanding Anxiety and Fear*,** when you experience communication anxiety, your body and brain are in a useless, even harmful state. You want to change your body's chemistry from fight-or-flight to energized and dynamic. It's easy; you simply have to trust your brain. Remember, **your brain is the boss**. Whatever your brain is thinking, your body buys into. If your brain thinks fear, your body will begin to be afraid. Remember, fearful thoughts, driven by your amygdala, gave you this horrible, scary feeling. It's your brain and body chemistry making you feel rotten, and worse, look uncool.

Fear control techniques—Now you will learn some techniques to change your body's state from fear to a controlled excitement. These three techniques are easy and effective. They have to be simple because, when you've got it bad, when your anxiety rages like a forest fire, your IQ drops about 40 points. You're dumb as mud. So you need something basic that you can remember and use—and it's got to work. Here are three techniques to tuck into your communications toolbelt:

1. *Be Here Now Breathing*
2. *Square Breathing*
3. *Calm Down Breathing*

Idle your engine

Manage communication anxiety—The idea is to lower your runaway metabolism. You're in a high-drive state; your pulse is high, your muscles are tense, you can't think. What if you could slow

things down, take control, and feel better? (see **Figure 5.3—Lower Metabolism & Anxiety**.)

Figure 5.3 Lower Metabolism & Anxiety

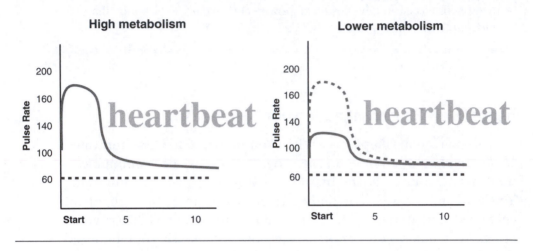

Be here now

This tip may sound a bit "groovy": **Be here now**. As you get ready to speak, think about the present moment. Don't let your mind wander to the near future, when you're going to be speaking. Remember, anxiety is your fear of impending danger. If you are literally *live* in the present moment, you will be invulnerable to anxiety. So keep your mind in the present. Think about the things you'll say; review your speech. Don't visualize yourself speaking—that will only raise your anxiety and metabolism.

Tip ✓ **Talk to good listeners**—While you wait to speak, find a position in the room where you can see your audience's faces. Study the audience; pick out people whose faces you like. For some wonderful reason, during the fast, flashing moment of a first impression, some people are more appealing to us. Maybe they resemble others we know and like. Perhaps they seem friendly. As you study the audience, you stay in the present moment, and you take a set of intimidating strangers and turn them into more familiar friends. When you begin speaking, and your metabolism is at its highest level, you'll want to talk exclusively to the faces you like.

Tip ✓ **It's a snap**—Here is another "be here now" trick that I learned
from a gentleman who teaches people suffering from chronic
and debilitating fear of flying how to overcome their disabil-
ity. Harith Razah works as an executive, but he conducts sem-
inars part-time for American Airlines. Mr. Razah suffered
from a crippling fear of flying and learned to manage his fear.
The trick he uses (among other techniques) is to give a thick
rubber band to each of his students. When they feel anxious,
they snap it on the tender flesh of their wrist. This sharp blast
of pain brings them back to the present moment. They con-
centrate on the sensation in their wrist, and in those moments
of minor pain they get important relief from their escalating
anxiety. They think about the pinch of pain instead of all the
things that could go wrong with the plane.

Try the wrist snap, or if your metabolism level is not that high,
study the back of your hand, your pen, or the paper your notes are
written on. These will all bring you to the present moment, where
anxiety cannot get you.

Tip ✓ Another idea is to listen to the other speakers. Really con-
centrate on what they are saying. Do not allow yourself to
think about your talk, or what will happen when you get up.
Don't worry about being ready when you're introduced—
you'll have all the time you need to bring yourself to the
peak of performance for your talk.

Be Here Now Breathing

Technique—If you can, get away from people; find a quiet place. Sit
down in a comfortable position. Shut your eyes. Take 10 slow, deep
breaths, and count them. As you inhale, think to yourself "*One*," and
see a number one on the screen in the front of your mind. The number
can be in a Times New Roman or Arial font, or a crayon scribble; it
does not matter. Continue to see the number as you slowly exhale. As
you take your next breath, say "*Two*," and see the number two, and
exhale slowly. Do this up to the number 10. You'll be amazed at how
well this technique works. It's fast and easy. Your anxiety begins to
dissolve away like an Airborne tablet in a glass of water.

Now, you may feel a little goofy as you do this, especially if you
can't get away from people. You may feel self-conscious sitting with
people with your eyes shut. I don't think they will even notice. If they

ask what you're doing, simply smile and say, "I'm thinking." I use this technique right in front of a large audience. Imagine you are with me, minutes before I walk into a big hotel ballroom to deliver a keynote address before a thousand people. The first thing you will notice is that I'm filled with communication anxiety. If you were to ask me a question, I'd look at you with wild eyes and say, "Huh? What did you say? I'm sorry." Then, you watch me walk out on the dais and take a seat. I sit in profile to the audience, shut my eyes, and begin to breathe slowly and deeply, and count my breaths. In no more than a few breaths, my chest and shoulders stop shuddering on the exhale count. By breath 10, I'm really calm—even a little spacy.

Can a space cadet present well?

Are you thinking, "Well Joel, if I'm all blissed-out, how am I going to speak intelligently?" Trust me, Sparky; the moment you're introduced, your metabolism will take off. You'll be really alert, but nowhere near as hyper as you were before you did the *Be Here Now Breathing* exercise.

Here are more techniques you can use to reduce the heightened metabolism you experience during communication anxiety. Again, the idea is to begin with less stress, so you'll enter the communication setting with a lower level of tension.

Do stress-reducing exercises to help you relax as much as you can.

Square Breathing

If you don't have time, or don't want to do *Be Here Now Breathing*, *Square Breathing* will ease your anxiety quickly. It's an effective tool that will lower your energy and douse some of the flames in that raging forest fire inside you. Here's how you'll do *Square Breathing* (see **Figure 5.4—*Square Breathing***):

1. Take long, slow, deep breaths on a timed count of two.

2. Take 2 seconds to breathe in.

3. Hold the breath for 2 seconds.

4. Let it out slowly for 2 seconds.

5. Hold for 2 seconds.

Figure 5.4 *Square Breathing*

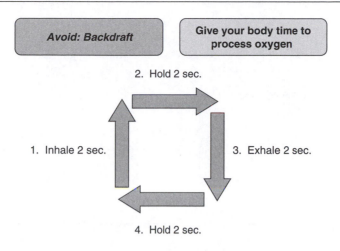

Tip ✓ If nobody is around, make a hissing sound as you exhale.

You may need only five or six breaths before you feel much better. **Caution:** Watch out for hyperventilating. If you take in too much air, too quickly, you could get lightheaded and even pass out. *Square Breathing* gives your body time to absorb the oxygen through your lungs. That's why you pause for 2 seconds at each step. You may need only a few square breaths to get the benefit . . . too many will leave you lightheaded and giddy.

Calm Down Breathing

The next technique is a variation of *Square Breathing* called *Calm Down Breathing*. It's my DePaul students' favorite communication anxiety-busting technique. They like it because it's simple, fast, and effective, and because people can't see them doing it. You keep your confident cool.

Calm Down Breathing is like *Square Breathing*, with the addition of a private message to your mind. The deep breaths address your body. The silent messages of "calm" and "down" soothe your troubled mind. Before you go on stage, take a deep breath. As you are inhaling, say to yourself: "Calm." Hold your breath for a few moments, and then exhale. As you release your breath, slowly say the word "Down." (Please see **Figure 5.5**—*Calm Down Breathing*.)

Figure 5.5 *Calm Down Breathing*

Stretch away your tension

You'll feel more confident if your muscles are loose and free of tension. When you feel anxious, the blood sugar and adrenaline make your muscles rigid with tension. So do stretching exercises to remove tension from your upper back, shoulders, and neck. This tension makes your throat feel thick and your voice sound funny. Tension makes you look nervous. The Women's Heart Association offers excellent stretches that ease the effects of communication anxiety, and they can help your heart be healthier, too (see **Figure 5.6—Stretch Away Upper Body Tension**).

Tip ✓ You can control your throat tension by **humming forcefully**. As you feel your throat begin to relax, hum more gently. This will relax your throat muscles, and remove any trace of tension from your voice. You will not sound nervous. You'll sound more confident and natural, and speak with greater ease. (Learn more ways to develop your voice in **Chapter 8— Message Delivery—Performing the Presentation**.)

Action Step Four: Fill your mind with positive thoughts

This technique will give you two great benefits:

1. You'll be able to reduce your anxiety and fill your body with positive energy.

2. You'll become more powerful. It heightens your leadership quality and credibility. Your audience will sense your positive energy.

Figure 5.6 Stretch Away Upper Body Tension

Stretches side of neck

- Sit or stand with arms hanging loosely at sides
- Tilt head sideways, first one side, then the other
- Hold for 5 seconds
- Repeat 1 to 3 times

Stretches back of neck

- Sit or stand with arms hanging loosely at sides
- Gently tilt head forward to stretch back of neck
- Hold 5 seconds
- Repeat 1 to 3 times

Stretches side of neck

- Sit or stand with arms hanging loosely at sides
- Turn head to one side, then the other
- Hold for 5 seconds, each side
- Repeat 1 to 3 times

Remember, you are what you think—The great author Kurt Vonnegut told us, "We are what we pretend to be." Your state of emotional well-being, confidence, and dynamism is the direct product of your last sequence of thoughts and experiences. *Your brain is the boss of your body.*

Tip ✓ **Test your brain's power**—Next time you lift a heavy object, perhaps when working out in a gym, test the power of a positive mental state. As you lift the weight, say the word "strong" or "power" to yourself. Concentrate on that word. You'll sense an immediate upward change in your physical power as you exert yourself against the weight.

Next, think the words "weak" or "heavy," and you'll notice your power rapidly drops off. If a simple word can change your physical

strength, what do you think profound and detailed thoughts can do? When you think positive thoughts that are derived from your experiences, you can generate a positive push wave of energy. People will follow you and believe the words you say. (See *The Fourth Component of Credibility* in **Chapter 6—Making People Believe You**: *Persuasive Communication*.)

How to build a list of *Personal Power Thoughts*©

Think about things in your life that make you confident and happy; things you've done to help people. Think about the people who love you and trust you. Visualize their smiling, loving faces. Remember the times you've been the big winner—in business, in sports, in love. Recall the time you were hired or promoted, landed a big contract, had your ideas accepted. Were you ever a hero?

If you've competed well in sports, think of a moment when you were playing well, without pressure or fear, when you were happy, in control, and winning. As you visualize this great moment, you will transform your nervous energy into positive energy.

Next, you must record these private moments of victory and accomplishment in a list. You will want to have a set of 10 things that will instantly make you feel good about yourself the second you think of them.

Important—The list must produce strong, positive emotions and tie into visual memory. You must see the event vividly in your mind, so you can really feel it throughout your body. This technique takes the energy rushing throughout your body and turns it into positive feelings of physical and psychic power.

Five things that make me feel good

Write down five moments from your life that make you feel great. Do this now, and you will have a tool you can use to decrease communication anxiety. Also, I'll sell more books. See, once you've written in it, the bookstore's resale value will be lower, so you'll probably decide to keep it, which means there will be one less used book on the market. Thanks for helping me sell more books!

1. _____

2. _____

3. _____

4. _____

5. _____

Think about the positive outcomes

An effective variation on the *positive thoughts* technique is to focus on the positive outcomes of your communication. If you feel anxious, and you insist on thinking about the impending communications event, think positively. Allow yourself to think only about the wonderful, beneficial things that will happen. You'll begin to feel powerful and energized. For example, picture the audience being delighted with your speech. Rehearse parts of your speech, and visualize the positive response that you'll get from the people in your audience. Think about what will happen after you've spoken, and the group adopts your vision. Visualize the benefits you'll accrue from speaking.

Positive thoughts

Technique You can gain control of your mind and metabolism. Think of a place where you feel relaxed, and practice thinking about that place. For example, if your favorite relaxation place is lying on the hot sand at the beach, picture yourself there.

Use each of your senses—touch, taste, hearing, smell, and sight—to remember that favorite spot. For example, you can smell the salt air and the breeze, feel the warmth of the sand and softness of the wind; you can see the bright, light blue sky, and hear the waves and sounds of far-off conversations.

The longer you practice remembering this, the more powerful and automatic it will become. The calming effect is wonderful and will always be at your command.

Taking control of persistent fears

Fear, particularly anxiety over an impending event, is a nasty, annoying emotion to live with. Our brains prefer to think about negative, fearful incidents. Unless you take control of your thoughts, left to its own resources, your brain chooses to pay more attention to fearful thoughts than to positive ideas. Your brain would rather think about the bad stuff that could happen than the good things that probably will happen. Think about all the things you've worried about

over the past few months. Now, how many of those disasters actually happened? Few, if any, I bet. Next, think about the lousy things that did happen to you. How many of them did you anticipate, think about, and develop a nice set of anxieties over? The answer, for most of us, is that 90% of the things we worry about, or even lose sleep over, never happen. And of the things that actually go wrong in our lives, few of them were expected.

False alarms go off in your head

You know that your brain stem does not understand the dangers you face today. When your brain stem comes to your rescue because you feel threatened, or are intimidated, it can make speaking harder.

Here is why—Your reptilian brain developed millions of years ago, when the dangers our species faced were physical. For example, your cave-dwelling ancestors were threatened by saber-toothed tigers or by running off a cliff—not by their coworkers who might laugh and ridicule them when they presented their financial analyses. To protect our ancient ancestors, the brain stem responded to danger by pumping out a rush of chemicals that made our ancestors momentarily stronger and faster, and their bodies better able to stand and fight, or run from danger (fight-or-flight). Unfortunately for us, our society has evolved faster than the human brain stem. The dangers we face today are social, not physical. As you prepare to present your ideas, your brain stem senses your fearful thoughts and "thinks" you're in physical danger. It rushes in to rescue you; it shuts down the cerebral cortex, and all brain activity is diverted to combat condition red; it reduces blood flow to your extremities, so if you suffer a cut you won't bleed to death. The brain stem increases your heart rate to pump blood to your upper body's fighting muscles. Sugar is shot into your muscles. You're powerful; your arms shake with energy. If your mission was to tear phone books in half, or leap into your audience and kill 20 people, you could. Your body is ready. But your job is not to become a killing machine; your job is to be cool. You are supposed to project a calm, confident, "I'm in control" attitude, to make your audience believe you are in charge.

Protection you could use

If your brain stem were designed to rescue you from the dangers you face today, it would not turn you into a fighting machine. Instead,

it would produce chemicals to heighten your intelligence and charm. For example, if your brain stem were the type of ally you needed during an important business meeting, it would send chemical messengers to relax your muscles, allowing you to move gracefully and gesture smoothly. Rather than making your mouth dry, it would order the production of extra saliva to lubricate your tongue and lips, so you could speak with greater fluidity. The brain stem would release endorphins to give you a feeling of well-being. Other chemical messengers would be released to heighten your intelligence, speed up your cerebral cortex's processing time, and decrease retrieval time from memory, thus allowing you to assess ideas and questions with greater brilliance. Your peripheral vision would be enhanced, so you could see more of your audience. You could read every person's reaction to your ideas. (Now the opposite usually happens: Your visual field narrows, giving you tunnel vision.) And perhaps the brain stem would help you become more socially attractive by releasing a pheromone scent, making you more sexually attractive to your listeners. Now, this is the brain stem you need when faced with social danger—something that will turn you into Cary Grant, not Rambo.

Your brain stem is obsessed with fear

Time and time again, your brain stem makes you miserable. It gives you rotten feelings when you should be feeling excited and powerful. It makes you stupid when you need to be intelligent. You become a klutz when you need grace and charm. Your brain stem can't learn from its past mistakes. It continues on its consistent track record of failure, as it obsesses about things that will go wrong. Fear and anxiety are hard to ignore. Your brain thinks it's protecting you. In reality, it may be harming you with pent-up stress and preventing you from optimal performance.

Action Step Five: Know your topic

Earlier, I made what I hope is a convincing case for mastering your subject matter before you speak. You should demonstrate mastery in the way you deliver your talk. Never read your presentation. You can speak from a bullet point outline using PowerPoint slides or handouts. You will carry on a conversation with your audience, because a good presentation is a lively exchange between you and your listeners.

Never, never, never, never memorize your speech—Note I did not say sometimes, or usually; you should never attempt to memorize a speech. Exception to that rule: If you are so talented that you can take prewritten ideas and deliver them with such elegance and fluidity that your audience is not aware you're speaking canned words, you can memorize what you want to say. But do not waste such a rare and valuable talent by going into business. A fortune and tons of fun await you in showbiz. If you want to stay in business, you can: Be your own manager.

The rest of us cannot take things we've memorized and deliver them in an audience-engaging manner. Sure, you'll get the words out, and if your audience is willing to work hard, they may receive some logical, factual content. But the major message you send them is, "Shut up, don't participate, I'll do the talking, you merely sit there." Your stilted, memorized tone creates a barrier between you and your audience.

The deer-in-the-headlights look

Many people have told me that one of their biggest fears about speaking before important audiences is that they will go blank during the presentation. They imagine themselves standing, speechless, before a group of people who undoubtedly will see them as idiots.

A great reason not to memorize a speech is that everyone goes blank in a presentation; we all forget a train of thought, or lose a word for a moment—it's normal. But if you blank in a memorized presentation, as you probably will, it's like death. You stand there frozen; your mind races, you fight panic. You either stand there repeating the last line you said, hoping to recover the link to the idea you've forgotten, or, like the third grader delivering the Pledge of Allegiance, you have to start over at the beginning. Either way, it's not a pretty sight.

Dealing with blanking out

First, you can expect that you'll go blank at least once during a talk. It's natural, and it will happen. In fact, the better your talk—the more spontaneous, the more involved you are, the more your audience is hanging onto your every thought—the greater the chance. You may fail to instantly find the right word or idea, as you create this lively communication experience. Panic can exacerbate the natural blanking that occurs. If you tense up and panic, you're dead. The audience realizes that something is wrong, and transmits fear back to you.

Stay cool, mon

Relax; forgetting is natural, and only lasts a few seconds at the most. See for yourself. Next time you're engaged in a conversation, notice how often you fail to find the right word, or how often you lose your train of thought. My recommendation is to handle it the same way you do in a casual conversation. Just wait, think, and it will come to you.

Two different speed zones— yours and the audience's

Besides the level of tension in you, another factor makes blanking in a presentation especially difficult: *Einstein's Time Shift*© (see **Chapter 7—Message Packaging—Strategies for Formatting Presentations:** *How You Say It*). The audience and the presenter move through two different time continua. To you, the speaker, time moves quickly. It seems as if you have barely started to talk, when time is up. For your audience, time is moving in the other direction: slowly. When you go blank, you feel as if you've been standing speechless before the audience, sweating bullets, with everyone staring at you for minutes; but to your audience, it's been only the blink of an eye. If you make too big a deal out of blanking, the audience is likely to be puzzled over what you're talking about. To them, you appear to have paused. So relax, take a few seconds to think about what you want to say. Usually your forgotten thought will come to you. Take a nice pause; your audience will believe you're thinking. You'll look smart and in control.

Move to the groove—Use body movement to unstick your memory. If you've waited, and what you wanted to say doesn't come to you, use the same trick that athletes use to get in the groove and improve their performance: Move. Standing frozen in the spotlight makes it worse. By the simple act of taking a step, you will unlock your mind. The same trick works when you're sitting at a table and you go blank. When you shift your body position, rapidly and with confidence, the movement will trigger recall.

"Look to the Force, Luke"—Use visual cues. You can always glance at your visual supporting aids, such as notes, or much better, the overhead projection of your outline. It's best to have your talk's key words on overheads (see **Chapter 10—Communicating With Tables,**

Graphs, and Charts: *Your Visual Toolbox,* and **Chapter 11—Maximum PowerPoint**).

Confession is good for the soul and memory

If all the above methods fail you, be honest. Tell the audience you forgot what you were going to say. Your candor will build a bridge between you, enhance your credibility, and bring them closer to your side. And, just as in everyday conversation, soon after you tell your listener you can't remember what you wanted to say, you will remember it.

Know More About How Your Mind Works: *Attribution of Cause*

This popular psychological technique is a rational approach to understanding how we think. Unlike other theories that describe human behavior as driven by internal states or personality, attribution theory starts with the premise that people are thinking, rational beings. People think like scientists, even though they don't have formal scientific training. We watch other people, notice events, and try to make sense of the world. While much of what we see appears to be chaotic, we still try to sort it out and create order.

For example, imagine what chaos business would be if accountants didn't have rules and rational ways of dealing with money as it flows in and out of the firm—or if marketing people didn't have methods of getting money for the accountants and finance people to play with.

Attribution theory—the scientist observes

We watch the world about us, explaining the events we see, why they happened, and assign causes for effects we observe. For example, imagine that you're sitting on the shore of a lake. You watch a sailor in a rowboat move across the lake. You want to explain what causes the boat to move.

As an intelligent person, trained to use attribution theory, you rely on two fundamental rules to explain causes for effects: "can" and "try."

1. **Can**—does the person have the ability to cause the effect? If the answer is yes, he or she may be responsible for causing the

effect. But while necessary, "can" information is not sufficient. The person has to try, too.

2. **Try**—did the person exert effort?

Together, "can" and "try" evidence are excellent explanations for responsibility.

As you look at the sailor and the boat, what "can" and "try" information do you have?

Test One Does the sailor have oars or sails? (can)

Test Two Is the sailor working the sails or pulling on the oars? (try)

If you answer "yes" to Test One and Test Two, you will attribute cause to the sailor. The sailor is responsible for the boat's progress across the lake.

However, if the answer to either the "can" or "try" test is "no," you'll make attribution to forces outside the sailor: For example, the passive sailor in the powerless boat may be moving because of the wind or current.

Attribution principle—internal or external locus of control

The locus of control is the source of power, or force, that causes things to happen. It's the mojo that moves people, places, and things; it empowers actions and causes results. We have two loci of control: internal and external. The power resides or originates either within or outside the person. If you believe that the motivation comes from within the person, you'll make the attribution that he or she is the cause, and is responsible. On the other hand, if you believe that forces outside the person were the cause, you would not hold that person responsible.

It's a foul assignment and your name is written all over it—(See **Table 5.1—Attributions Why Your Supervisor Gave You a Dirty Job**.) For example, consider the internal forces that would cause your supervisor to give you an undesirable assignment. You receive a voice-mail from your superior assigning a nasty, bothersome little project that no one in his or her right mind would want. What caused her to give it to you? Here are two lists of possible causes. The first list contains all internal motivations. The second is a set of external attributions you could make to figure out your supervisor's actions.

Table 5.1 Attributions Why Your Supervisor Gave You a Dirty Job

Internal attributions: Why you

Internal attribution	What it means
She thinks you're intelligent and have expert skills.	She knew you handled messy projects well.
She's prejudiced.	She thinks people of your gender, racial, or national characteristics or sexual preference like this work.
She's selfish and greedy.	She will look good in the eyes of her superior.
She knows your disposition.	She knew that you wouldn't turn her down or fuss too much.
She wants to promote you.	Her desire to see you succeed; while undesirable, this project will show how tough you are and spotlight you to others in your organization.

If you believe any of the above reasons were deterministic in her giving you the assignment, you would blame her, thinking she's at fault.

Now, consider this list of external attributions for cause:

External attributions: Why you

External attribution	What it means
Other people were not acceptable.	Your supervisor expressly suggested you be given the assignment.
Everybody else was sick.	You were the only one available.
It's the company's operating policy and procedure.	As part of your company's policy, miscellaneous assignments are given in strict rotation, according to seniority and the last project assigned. Your name came up.

If you make the attributions for the cause behind your supervisor's assignment to be external forces, you'll be far less likely to blame her.

Law and Order uses attribution theory

Juries make decisions of guilt or innocence using attribution theory. If they believe that a defendant's motivation was due to internal forces, they deliver a guilty verdict. If the defense can successfully

demonstrate to the jury that external forces were at work, the defendant is pronounced innocent.

For example, imagine that you're on a jury that must decide why a wealthy young man killed his butler.

External: The butler went berserk, and attacked him with a lead pipe in the library. Your verdict: not guilty, self-defense.

Internal: The butler was blackmailing him with candid photos that showed him committing adultery. Your verdict: guilty, murder.

In a personal injury case, the jury decides why the patient died. They determine if the doctor was at fault.

External: The patient had a rare fungus that quickly enveloped his body; there was no known cure. Verdict: not guilty.

Internal: The doctor was drinking, ingesting prescription medications, and misdiagnosed the case. Verdict: guilty, responsible for the patient's death.

How to use the power of attribution theory to manage speech anxiety

Just as you assign causes for other people's actions and the outcomes of events, we use attribution to explain why we feel the way we feel at any given moment.

Humans experience a wide range of emotions: anger, fear, love, passion, envy, desire, greed, anxiety, elation, and more. As an adult, you have become sophisticated in detecting the various types of emotions you experience at any given moment. While you may feel an extensive set of emotions, the physical feelings you have are quite limited. In fact, the same chemicals flow through your body during most emotions. Emotion is rather simple chemically, but is a complex attribution. You use external cues to make complex explanations for a limited set of physiological responses and feelings. You use information from your environment to explain your feelings.

For example, imagine it's late one night; you've just finished shopping at the mall. As you walk to your car from the mall, suddenly, in your peripheral vision, you see a stranger jump out from a dark corner. You take that set of information: human form; sudden, aggressive movement toward you; and the fact you're in a vulnerable

situation; and you make the attribution that the sudden rush of feelings you are experiencing is caused by fear.

Now, change the setting in your mind to a romantic, softly lit watering hole. You're sharing a lively, loving conversation with a person of the gender you prefer. This person is attractive and charming, and you begin to experience a slowly building set of physical feelings. When they reach their peak, these feelings are almost identical to the body chemical you generated when the stranger startled you in the mall parking lot. The same set of chemicals produce the same body feeling. One feeling is unpleasant and frightened you. You hope in your heart of hearts that it never happens again; the other is a moment you wish could go on forever, one you'll choose to return to again and again in your memory.

Situational information determines your feeling

If you get a letter from the IRS, you might label your feelings as anxiety or fearful expectation. Should you find yourself speaking before an audience, you could attribute your enhanced physical state to the fact that you're about to seize a thrilling opportunity—one that will confirm your exalted status and knowledge. Or you could decide to believe that you are a victim trapped in a frightening experience, one that will mean huge risk, probably failure, and humiliation. How do you decide? Do you realize the attribution you make is entirely up to you? You pick the one you most believe. That will determine how you feel, and it will regulate how you speak.

What is the cause of these feelings?

During significant business communications, your body is alive. Adrenaline is flowing, your blood pressure is up, and your heart is pumping. How do you explain these symptoms? Possible attributions could include that you're weak and vulnerable. Or you could choose to attribute the feelings to excitement and power: You sense that the audience loves you, and you feel totally alive. That second set of attributions—the feelings of excitement and power—is what successful business leaders make, it's what they tell themselves. And they really believe it.

Seven Keys to Managing Communication Anxiety

Here is a list of seven practical keys that will help you manage yourself through communication anxiety.

Key One The natural chemicals flowing through your body and mind, as a result of your excitement, give you a case of "temporary insanity."

Insight into attribution for feelings

Let me share some objective scientific evidence that will clearly demonstrate how people label their body feelings based on information about the settings they are in.

In these psychological studies at a leading university, undergraduate male students were given heavy, soundproof headsets to wear, like the headsets that airport ground crews wear as they wave your plane into the gate. The experimenters convinced the young men that what they were hearing in the headsets was their own heartbeats. The young men were given an album filled with photos of nude women. As the subjects looked at certain preselected photos, the experimenters turned up the subjects' "heart rate." At the end of the experiment, the men were encouraged to select one of the photos (their choice) to take with them as a reward for having participated in the study. Each time, the young men selected the photo that accompanied the faster "heartbeat." What made it more interesting was that the photos were pre-rated for attractiveness by a panel of judges. The experimenters had increased the heart rate for the photos that were consistently rated as less attractive. The subjects made the attribution: "I liked her best."

If you found the first experiment interesting but of questionable ethics or taste, wait till I tell you about the second experiment that was conducted. Everything was the same as before: young man listening to

headset with "heartbeat," looking at nude women. But this time, a picture of a nude male was inserted in the middle of the album. Guess which picture the experimenters increased the heartbeat on this time? Right you are. And guess what reaction these young men had, at an age when much of their sexual identity was being established? Subject after subject began to believe that he was gay, though his sexual orientation was heterosexual. The experiments went into greater ethical jeopardy, because the researchers did not adequately debrief the subjects and explain what they had been through. This series of studies profoundly demonstrates the power of attribution. If young men can be convinced that they have an attraction to another person based on heart rate information, you can convince yourself that your heightened metabolism is the result of excitement and power, not fright. This is exactly what I recommend you do—convince yourself that you're excited, and tell your audience you're excited to be speaking with them.

- During the opening part of your talk, you're under exceptional stress and have an elevated pulse rate. You may not remember what you were going to say. You'll feel as if you're riding on a runaway freight train.

Use the *Question Opening*© technique (**Chapter 7—Message Packaging—Strategies for Formatting Presentations:** *How You Say It*).

- Know the first 30 seconds well. After you get through the beginning, you'll be fine.

Key Two Let your heightened metabolism work for you.

- It's energy, so use it. Move, be dynamic; be excited. Tell your audience you're excited to be speaking to them. Elaborate, and tell them why. Your ideas are superior, and you have found solutions; or better yet, because they are impressive, important people, and you realize the magnitude of the honor bestowed upon you by being invited to speak to this esteemed group. Remember, you must be sincere. If the listeners believe you're only stroking them, they will have to hose you off the sidewalk. You've killed, or badly wounded, your credibility.

- Don't try to be cool, whatever you do. Your body is alive with power and energy. Your muscles are filled with adrenaline and sugar; they shake with strength and drive. Your breathing rate is faster and deeper, as your body demands more oxygen to

maintain this heightened metabolism. You'll only increase your stress if you try to stand still and look cool. If you're taking small, cautious breaths, you're not feeding the animal you've become. Breathe deeply; drink in the oxygen. Move, too.

Key Three If you think your excitement is showing . . . tell your audience you're excited to be speaking to them.

- They will attribute your obvious agitation to your excitement, and they will be flattered. One result: The audience will like you better, and you'll build credibility.

Key Four Remember, the audience is on your side.

Especially during the opening moments of your presentation, your audience wants you to speak well. Have you ever listened to someone and thought, "I surely hope this speaker is boring?" Your listeners want an entertaining, informative presentation.

Think of your listeners as partners in your presentation. It's as if you're at the same party. Everybody wants to have a good time.

Key Five Try to meet the members of the audience before you speak, shake their hands, and look them in the eye.

- Tell them you're one of the speakers. Thank them for coming. This human contact will greatly reduce your anxiety over being a stranger in the room. Even if you know the audience, and work with them every day, a couple of moments of human contact will greatly enhance your sense of ease, and their sense of participation in the talk. Together, you'll have a better communication experience.

A tip for meeting strangers is to look in their eyes. See if you can guess what type of people they are—friendly, serious, analytical, humorous? See if you like them or feel an affinity toward them. Most of us make a rapid, if not accurate, determination during the first few moments when we meet somebody. We either like the person right away, don't like the person, or find it hard to get a reading on the person. Perhaps the person reminds you of someone in your family, someone you work with, or someone you have met before. If you begin your talk with a handful of people you like, you're way ahead. You will focus your attention on them initially. There's more on this technique in **Chapter 8—Message Delivery—Performing the Presentation.**

Key Six Just before you're introduced, study the faces of your audience. Look for friendly faces.

- This is an application of the "meet the audience" technique discussed above. You'll find that some people are naturally better listeners. They give feedback; they look at you with expressions of interest and liking on their faces. If you try to talk to the people who have blank or hostile faces, or who are looking down, you'll find it disconcerting. But by focusing on the good listeners, the people you get a good feeling from, your own attitude will be positive and confident as you begin to speak to these better listeners.

- As you begin to hold these individual conversations with the good listeners, the others will start tuning in, and become part of the communication experience. Focusing on the bad listeners, or the people tuning out, will distract you by giving you false feedback. Talk to the good listeners in the audience.

Key Seven Focus on the audience and your message.

- Concentrate on your ideas, not on yourself. If you're aware of how you are gesturing or of your physical symptoms, you heighten the communication anxiety reaction. You'll get nervous if you think of yourself too much. Think hard about how to best express your ideas.

- Look at the audience one at a time: Hold brief conversations with each person, moving from one good listener to another.

- Forget about yourself. You don't have to spend your limited mental awareness and thinking ability worrying about how you're conducting yourself. You have been beautifully reared and have fine business manners. Your natural gestures, the ones you make in a presentation, are fine.

- What counts most in a business presentation is a communication with the audience of facts and emotion, spontaneously delivered, by a well-prepared authority on the topic: you.

- Great speakers are hungry to share their ideas with the audience; they really don't think about what their bodies are doing. Their motions and gestures become automatic. Train yourself to avoid "self-monitoring behavior."

Speech anxiety: Barrier to success

What keeps people from finding success and recognition in their business lives? Is it too little planning? Bad luck? Not enough effort? Is it lack of capital? Sure, these reasons have been the cause of business failure and lack of advancement. Think about yourself and your career. Like many people, you may find that speaking anxiety has held

you back. Not because you got cold feet at the prospect of addressing the 5,000 national sales representatives and distributors at last year's national meeting. That would scare anybody. I am talking about the times when you did not speak up at a meeting, when you were held back by anxiety, or by an unfocused, confused mind. How often have you not made or returned a phone call because you did not want to speak to another person? Perhaps you were afraid of some unknown factor. How often, after the meeting was over, perhaps at your desk or riding in your car, have you kicked yourself for not having spoken up? We regret the things we did not do . . . not the things we did.

Advanced Fear Management

You must make an extra effort to deal with these pesky, anxiety-creating fears—Do you have recurring thoughts of fear and anxiety? Do you find yourself revisiting fearful visions or recollections during the day? You can rid yourself of these negative, energy-draining moments by taking yourself through a systematic analysis. At the end of this process, you'll find that your fears will be greatly reduced, and better yet, they won't recur as often, if at all. This technique has been known to rid people of their nagging fears forever. If you like, practice this technique by thinking about a moment that will put you into a state of speech anxiety. For example, visualize yourself blanking out in front of an important audience and having people laugh at you. The more vividly you recollect the fear, the more you'll experience this technique.

Step One: Sense fear and its cause—Visualize the fear, the negative, clearly. You want to really feel the anxiety.

Step Two: Write down or say aloud exactly what you think will happen—Describe the disaster in clear terms. HINT: You must not merely think about the fear. The fear must be brought out into the clear light, where you can examine it, by writing it down or saying it aloud.

Step Three: Rank the magnitude of fear on a scale of 1 to 10—Assume that your worst fears come true. How bad would that be? Or how severe a fear is it? Let 1 be hardly any fear at all, a minor fear, and 10 be the end of your world as you know it, the worst outcome you could imagine.

Step Four: Reassess fear and the likely, realistic outcome—Next, revisit the potential situation that is causing the anxiety. Describe, either by saying aloud to yourself or by writing down, what realistically will probably happen.

Step Five: Re-rank magnitude of fear on scale of 1 to 10—Finally, sense your fear level, and re-rank the magnitude of your anxiety. You'll find fears that started out as an **8** or **9** have dropped way down to a **2** or **3**. You'll find that they aren't worth thinking about.

This technique allows you to put fears under the microscope. Fear is sneaky. It lurks in the background, in the shadows, whispering at you. So your fears may be hard to grasp and deal with. To take back control, you must bring your fears out, one by one, on center stage. Put fear in the spotlight, and give it a microphone. In that cold, rational light, fear can be dealt with.

Give this technique a try. Return to that list of negative outcomes you put together earlier in this chapter. Pick a really ugly, scary fear and use these five steps to whittle down that redwood of a fear to a toothpick.

Getting more help

All forms of anxiety, including communication anxiety, are serious problems that require serious remedies. If you feel that the ideas and techniques you've read in this book don't help you enough, you may say, "Joel, I need more help." Trust your senses: You're right, you do need more help, and the better news is that you can get effective help. Be sure to read the special section below by Dr. Corey Goldstein, a renowned physician and authority on psychopharmacology at Rush University Medical Center. Dr. Goldstein is an expert at helping people manage their communication anxiety with medication and therapy.

More tools to fight anxiety—Millions of people experience anxiety that can't be controlled by breathing and positive thoughts; they need medication and more aggressive, intensive treatment. Physicians trained to treat anxiety have a host of medications they can prescribe for you. And therapy has taken leaps and bounds in effectiveness, from cognitive therapy to Eye Movement Desensitization and Reintegration (EMDR). Help is waiting for you. Please don't suffer from the effects of anxiety anymore.

Contact the **Anxiety Disorders Association of America**, a fantastic organization (www.adaa.org/). They will help you find a trained professional in your area who can help.

This next section will open the door to breakthroughs in medical science that can give you more potent tools to deal with communication anxiety. You'll learn from Dr. Corey Goldstein, who has helped thousands of people take greater control of their lives.

Medical Management

Corey Goldstein, M.D.

Performance-based anxiety is common. Millions of people suffer profound anxiety when doing important, day-to-day things. Public speaking anxiety is even more common. While the techniques outlined above are useful for reducing communication anxiety in the majority of people, some people will not respond to them. In fact, many of these "non-responders" are so anxious that the thought of even trying to practice a breathing exercise, or trying imagery, is paralyzing. Fortunately, most people have to speak in front of others only rarely. However, when you are faced with a mandatory public speaking event, one you can't avoid, you can have a debilitating problem.

A good example of a familiar speech that is frequently overwhelming is the toast to the bride and groom, traditionally given by the best man at a wedding reception. The best man's anticipatory anxiety can overwhelm his life, and these feelings begin weeks in advance. His anxiety often overshadows what would otherwise be a joyful event. As the wedding draws near, the event itself is relegated to the backseat, while his speech becomes an intrusive thought. Even after he has given the toast, the best man can be plagued with doubt as he replays his behavior during the speech. What a horrible way to enjoy a loved one's wedding.

I have seen many professionals avoid public speaking, to the detriment of their careers. The effect of this avoidance is twofold:

1. You deny yourself a potentially rich, rewarding career path.

2. You lose the chance to learn and grow by exposing yourself to an anxiety-provoking situation that could improve with repetition and practice.

What to do when communication anxiety is overwhelming

What can you do if you fit into the "severe" public speaking anxiety category? Well, you can always avoid speaking. This is certainly not a bad tactic, especially if you can afford to use it. After all, humans have limitations, and acceptance of our limitations is not necessarily a bad thing. However, if you cannot rely on avoidance because of career, social, or personal pressures, you can take helpful steps.

Professional help—Seeking help from a professional is the first step; enlisting an expert is a good idea. Almost every community has primary care physicians, psychiatrists, psychologists, and other psychotherapists who are familiar with the treatment of severe communication anxiety.

You can expect the physician to begin with a thorough evaluation of your overall mental health. I believe that taking a complete history is absolutely essential. It's true that severe communication anxiety can be isolated—that is, a problem unto itself. However, communication anxiety is often an extension of another problem. For example, people who suffer from extreme communication anxiety may be suffering from *generalized anxiety disorder, social anxiety disorder,* or *attention deficit disorder.* I have even treated patients that suffered from clinical depression, who, once their depression was managed, enjoyed the added benefit of a significant improvement in their communication anxiety. While you may want to get the "cure" immediately, and feel that having a thorough evaluation is overkill, professionals see this as an essential step to finding the starting point for treatment.

Non-pill relief

If your severe communication anxiety seems to be isolated, and is not part of other life and personal problems, I generally recommend nonmedical treatment as the best first route to relief. For example, *cognitive* and *behavioral techniques* can work wonderfully and quickly, not only for communication anxiety, but also for life problems in general. These treatments include gathering ideas and beliefs you may have about a particular problem. Over time, these beliefs are evaluated and challenged to reduce the undesired physical and emotional responses.

Exposure techniques can sequentially reduce a patient's debilitating symptoms through repeated, step-by-step practice. With professional guidance, you trace what is running through your mind prior to, during,

and after the communication event. Working with your physician you learn to question: "Are my thoughts consistent with *reality?*" and "Is there evidence to support my thoughts?" and "Is it possible that I'm jumping to conclusions, or *catastrophizing?*" A good coach or psychotherapist can help you to slowly chip away at the problem with small steps, meant to eventually minimize anxiety.

Pet the barking dog—Repeated exposure can be used to your advantage. For some people, just getting up in front of others and speaking is a major step. Before such a patient can apply more advanced speaking techniques, the first step could be to write out the entire talk, as well as answers to potential questions. This is the "get through it this time and read less the next time" strategy. You come to recognize that failure to be perfect is simply a reality of being human. The next time you may rely less on notes, but have them in front of you as a safety precaution.

Think about your speaking experience—As part of this treatment, you should take some time before and after to evaluate your thoughts and feelings. In addition, remember that negative thoughts often produce additional negative thoughts, eventually leading to despair and anxiety. So don't forget to challenge those thoughts. At every possible opportunity, introduce a new communication anxiety technique, as they will become increasingly useful once your mind reduces anxious barriers. (See **Chapter 4—When You're Afraid to Communicate:** *Understanding Anxiety and Fear.*)

A pill may help

What can you do if cognitive and behavioral techniques do not work for you? Or what help can you get if you have only 2 days' notice prior to a public speaking event and you are freaking out? Once again, avoidance is always an option, and again, not a bad one, but this "technique" is not always available. This is the point where medications are a good option.

Keep in mind that medications are often used as a helpful adjunct to all the techniques mentioned above, and only as a short-term solution. In addition, they are most useful when some anxiety remains intact, in order to facilitate learning—this is where a good, experienced prescribing physician comes into play. Too much medication can be a barrier to learning new and useful techniques for improvement. You can make informed, positive decisions with your health

care provider about whether or not medication may be an appropriate option for you.

As with psychotherapy, medications need to be placed in the overall context of the situation. Symptoms can often be part of a larger process. Dealing with this process may indirectly improve communication anxiety. Again, it is essential to seek the help of a good, experienced physician. Never attempt to self-medicate.

Medications that ease communication anxiety

Caution—Some physicians use these medicinal options heavily. Please note that few studies have been completed on this subject; the scientific evidence as to their efficacy is lacking. Therefore, what I will be discussing should be thought of as guidelines that may help some individuals based on my experience, and discussion of cases with other physicians. As with treatment of any problem, the goal should be to maximize benefit, while minimizing the "cost." Every medical plan has potential adverse effects.

Prescription beta-blockers—Many physicians have found that the class of antihypertensive medications called *beta-blockers* can be useful, while creating only minimal problems. Beta-blockers are most commonly used in the treatment of cardiovascular problems such as high blood pressure. Today, only limited data support their usefulness in easing communication anxiety. *Propranolol* and *atenolol* are two medications in this class that can be quite helpful in reducing the common physiological symptoms of communication anxiety, such as rapid heartbeat, sweating, reddening of the skin, tremor, and voice quivering. Most prescribing physicians generally use small doses of beta-blockers, compared to those necessary for the treatment of cardiovascular disease. The net effect is often a moderate reduction in overall anxiety with minimal problems. The logic of using these medications is that if one can reduce physiological symptoms, then a lessening of mental symptoms will follow. These medications may have an additional effect directly on mental symptoms, but for now, we will go with the "indirect" effect.

Prescription propranolol—I generally prefer 10 to 20 milligrams (mg) of propranolol because of its short duration of action—about 4 hours. For lengthy periods of exposure, I will either ask the client to repeat the propranolol dosage as directed, or use atenolol, which has a longer duration of action. Propranolol is also available in a longer-acting,

"sustained-release" formula. I have found these medications to be the least intrusive in terms of learning new anxiety management and reduction techniques that, hopefully, will eventually preclude the need for medication. Some patients experience a minimal sedation, but the sedative effect is usually countered by the energizing nature of delivering the presentation. Occasionally, blood pressure can decrease, resulting in lightheadedness or dizziness. Obviously, the lower the dose, the less likely this is to happen. I always have people take a test dose prior to their public speaking event to ensure safety. Suffering severe anxiety in a public forum is bad; passing out in front of the group is worse. During the test dose, most people report no effect either way—this is a good thing. Oddly enough, this intervention—for this specific purpose—seems to only work when the pressure begins, when the performance takes place.

Prescription benzodiazepines—Many physicians go for a more "reliable" strategy in the *benzodiazepine* class. Examples are *clonazepam*, *lorazepam*, and *alprazolam*. Brand names are *Klonopin, Ativan*, and *Xanax*, respectively. While there are many other options in this class, the majority of physicians prescribe these specific drugs because their relatively short duration of action lowers the chance of adverse effects.

Benzodiazepines act in an opposite way to the beta-blockers. Benzodiazepines are meant to reduce psychological anxiety first, and possibly, the physiological symptoms indirectly. An obvious downside is that they can produce a state of being a little too relaxed, thus reducing the likelihood of learning taking place. In addition, in some people, benzodiazepine medications can alter cognition, or patterns of thinking. Therefore, the likelihood of reduced mental alertness and sedation may be slightly greater than with beta-blockers. As with propranolol and atenolol, benzodiazepine medications can be used in small doses that only "take the edge off," as opposed to completely reducing, anxiety, in hopes of minimizing adverse effects. When necessary, I usually prescribe lorazepam. Because of its relatively short duration of action, the likelihood of abuse is reduced when compared to others in the class. My consistent strategy is to prescribe limited quantities of small doses.

Prescription antidepressants—Communication anxiety may be linked to clinical depression. For many patients, the use of antidepressants—in the treatment of another problem, such as debilitating *generalized anxiety disorder, social anxiety disorder,* or *depression*—gives

the secondary benefit of reducing performance-based, or communication anxiety. While this is usually not the primary goal of treatment, patients enjoy this additional benefit. It should be noted that many of the so-called "modern" antidepressants are quite effective in reducing the symptoms of anxiety disorders.

Help is available

If you've tried to lower your metabolism before speaking, and done your best with the positive visualization exercises you learned in **Chapter 4—When You're Afraid to Communicate:** *Understanding Anxiety and Fear* and in this chapter, you may want to ask a qualified physician for help.

Chapter 5 Summary

Managing Communication Anxiety:
Action Steps You Can Take

Key Ideas

🔑 When you get speech anxiety, your pulse soars to intense levels, as it does during heavy physical exercise. After 3 to 5 minutes, your body begins to slow down, and your pulse drops dramatically to 90 to 100 beats per minute (bpm).

Physical symptoms

It's as if you're temporarily insane.

- Your brain releases catecholamine into your bloodstream.
- You hear your pulse pounding in your head.
- You feel your body demanding lots of oxygen.
- You have trouble inhaling.
- Your field of vision narrows.
- You feel nauseated from the adrenaline.
- Your stomach has butterflies caused by the adrenaline.

🔑 Your brain is the boss. Your body is your brain's audience. Whatever your brain is thinking and feeling, your body will feel too.

🔑 *Einstein's Time Shift*
- For the speaker, time moves quickly.
- For your audience, time moves slowly.
- When you go blank, it seems as if you've been standing for minutes. To your audience, it's only the blink of an eye. To them, you've just paused.

Managing Anxiety

Communicator's Checklist

Action steps you can take

❑ **Say "I'm excited."** You will make sense to your audience, in a positive way. You've explained your behavior, and you have offered a flattering explanation.

❑ **Be here now.** Do the wrist snap, or study the back of your hand, your pen, or the paper your notes are written on.

❑ **Fill your mind with positive thoughts** (vivid memories). Build a list of personal power thoughts. Think about positive outcomes.

❑ *Be Here Now Breathing* **(five steps)**

1. Find a quiet place.

2. Sit down in a comfortable position.

3. Shut your eyes.

4. Take 10 slow, deep breaths, and count them.

5. See or visualize each number as you count to 10; feel your breath.

❑ *Square Breathing*

1. Take long, slow, deep breaths on a timed count of two.

2. Take 2 seconds to breathe in.

3. Hold the breath for 2 seconds.

4. Let it out slowly for 2 seconds.

5. Hold for 2 seconds.

Caution: Watch out for hyperventilating!

❏ *Calm Down Breathing*

 1. Inhale—say, "Calm."

 2. Exhale—say, "Down."

❏ **Stretch away your tension**

- You'll feel more confident if your muscles are loose and free of tension.
- Tension makes you look nervous.
- **Voice:** Control your throat tension by **humming forcefully.**

❏ **When you go blank, do this:**

 1. Relax.

 2. Take a few seconds to think about what you want to say.

 3. Use body movement to *unstick* your memory.

 4. Glance at your slides.

If that does not work, tell the audience you forgot what you were going to say. You will then remember it.

Keys to managing anxiety

❏ Use the question opening technique.

❏ Move. Be dynamic; be excited. You have energy, so use it.

❏ Don't try to be cool, whatever you do.

❏ Tell your audience you're excited to be speaking to them.

❏ Remember, the audience is on your side.

❏ Meet the members of the audience before you speak, shake their hands, and look them in the eye.

❏ Look for friendly faces. Hold conversations with the good listeners.

❏ Concentrate on your ideas, not on yourself.

❏ Look at the audience one person at a time; hold brief conversations with each person.

6

Making People Believe You

Persuasive Communication

There are questions that people always ask themselves when they realize that they are the target of persuasion:

"Why is the speaker telling me this . . . what is his or her motivation? Can I trust her? Is he looking out for my best interest? Does she know what my best interest is? Or is she only trying to take my money, get my vote, and persuade me for her own gain?"

First, people must believe you— managing your credibility

I know that you want your listeners to trust you—that's not a new idea. You're a good person; you think of others. You consider the impact—of your actions, the things you recommend, the plans you advocate for others—on society, on the environment.

How can you communicate your goodness, your credibility? You can say to people, "Trust me," but will they? Just because you say they should? I think that you can raise defensive flags in your listeners' minds by saying, "To be honest . . ." How many times have you heard that phrase? It has no meaning because you've heard it so often; it becomes a babble of filler words. When people say to me, "To be honest," I notice that they seem tense, hesitant. My thought is, "Why

121

are you saying at this moment that you're being honest? Haven't you been honest earlier?" Sure, sometimes it's just a meaningless filler word, a sign of uncertainty. But when someone says, "To be honest . . ." I do wonder if he or she is confessing some deeper truth.

Source credibility

High credibility is something you want. When your audience believes that you have high credibility, wonderful things happen.

- People will listen more intently to what you say, and for longer periods of time.

- A high-credibility communicator is far more persuasive than someone with lower credibility. In study after study, speakers with equivalent speaking skills and delivery style gave the same message to an audience. The only difference between the two was their credibility. For example, one speaker was presented as an expert in the field, and the other was considered a well-informed amateur. The expert was far more persuasive than the well-informed amateur. (We'll explore the characteristics of a credible communicator later in this chapter.)

- You'll enjoy more control over the communication situation. People will respond to your questions, and the audience will conform and follow you during your presentation. You'll benefit from this heightened degree of audience cooperation.

You've got to answer your listeners' unasked question

Of all the variables under your control during a presentation, credibility is the one that contributes most to your persuasive power. You'll want to include messages in the presentation that are designed to enhance your credibility.

Credibility messages are things you say and things you do. **It's simple**: If your listeners believe you have high credibility, and your motivation is to their benefit—they will follow your plan.

Credibility and the team player

Of course, your foremost goal is to build credibility for yourself. But some magical things happen when you craft credibility for your teammates and for your firm. Building credibility for others builds credibility for you. As their status and estimation rises in the listeners' eyes, your credibility grows too, through association. The attribution

is "birds of a feather." In communication, we call it the *halo effect*. Around election time, you'll see those masters of persuasion, politicians, flocking together to share the wonderful, warm glow of the halo effect. For example, when the president comes to town, notice how the politicians cluster together having their photos taken with him (unless the polls fall below 40% favorable). When the president is in trouble, they run from the White House spotlight.

Ancient Greeks' secrets of credibility

Modern scientists have used advanced technology to uncover the most powerful secrets of persuasion. First Yale—during and after World War II—then Stanford, Michigan State, Florida State (Go 'Noles!), Columbia University, and other leading communication research institutions have conducted endless experiments, surveys, and Adelphi Think Groups. After hundreds of hours of mainframe computer time and hundreds of scholarly articles, we've managed to confirm what the ancient Greeks knew all along. The following is the list of ancient secrets:

1. Listeners believe that a high-credibility communicator is far more persuasive than a low-credibility speaker.

2. Credible people have three characteristics:
 - Expertise
 - Trustworthiness
 - Goodwill

This is not to sell modern communication scholars too short—we've discovered some useful facts about credibility and persuasion. I'll share those with you in a second. First, let's talk more about the three personal characteristics of a highly credible communicator—*The Three Pillars of Credibility*, and how you can enhance your credibility in the eyes of others.

Three Pillars of Credibility: Expertise, Trustworthiness, and Goodwill

Credibility Pillar One: Expertise— *You are what you know*

What have you accomplished in your life? What degrees do you hold? What honors have you received? What can you do: operate software, fix things, find things, and create ideas? What do you

know: technical facts, financial analysis, and foreign languages? Think about the specialized training you have taken, the facts you have at your command. You demonstrate your expertise as you present your ideas. People infer your expertise through the speed, accuracy, and facility with which you use jargon and terminology, and through how well you translate technical terms for them (the laypeople). Your job title demonstrates your expertise. Some job titles are more credible than others. For example, "sales representative" carries lower credibility than "marketing executive."

Other professionals' esteem

A sure-fire way to build high credibility for yourself is to have other people in your profession speak highly of you. Have you ever noticed how physicians and lawyers are reluctant to say anything against another member of their profession? Should your surgeon accidentally sew your foot to the top of your head, another surgeon, if pressed to comment on her colleague's work, would probably say, "The stitches were beautifully executed—notice how closely placed and even they are." Physicians and lawyers clearly understand how important it is to maintain each other's esteem, at least to laypeople and outsiders. They have strict formal and informal codes to maintain this important source of credibility.

Educational degrees

Advanced educational degrees give objective evidence that quickly communicates who you are through what you've achieved. Educational degrees also serve as evidence of your self-discipline and, thereby, your trustworthiness. The pedigree of your alma mater is important, because the reputation of the school awarding your diploma extends to you through the halo effect. Simply stated, *You are who you hang with*. Expertise takes time to build. If you have an important meeting coming up, you can't rush out and buy yourself a set of expertise. Expertise can be communicated, but it can't be instantly created. You can't get more expertise during a presentation.

Credibility Pillar Two: Trustworthiness

We all like people who do what they promise. It's an increasingly valuable trait. When we think about a trustworthy person, we think of rather lofty attributes: honor, truth, and even ethics. But trustworthiness can be as simple as showing up for a meeting you had

promised to attend, or completing a project by the deadline. Trust is "Can I take your word and believe that you'll give me your honest opinion?" For example, letting the boss or an important customer know when they are wrong is an art.

Trustworthiness will take time to build. You can't expect people to trust you upon first meeting. We all put new acquaintances and business associates on a rather short leash until they have demonstrated to us, through their performance, that they are trustworthy and will deliver what they promise.

Without trustworthiness, your credibility is worthless. The business world is filled with untrustworthy people who are highly expert.

Today, people are skeptical of experts. They wisely believe that experts who don't use their expertise "to help" can be dangerous. For example, people may have the following associations:

Financial	Insider trading; reverse blue-lining
Marketing	Adulterated baby food; discounts
Government	Bureaucrats; politicians
Law	Selfish, careerist prosecutors running up their conviction records; greedy personal injury lawsuits, corrupt judges; tax laws written to benefit a few fat cats

Time is the limitation on trustworthiness

Instant trustworthiness—just add water and microwave does not exist. You have to build a track record before your trustworthiness will be well known. Perhaps that is why personal recommendations are so effective in gaining new accounts, jobs, and access in the business community. When you're meeting someone new, a hardy recommendation from a person who knows you both can establish your credibility.

Credibility Pillar Three: Goodwill for your audience

Now, the good news—The most important part of your credibility—communicating an attitude of goodwill for your listener—can be managed during the presentation. You can build and manipulate your listener's perception of your goodwill during the communication. Actually, your listener will decide how well you rate on this dimension of credibility as you communicate.

Aristotle's ideal communicator

The ancient master of persuasive communication, Aristotle of Athens, was called the ideal communicator, a "man of goodwill." He called credibility "a mantle of reputation and personality worn about the speaker's shoulders."

The secret behind projecting goodwill—You have to feel it. You can't fake goodwill unless you're a talented actor. People are sophisticated at detecting insincerity. We're like dogs sniffing for fear. Think about the time when you were a little kid, and you were going to visit relatives or a family friend. They had a dog, and the adults told you how to act when you first meet a new dog. They probably told you not to make any sudden movements: Hold out your hand and do not show fear. The same principles apply to business communication. You must project your feeling of goodwill to your listeners. Sure, you can communicate your goodwill with words, but unless you've got the attitude to back it up, your listeners will not fully believe you. Words can ring hollow.

Set your attitude before you meet

Work to place the good of the other person in your heart. As you are packaging your message, consider how your vision will affect your listeners. How would they like to learn about your plan? It's not enough to present your ideas with a spirit of goodwill—you must develop those plans with the other person's best interest as your highest interest.

Aretha said it best: "R-E-S-P-E-C-T"—Have genuine respect and admiration for your audience. This is the first step in setting your mind and attitude for optimal communication. You don't have to agree with everything the person says, is, and does. But you must find something you admire about your listener before you can project goodwill.

Look in the mirror

Look in the mirror and see the other person's reflection, not your own. See things from the other person's viewpoint first. You may feel uncomfortable in focusing your attention on the other person's perspective. Perhaps you fear losing "what I want to say"; or perhaps you're concerned you'll end up changing your viewpoint or plans. Don't worry about forgetting what you want to say. You'll remember when it's your time to speak. More on this in **Chapter 7—Message**

Packaging—Strategies for Formatting Presentations: *How You Say It.* You'll find great success as a speaker, leader, and persuader when you learn how to communicate from the listener's frame of reference.

The fourth component of credibility

I know I told you that there are three major components of credibility: expertise, trustworthiness, and goodwill. That is true; those three have been with us since ancient Greece. But modern research has uncovered another component, and I think it's important: dynamism. Dynamic speakers persuade people. Not just pulpit-pounders, like born-again Christian preachers, or even fiery stage pacers, like management guru Tom Peters (an excellent thinker and speaker). You don't have to use bombast and dramatic explosions to be effective. You can communicate dynamism through enthusiasm. Remember how I said that mastery of message was the most important ingredient in persuasive, effective business communication? Well, when you free yourself to talk about ideas that you really understand, and you take time to think about how to communicate them from your audience's viewpoint, you're ready to be dynamic. All you have to do is care if they get it. That is all you have to do—care—and show that you care.

Fluid presentation—another type of dynamism

To talk freely with your listeners, letting the words flow from your mind unedited, is a powerful dynamism in presentation. It's okay to search for the right word, to let your audience see you struggle for the right expression of your idea. It shows that you care. But coolly searching for the right way to spin the phrase is not dynamic, and will undermine your credibility. Remember that great *Saturday Night Live* character "The Pathological Liar," portrayed by Jon Lovitz? You could always tell when he was about to lie, because he'd pause, lose his fluidity, and stall . . . "You know, my wife . . . ahhhhh . . . Morgan Fairchild . . . yeah, that's the ticket." If you're trying to be too cool in a presentation, without meaning to you'll come off like "The Pathological Liar."

Credibility from the audience's eyes

So far, we've looked at credibility as a set of characteristics possessed by the speaker (age, gender, education, job title), and by things the communicator does (goodwill, dynamic delivery). Next, we're

going to shift perspectives and use an information-processing model: attribution theory. We'll look at how the listener uses information about the communicator and information from the communicator's message to determine the speaker's credibility.

Attribution theory and credibility

After reading this section, you will be able to look at yourself as if through your listener's eyes. You remember that attribution theory shows us that people are rational scientist types who are trying to explain why things happen—explaining the causes behind the events and effects they see.

When your listeners are thinking about your message, they think about the logical and emotional ideas you're sharing, the vision you want to communicate. They are asking big credibility questions: "Why is that person saying those things?" "What is his motivation?" "Is the speaker's motivation due to objective facts, or his bias?" or, "Is it for my good or only to line his own pockets with my money?"

What do you think these communicators had as their motivation for delivering the following messages?

- "I did not have sex with that woman."—President Bill Clinton
- "Saddam Hussein has weapons of mass destruction."—President George W. Bush
- "This car has not been in an accident."—car salesperson
- "Attribution theory can help you be more persuasive."—Joel Whalen

Are the speakers sincere (*trustworthy*), do they really know (*expertise*), and do they care about me (*goodwill*)? Do they have information bias? For example, you may believe that Joel is an expert and that, as an educator, he is trustworthy and motivated by a sincere desire to help me learn important ideas. But what if he is limited in his knowledge? What if he is caught up in psychological theory, stuck living in the "ivory tower," or if his knowledge, while well meaning, is out of touch with reality? Joel's opinions could be the result of his limited and biased information set.

Research has shown that people tend to consume information that supports their narrow expertise or their social, religious, or

political bias. Liberals don't read *National Review,* or listen long to Rush Limbaugh without switching stations in disgust. Conservatives don't go to many National Organization for Women seminars, or tune in Air America.

Credibility flows within you and without you

Remember how the sailor and the boat were moved either by internal (rowing, effort, ability) or external (wind, current) forces? The cause of the boat's movement was either the sailor (internal) or nature (external).

Your listener will ask the same question: "What is the locus of control—internal or external?" We all know that persuaders with internal motivation for their messages have low credibility, while speakers with external motivation have high credibility.

Put your credibility to work

You will receive a higher credibility rating from your listeners if they make an external-locus-of-control attribution to your motivation for being persuasive than you'll get from a glowing set of source characteristics. Your goodwill (external motivation = good outcome for the other person) is more powerful than a big job title and advanced degrees. We prefer a skilled doctor who shows tenderness and a good heart over a world-class bastard. Look at **Table 6.1—Credibility and Attributions** and make some attributions for those persuasive attempts presented earlier in this chapter.

So, open up, let your audience know that you like them. Be sincere, speak from your heart, be enthusiastic, and show your honest emotions. Don't strain to generate emotion—it will flow—but be sure to let emotion come, and don't try to be cool. The audience will trust you more.

Table 6.1 Credibility and Attributions

Low Credibility Internal Locus	High Credibility External Locus
Ignorance	Facts
Greed/gain	Truth (observable)
Information bias	Consensus opinion (other trusted people agree)

Persuasive communicators and their message

Locate the speaker's internal or external motivation in making these statements.

	Internal	External
"I did not have sex with that woman." President Bill Clinton	☐	☐
"Saddam Hussein has weapons of mass destruction." President George W. Bush	☐	☐
"This car has not been in an accident." car salesperson	☐	☐
"Attribution theory can help you be more persuasive." Joel Whalen	☐	☐

Credibility builders: some tricks of the trade

Professional advertisers and salespeople know that, when you're selling, you can blow your credibility with the buyer by promising too much. Salespeople can get themselves in trouble by weaving too elegant a tapestry of wonderful benefits for their prospective clients. You can make a big mistake by claiming too much for your product, your ideas, or yourself—whatever you're selling.

You can't be the greatest in everything—When you tone down your pitch to be more moderate when claiming your product or service's superiority, what should you throw away? I suggest you follow the plan of disclaiming, or throwing away the least important attribute. Of all the things your product can do for your client, only one or two will be the things they really want. In sales, we call the product features that the audience really wants the buyer's "hot buttons." As a master salesperson—and now attorney—Ken Platt, taught me, "You can see their eyes dancing up and down when you describe the benefits to them."

For example, imagine you're buying a car. The model that has captured your fancy has a list of 10 features you want. Only one or two of those attributes will be important to you, say price and styling. Several more will be of moderate or low importance (e.g., mileage, *Car and Driver* magazine's high-praise review, the options package, and the dealer's reputation for fair dealing and good service). One or two elements of the attribute set will be of little or no importance to you (e.g., zero-to-60-mph acceleration and the size of the ashtray). The savvy

salesperson will have astutely guessed that you probably aren't a speed freak and that you don't smoke. She'll say, "Our acceleration is slow, so you're in no danger of whiplash when you take off from a light. But we're top-rated on gas mileage, and that's a benefit many of our customers prefer." By disclaiming or throwing away one product attribute (acceleration), she is free to place extra emphasis upon the product's other attributes. When astutely applied, this message strategy has been demonstrated in experiments (Mizerski, 1978) to heighten the speaker's credibility. Lesson learned: A little "aw, shucks" modesty can pay off. If you choose to be modest about an attribute on which the listener places lower value, you'll be more persuasive, too.

How to apply disclaiming to build your credibility

If you're selling professional services, admit that you're not an expert on the unimportant issues, but claim expertise on the issues that are important to your potential client. You too will enjoy greater credibility and persuasive power. For example, today most professionals are specialists. If you're offering financial planning services, you may say, "If it looks as though capital gains taxes are going to be an issue, we can call in Jane Franks—she's our tax law expert. My area is mutual funds—that's what I really know."

Wingman© technique

You've probably already used this wonderful technique without realizing it: Have other people build your credibility by telling the listener how wonderful you are.

Picture this: Two young men walk into a bar (picture Goose and Maverick in *Top Gun*). They swagger up to the bar, take a seat, and order beers. Next, they survey the room looking for women they would like to meet. Maverick points out a young woman sitting near the jukebox. His *Wingman*, Goose, slides off his barstool and walks over to her. He says, "Good evening. My friend over there wants to meet you, but he can't. He may be the greatest fighter pilot at El Toro Naval Air Station, but he's worried about this kid he's tutoring. He's a Big Brother, and his little brother is not doing well in school. It's got him upset. So, I just want you to know that if he tries to talk with you, give him a chance, he's really a great guy, but he's not himself tonight."

Okay, I know, that pick-up line is crap. Give me a break. I've been euphorically married for 25 years, and have no idea what I'm talking about when it comes to today's mating rituals. I'm an old guy. But you get the idea. If Maverick had walked up to her and said, "I'm the

greatest fighter pilot at El Toro, when I'm not tutoring my Little Brother . . ." he'd be shot down in flames.

If you've ever been interested in meeting someone, and one of your friends knew the person, did you ask them to, "Say something nice about me"? Then, after your friend made the Cyrano de Bergerac pitch on your behalf, the first thing you asked them was: "What did you say about me?"

It's better for your *Wingman* to build your credibility for you.

Wingman in the sales call

When successful professional salespeople make a team sales call, they always agree on two things first:

1. Who is going to take the lead? Who will direct the call, and who will take the subordinate role? If this is not clearly understood, the two salespeople will probably interrupt each other, struggle for position, butt heads, and embarrass themselves before the customer.

2. Agree to do a *Wingman credibility* pitch to the client on behalf of the teammate. "Margaret here is remarkable—she knows more about products in our industry and works harder for her customers than anyone in our organization. It's a privilege to work with her. You're getting the best."

They double-check which aspects of each other's set of credible credentials they want the partner to pitch to the customer.

You're a product

In many ways, you are a product—you take yourself on the open market to find a job. You sell yourself to suppliers, coworkers, supervisors, and customers. At home, you're still a product. You tell your spouse you love him or her and that you are worthy of love, trust, and commitment. If you're blessed with children, you probably balance yourself between salesperson and tyrant. If you interact with neighbors, shopkeepers, lawn care experts, exterminators, plumbers, and cops, you're in sales.

When you first meet people, you want them to know how wonderful you are. You want the benefits of high credibility. How can you let them know about your expertise, trustworthiness, and goodwill?

You don't want to have to recite your own credentials. You'll come off as a braggart, or you will hold back the volume of your braggadocio. Either way, you end up with lower credibility.

Wingman in job interviews

If you want to project an aura of power, leadership, and high credibility, talk about what you believe in, your vision for the future. Let other people, your résumé, letters of recommendation, and other "objective" material present your expertise and trustworthiness. When you talk about what you see for the future, your philosophy of business, and how you see the markets and effective internal operations, the image of leadership flows to you. If you talk about your credentials, no matter how well or elegantly, your self-promotion is not as effective as it could be if someone else were to do it for you.

The single most effective political commercial

When selling a candidate, I always use a standard format that is effective when the candidate speaks to a group live or in a radio or television commercial. (I've run three successful political campaigns: school board, secretary of state, and state senator.) In a commercial, the announcer comes on first and recites the candidate's credentials in glowing terms, and then says, "Meet Senator Harriet Firecracker." Then Senator Firecracker talks about her vision for the new state, and what she believes. It works beautifully. For more on using the *Wingman* technique in team presentations, see **Chapter 8—Message Delivery—Performing the Presentation**.

Warning: High credibility can backfire on the professional

If you are like many businesspeople and professionals, your credibility is important in communicating the complex, technical ideas that are part of your professional life, for example, financial and business plans and medical diagnoses. You'll be making recommendations and trying to influence decisions on major deals, such as capital installations.

These persuasion events require a special type of skill in manipulating not only your message and how you deliver it, but also your credibility, which requires special care.

Too much credibility can be just as harmful to selling your plans as is too little credibility. That may not make sense now; it didn't to me until I saw the experimental evidence myself (Whalen, 1986; Whalen & O'Keefe, 1987).

When high credibility can kill you

Your high credibility can cause you problems when the buyer can't adequately judge your product, service, or idea. She will make the decision to buy or not to buy by judging your credibility. In this type of persuasive situation, establishing credibility is paramount. For example, consider your thought processes when your physician suggests that you follow a change in diet or undergo a surgical procedure. You largely take her word for it. While she may offer a fine explanation of the diagnosis, the procedure she's recommending, and the likely prognosis, she doesn't make a complete technical presentation. She doesn't send you home with a stack of medical journal articles relating the complete story of the disease's etiology and proposed surgical procedure. You just take her word for it. It's good that you do; most physicians can be trusted; their judgment can be verified easily with a second opinion from another medico. You use the physician's credibility to make your decision: expertise (medical training), trustworthiness (other patients, references, your past relationship as a patient), and goodwill (she's a healer and has devoted her life to serving humanity).

Credibility and the business professional

Unlike the physician, your persuasive job as a businessperson is far harder: You can't allow your high credibility to get in the way—and it will. There can be a real danger in letting the person take your word for it.

Using the attributions, we see that your decider or audience is weighing two different types of information during your presentation (see **Figure 6.1—Credibility and the Technical Message**): (1) Information about you, the source (credibility); and (2) message information (ideas), that is, the data in your presentation. Now your listener can choose to make judgments based on the facts you bring forward in the presentation (i.e., message) or information on the presenter's credibility, or both. When the message is complex—for example, highly technical, mathematical, or statistical in nature and outside the decider's area of expertise—he will prefer to take your word for it. He uses source information (credibility) to make the decision for him. The

Figure 6.1 Credibility and the Technical Message

listener transfers responsibility for decision making to you, as you did when the physician recommended your surgery, in the example above.

The listener selects between two types of information in making a decision: (1) source information; and (2) information contained in the message. When the message is technically complex and too challenging for the listeners, they take the path of least resistance: They use the source credibility information to make their decision, and stop attempting to comprehend the message.

The person you're persuading will listen attentively to you, thinking about what you say until two things happen: (1) You've established your expertise and goodwill toward the listener, so he trusts you; and (2) your listener has decided that the issue is more complex than he wants to, or can, deal with. He stops listening to you, stops the rigorous mental effort it takes to process the data you are transmitting, and takes your word for it. This will happen more frequently when the listener is under work pressure or is short on time.

Your high credibility allows the buyer to shift attention from the *message* to the presenter's *ethos*.

Here is the problem

Problem: They'll remember less about what you've said. They can't remember why they were persuaded (the facts), but they will remember you. If they have to take your recommendations to another person, the boss, who is the "real decider," you're in trouble. The boss will say, "Tell me, Harpwell, what do you think we should do: Buy the property in Ireland and build a factory from the ground up, or convert our St. Louis factory?" Harpwell will say, "Boss, you've got to meet that financial analyst, he was really sharp. I believe we must go to Ireland and set up shop." The boss says, "Okay, tell me why." Harpwell searches his memory and can't remember much. Your

messenger is dropping the ball and your deal is slipping away. Sure, it's all in the technical report, but Harpwell, the trusted assistant, is making hamburger out of the presentation because he was over-whelmed by the data, and impressed by you. It's the curse of charm—you've faced it all your life.

Turn down the credibility

Often when you're presenting highly technical or complex plans, the person you are presenting to is not the final decider. You know that your plans will proceed through the organization, escorted by others, and you can't go with them. You've got to implement a strat-egy that ensures that your listener will remember what you say. Here are some suggestions for dealing with this high-credibility/low-comprehension, technical presentation dilemma.

- Build in lots of decision points or choices for the listener. This gets the listener involved and forces your listener to use higher order mental processes to think about your questions and make a choice. Because of this mental muscle movement, the listener will remember more.

- Present two sides of the issue, to create some doubt in the lis-tener's mind. Of course, you present the weaker version of the other issue. Again, this gets them thinking and remembering.

- Say: "I work for North American Gumbo Corporation, and, while I really think this is the best solution, I have not fully explored the other options. You've got to make the decision."

- Or my favorite: Say to the decider, "If you like this proposal, may I suggest we meet to plan how to present it to your boss? I can help you anticipate some of his probable questions and give you some answers that'll make you look smart. I've learned that, without a good briefing, executives can be caught short, and be embarrassed by the boss."

Chapter 6 Summary

Making People Believe You:
Persuasive Communication

Key Ideas

When your listeners believe you have high credibility, they will listen to you for longer periods of time and be more cooperative with you during your presentation. Because they believe what you say, you are likely to persuade them.

To ascertain your credibility, your listener will ask:

- "Why is the speaker telling me this?"
- "What is her motivation?"
- "Can I trust her?"
- "Is she looking out for my best interest?"

Credible people have three characteristics (credibility pillars):

1. **Expertise** is your title, degrees, and other professionals' esteem. Expertise can be communicated but can't be instantly created. You can't get more expertise during a presentation.

2. **Trustworthiness** takes time to build up. You have to establish a track record before your trustworthiness will be well known.

3. **Goodwill** can be created during the presentation. You can build goodwill and credibility by projecting genuine respect and admiration for the audience. You have to feel it. You can't fake goodwill. People are sophisticated at detecting insincerity.

☞ Listeners think about your motive. They make attributions. If your listener thinks that your opinion comes from an internal source, i.e., your ignorance, greed or possible gain, or biased information, you will have low credibility. You will have high credibility if you offer facts, truth (observable), and consensus opinion (other smart people agree).

☞ When the message is complex, for example, highly technical, mathematical, or statistical in nature, and is outside the listeners' area of expertise, they will prefer to take your word for it, rather than fully understand the technical message.

Problem: They will remember less about what you've said. They can't remember why they were persuaded (the facts), but they will remember you. If they have to take your recommendations to another person, the boss, who is the "real decider," you're in trouble because they will not be able to explain "why" the idea is good.

Building Credibility

Communicator's Checklist

Build goodwill

❏ Work to place the good of the other person in your heart. As you package your message, consider how your idea will affect the listener. Find something you admire about your listener to feel goodwill toward him.

❏ Plan to answer your listener's unasked question.

❏ Disclaim or throw away the least important attribute.

❏ Use the *Wingman* technique.

❏ Decide who is going to take the lead on a sales call.

Make sure the listener remembers what you say

❏ During your presentation, build in lots of decision points, or choices for the listener to make. Present two sides of the issue to create some doubt in the listener's mind. Say: "While I really think this is the best solution, I have not fully explored the other options. You have to make the decision." Offer to present the idea with the buyer to others in his organization.

7

Message Packaging— Strategies for Formatting Presentations

How You Say It

When you deliver a presentation, your success comes from two things:

1. What you say.

2. How you say it.

First, we'll talk about what you say with some super message packaging strategies. You'll learn how to construct powerful messages: the "what you say." Second, you'll learn "how you say it." I'll show your how to design individual and team presentation strategies.

Rock around the clock format

If you were to walk into the on-air studio at your favorite radio station, you would notice a prominent, multicolored, pie-shaped

chart pinned to the wall. This ubiquitous little device is called a "clock format." It tells the radio host exactly what to do at each part of the hour during a show. All the disk jockey has to do is follow the instructions printed on the clock format. Each slice of the pie calls for a different type of record (Oldie Goldie, Top Ten, House Music, and so on), or specifies when to play a commercial. It even tells the DJ when to read the weather or a public service announcement. The disk jockey also knows to say the station call letters first when "coming out of a record," and last "when going into a song"; formats call for countless other prescribed patterns of performance.

Now, you might think that the clock format is restrictive, but it's not. Rather than a straitjacket, the clock format allows disk jockeys great freedom. For example, if a DJ is a bit tired, not feeling well, or not especially "spark plug" creative, the disk jockey can lay back, just follow the format, and have a fairly good show. Listeners might not even notice a difference. Then, when the jock feels great, he or she can go beyond the format and soar. The station management is assured of consistent program quality, thanks to the clock format.

Clock format presentations—When you learn a *presentation clock format*, you will be able to make good presentations even when you feel rotten, or when you don't have sufficient time to prepare. Then, when you feel tops, and have time to work on your presentation, you can use the clock format to soar, climbing the heights of persuasive success.

My students and participants in my effective communication workshops tell me that the message-packaging formats are the favorite things they learn. I've taught thousands of people how to use them successfully. They will work for you, too.

The first presentation element that you must format is your opening.

Opening the presentation

It is critical to take charge and make the right impression during the opening of your presentation. The listeners are forming opinions about you, and simultaneously, you're probably going through a psychological and metabolic sleigh ride with some level of communication anxiety.

As you take center stage in a theatre, or stand at the head of a conference table, you have three primary and immediate tasks:

Task One	Capture the listeners' attention.
Task Two	Take control of the meeting and the room.

Task Three Build a good feeling of rapport with your listeners—for yourself, and if you're on a team, for your teammates.

I suggest you don't risk being too cute or clever when you open. Save that for later, when your metabolism has settled down and you're calmer. Play it nice and friendly, but straight.

Opening the presentation—Start each presentation by introducing yourself (and your teammates), or if you're well known to the group, or have just been given an adequate introduction by the meeting's chair, you can introduce yourself by the task you've undertaken, or the purpose of your talk:

> "Mel, Cindy, and I have been asked to analyze market growth rates for five SBUs and make some recommendations. We hope, as you leave this meeting, you will agree. We have one SBU that deserves our support, and we will have to prune two SBUs to fund our winner."

In less formal meetings, a great way to take control is to state the purpose of the meeting—or your portion of the meeting—formally and clearly, with some gravity to your demeanor.

Be sure to make a prediction for the audience. The first thing you tell the audience is what they are about to hear . . . what you want them to believe, or know, at the end of your talk.

The *Question Opening*

A wonderful way to instantly capture your audience's attention is to ask a question. The *Question Opening* will work well, but you must do two things:

1. You must ask your audience a question that you really want them to answer—either aloud or in their minds.

2. You must wait for the answer.

If you ask the question with the pose of the intellectual rhetorical lecturer—for example, "What could the Bard be thinking when he wrote 'Double, double, toil and trouble'?"—you'll signal to your audience to "shut up, sit there, and listen" and "let me do the talking." You'll shut down communication just when you want to open up the communication. You must be patient and wait. Give your audience

plenty of time to think (see *Einstein's Time Shift,* p. 145). As they are thinking, look at their individual faces, smile and nod, encouraging them to think. Most of the time, some of the audience will answer aloud. When they do, you know you've got them hooked.

Brainwashing—When you ask a question that causes your listeners to go into their memory and search for an answer, you've caused your listeners to focus their attention on seeking the answer to your question. Thus, you've created a group-mind: The audience's shared vision is what great presenters seek. You now have their attention, and you've directed their thinking to the task at hand (see **the power of brainwashing** below).

Bonus—The moment your listeners answer the question, you will notice that your anxiety eases. You begin to have a conversation with your audience. It's far less stressful for most people to have a conversation *with* someone than to talk *at* someone.

Checklist for successfully executing the *Question Opening*

❑ Ask a question you want answered.

❑ Pick a topic for your question that will cause the audience to consider the issues at hand.

❑ Pick a question that causes the audience to use their sensory memory to find an answer.

❑ Act as though you really want an answer. You must look at the listeners with the attitude and behavior that you're expecting a response.

❑ Use *Question Openings* that are *open-ended,* that is, they begin with "How," "What," "Where," "Why," or "When." These produce the best responses.

❑ Avoid questions that begin "How many?" as in, "How many of you are left-handed?" followed by the audience raising their hands. Asking for a show of hands does not get the audience thinking about your topic as well as *open-ended questions* do.

❑ Use the *Cascading Question*© technique by asking a series of questions beginning with a global, general question followed by more

specific questions. For example, if your topic is "Mom's home-baked cookies," ask,

> "Where did you grow up?"
>
> "Did you come from a large or small family?"
>
> "Who was the cook in your family?"
>
> "Who did the baking?"
>
> "What did they bake?"

❏ You must pause to wait for the audience's answer (see *Einstein's Time Shift* below). Look at the listeners' faces to see their reaction, and wait for their response.

❏ When the listeners answer the *Question Opening* either verbally, or many times, nonverbally, respond with an affirmation.

Einstein's Time Shift

Did you know that when you're speaking, time is moving forward at a different rate for you than it is for your listener? It's a fact. Time flies by rapidly for the speaker. You feel as if you've been speaking for only a few minutes, when in fact it's been a half hour. For your audience, time is passing slowly.

Example—When you're in class, at a meeting, or attending a daylong workshop, and the time begins to drag on, you look at your watch. If you're like me, you say to yourself, "I'm not going to look at my watch for another 15 minutes." Then, you wait for what seems like a good 20 minutes, disciplining yourself to not look at your watch. Finally, you take a peek and holy-moly, it's only been *4 minutes*. Drat. The difference in time perception, between speaker and audience, is what we call *Einstein's Time Shift* (see **Figure 7.1—Dr. Albert Einstein**).

Time shift and the *Question Opening*

When you do your *Question Opening*, you will experience *Einstein's Time Shift* big-time. "You'll say, "Think about the last time you bought a car. Did you go to a new car dealer?" You'll wait for an answer, but the audience just stares at you. You get this cold flush of panic. You're already experiencing a good dose of communication anxiety because, after all, this is the beginning of the presentation, and you're using the *Question-Opening* partly because I told you it

Figure 7.1 Dr. Albert Einstein

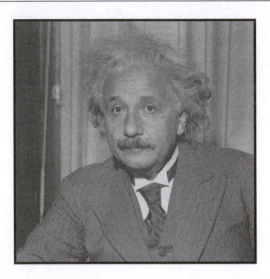

would ease your anxiety. But now, your anxiety is going through the roof. So you panic, and say in a rush, "Well, most people do go to new car dealers . . . and that's what I'm going to talk to you about: the new car buying experience . . ." (pant, pant, pant). You're ready to pass out.

Your listener's perspective—Remember, time is moving far more slowly for the audience than for you. You feel as though it has been 15 minutes since you said, ". . . go to new car dealers," and the listeners just stare at you. You panic and start to talk.

To your listeners, it has been only 2 or 3 seconds. Your audience is in slow-mo; they are just beginning to realize you are asking them a question and want an answer. They are beginning to feel the surge of emotion and energy that your question has created, and in one more second, they are going to answer your question, and get involved, but you interrupt them.

It's too bad that you did not wait another second or two. If you had, your listeners would have begun to talk. Your anxiety would have taken a nice dive downward. But you stepped on their natural reaction. All you needed was a bit more patience and a jot of courage. If you had looked back at your audience with a strong, confident smile, nodded slightly, and waited for that eternity, you would have gotten their answer.

You can also use the *Cascading Question* technique to wade through the time-dragging sludge of *Einstein's Time Shift*.

The power of brainwashing

When you ask a question and the listeners decide you really want an answer—and they agree to answer—a wonderful sequence of thoughts begins to unfold in their minds. First, your question sets their minds to zero. Whatever they were thinking before you asked your question is gone. The listeners stop thinking their own thoughts and go to short-term memory (STM) and long-term memory (LTM) to get the data needed to answer your question. These memories are loaded into working memory (the part of your mind you're aware of, where your active thoughts live). You've effectively brainwashed your listeners. Along with the rational thoughts come emotional memories, and sensory memory (scenes and feelings from your experience).

If you've designed your question correctly, and asked your listeners to consider factors that have some emotional quality to them, you can begin creating a mood or attitude in your listeners. (*"Remember when you had your first job interview? Remember how you felt?"* or *"Who is going to tell these workers they are fired?" "What do they tell their families?"* or *"What do you think our customers will say when they see this price increase?"*)

Questions can also provide the method of analysis you want your listeners to employ when they think about your ideas. (*"I suggest that past market performance may be the best predictor of this plan's success . . . and how do you think the market has performed?"*)

When you ask your audience questions, you draw them into your presentation and produce higher involvement on their part with your ideas. Questions can produce a higher activation and emotion in your listeners; and studies show that a moderate level of listener activation produces greater attitude change: You become more persuasive.

How to structure your presentation with questions

When you become skilled at using questions, you can deliver a presentation that is composed largely of questions. You'll find that you use more questions than direct statements.

Here's how to build more questions into your communication: Your first step is to think about how your audience sees things. Your point of view may be different from your listeners'. You should ask questions that come from the audience's perspective; after all, it's their memory you're attempting to tap into, not yours.

Start at the end—Think of the logical sequence of thoughts needed to analyze your plan. You might want to start at the end, with the

conclusions you want your listeners to embrace, and work backward. Think of the facts, the trail of thoughts that will lead to the right conclusion. Now, think of the questions the audience would ask, or should ask, to discover each premise. You now have an ordered set of questions, a logical sequence of thought. As the listeners answer each of your questions, they will be taking another step down the path to your idea. You—with your fine, well-trained mind—came to those conclusions, so your listeners probably will, too. Your questions will lead the audience down the path of reasoning to your conclusion.

Example: questions leading to a conclusion

Conclusion—I should drink eight 10-ounce glasses of water a day.

1. How good is your health?
2. What do you do to take care of your body?
3. What role does good nutrition play in your life?
4. What are some things you do to get good nutrition?
5. What are some of the beverages you drink for health?
6. How much water do you drink?
7. When and how often do you drink water?
8. Do you know how much water doctors recommend you drink?
9. Would you be surprised to know that doctors recommend we drink eight 10-ounce glasses of water each day?

A classic presentation format—*Tell 'em*[3]

Tell 'em$_1$ Tell 'em what you're gonna tell 'em.

Tell 'em$_2$ Tell 'em.

Tell 'em$_3$ Tell 'em what you just told 'em.

You may have heard of this format before. You will want to use this magnificent, simple, and yet powerful presentation format in all your presentations. It works every time. You may think to yourself: "But doesn't it get boring?" "Don't they know what's coming and tune out?" The answer is **no**. The opposite is true. Rambling, unplanned messages are boring, unless you're Robin Williams. Businesspeople's

attention span is getting shorter every year, because every year their responsibilities grow and their resources (staff and money) shrink. In addition, as markets and organizations grow more complex, they have more to think about and remember. You must respond to this increasingly demanding communications environment with short, tightly organized presentations.

Tell 'em₁ Tell 'em what you're gonna tell 'em

In clear, right-to-the-point words, tell them what you want them to know, believe, and/or do, because of your presentation. Do this right away, as soon as you can, at the beginning of your presentation. Open with a short, sharp, clear conclusion.

Tell 'em₂ Tell 'em

Use facts, figures, reasoning, models, evidence, and description to show them why you believe what you're presenting. *Important:* Be sure to tie in your evidence and reasoning directly to your conclusions. Don't assume that your audience is drinking in your every word. They may be only half listening to critical points. You must be specific, perhaps even redundant.

Tell 'em₃ Tell 'em what you just told 'em

Frequently, speakers find that ending the presentation is the most difficult part. Perhaps you've heard other speakers who opened their presentations with fire, spoke brilliantly and clearly, then seemed to run out of energy at the end and closed with a series of rambling bursts of nonsense: *"Well, I guess that's all, are there 'uh' . . . any . . . 'uh' . . . questions? Well, I guess not . . . so, 'ah' . . . thank you."* The last impression you leave your audience is the most powerful. In longer presentations, your final message (recency effect) lasts even longer in your listeners' memory than your initial impression (primacy effect) (see **Chapter 3—The Power and Limitations of Speaking**). Planning both your opening and closing is important. You may even want to script it in advance.

The *Cold Closing*©

A solid-gold, works-every-time closing—The first and last impressions you give an audience are the most powerful and the most remembered. A sure-fire closing follows this recipe:

1. Quickly summarize what you've told them.

2. Make a strong, positive prediction of what good things will happen in the future if the listeners follow your ideas.

Bonus—Remember, leadership flows to the person who has a vision of the future. Your listeners will ascribe that characteristic to you if you use this closing.

You must shift your attitude for the *Cold Closing* to work. Here's what happens: As you speak, you're reliving a moment in your life—a vivid, real recollection. By contrast, the *Cold Closing* is a shift to saying "Good bye." It's not about the past; it's about looking to the future.

Checklist for successfully executing the *Cold Closing*

❑ Stop thinking about the past "moments" you have been recalling.

❑ Raise your energy level.

❑ Pause for a beat, and bring yourself to the present moment.

❑ Think about the future.

❑ Get ready to give the floor back to your listeners. Your *Cold Closing* turns it back to the audience.

❑ Tell your audience something you want them to experience in the future.

❑ You will feel as if you're saying "Good bye" to a friend you won't see for a while.

No *Thank You* allowed

Please don't say "Thank you," signaling to the audience that you're finished, and it's time for them to applaud. That is for amateurs. Think of it this way: If your presentation is good, if you've just delivered a well-conceived, carefully planned, beautifully delivered set of ideas, then you have worked hard. Your audience *should* thank you. **And they will, if you let them.**

Technique **To execute the *Cold Closing*:** You will need to wait for your applause, since it takes a couple of seconds for the audience to react (*Einstein's Time Shift*).

End your presentation like a Grammy-winning rock star—Too many amateur business presenters do a slow, clumsy, *board fade* ending.

A *board fade* is a way to conclude a record, while the band continues playing, as the recording engineer slowly *fades* or turns down the volume to end the song. This is an acceptable technique, but a better finishing touch is the *Cold Closing*, where the band finishes their song with a strong, concluding set of chords, or a powerful, clean drum riff. A *Cold Closing* is a strong statement that sticks in the listener's mind; a board fade is just that—boring.

Over the years, I've watched thousands of business and student presentations. Too often, I've seen a good team kill their final impression with a rambling, weak finish. You can leave a strong, positive impression with a *Cold Closing*.

Warning: Don't ask for questions

How many presentations have you seen that end with "Any questions?" The presenter may even have a last slide projected on the screen that says *"Questions???"* And how many times have you seen the audience stare back at the presenter in total, numbing silence? Then, the presenter looks a bit disappointed, loses energy, says "Thank you" again, and slinks off stage. What a rotten, discouraging way to end what was probably a good presentation.

Think about what you've done: You've not just asked for questions, you've asked, "How many of you give a flying fig about what we've been talking about? How many of you are convinced? Who among you are interested in putting more time and resources into our plan?" By their silence, they are signaling the group's lack of interest, and perhaps lack of support. If the audience is undecided, you can kill your own plan by asking for questions.

Can you see how *Einstein's Time Shift* could create a problem for you as you try to end your presentation? You ask your audience if they have any questions. Because you're suffering from *Einstein's Time Shift*, before they can answer you, you cut the audience off. The trap you fall into is that you don't wait long enough for answers.

If your audience has questions, they will ask them. In fact, they will probably ask you questions throughout your presentation. If they have questions after your presentation is concluded, they will ask them. Your listeners are not going to need your solicitation or permission to speak with you. It's far better—to build consensus and support for you and your ideas—if the audience wants to ask questions, rather than you prompting them.

A perfect strategy:
The *Nichols' Two-Things*© Presentation

Critical decision: "How much data to present?"—This is the most important, and the easiest, decision you have to make. In fact, I'll give you the answer right here: Your goal is to communicate **two ideas** to your audience.

Here's why—You know that in oral presentation the volume of facts your listeners will retain is quite limited—but the mass of nonverbal and attitudinal information is massive. If you try to get your listeners to remember three things, they'll forget everything you told them. But if you tell your listeners: *"Here are two things you'll want to take with you: A & B"* or *"The two major things operating here are: A & B,"* the chance they'll remember them is 90%. Brief oral presentations are best, so say just enough to support and illustrate your two visions.

You can help your listeners remember more than the two major ideas by tying in other facts directly to your major points.

Table 7.1 Reducing Massive Constructs to Two *Big Messages*©

Two Big Messages		
Massive Construct	*Big Message One*	*Big Message Two*
Love & Marriage	Heart-shaped bed	Pounding silver into jewelry
Raising Children	Sparkling eyes	Spines of steel
Voicemail	Drop off your to-do list	Door is slammed shut
Marketing Strategy	Find the right spot on customer's itchy back	Gently scratch that itch
Financial Strategy	Bet the pot – Win the pot	Bet one chip – Lose one chip

Each *Massive Construct* can be reduced to two *Big Messages* that summarize and create a theme. Listeners remember this theme, the *Big Message*.

Any set of data, no matter how complex, can be reduced to one or two major themes. For example, consider the classic and much used themes of "good and evil." A theologian can summarize Moslem and Jewish and Christian philosophy in terms of "good and evil." Historians can do the same with "Good versus Evil" when writing about World War II (Allies = Good; Axis = Bad). Investment strategies can be framed as "good or evil" (see **Table 7.1—Reducing Massive Constructs to Two *Big Messages***).

Give your listeners a *preview*, then *guideposts* along the way

Dr. Don Nichols, an international expert in message packaging and communication, and inspiration for the *Nichols' Two-Things*, suggests you start your verbal presentation with a preview of what the audience is about to hear. At the beginning, you give your listeners *guideposts* of what they can expect to hear during your talk. We call these guideposts *Big Messages*: sensory-rich phrases that communicate the essence of your message's meaning. *Big Messages* help the audience hang on your every word and remember what you say. You'll be amazed how much more persuasive you'll be when you give your listeners *Big Messages*.

Write your presentation in 5 minutes

You can write any presentation in 5-minutes, guaranteed, using **The *Nichols' Two-Things* Presentation**. During the late 1960s and early 1970s, Dr. Don Nichols earned a national reputation as a winning debate coach. His Texas Junior College teams consistently won national championships against Ivy League debate powerhouses. The secret was (1) exhaustive preparation of facts—his teams were more knowledgeable and better prepared; and (2) his secret weapon—the *Nichols' Two-Things* Presentation. While other teams were executing their strategy of overwhelming the judges with a mountain of facts, the Nichols-coached Texas teams were concentrating their facts into two *Big Messages*. Here is his elegant system for organizing a massive set of facts and ideas—the *Nichols' Two-Things* Presentation. This elegant message development and delivery system uses three principles:

Principle One	*Repetition* of *Big Messages*
Principle Two	*Making links* between the evidence and facts you offer and the *Big Messages*
Principle Three	*Visualization* Your *Big Messages* and evidence should use sensory modalities, particularly your listener's visual senses
Remember Sense Memory	Effective communication is creating pictures in your listener's mind.

Dr. Nichols showed his debaters how to take a piece of paper and make the classic outline structure you see in **Figure 7.2—*Nichols' Two-Things* Presentation** on page 154.

Figure 7.2 *Nichols' Two-Things* Presentation

Nichols' Two-Things N2T

Topic _____

1 _____ 2 _____
 ① _____ ① _____
 Ⓐ _____ Ⓐ _____
 Ⓑ _____ Ⓑ _____

 ② _____ ② _____
 Ⓐ _____ Ⓐ _____
 Ⓑ _____ Ⓑ _____

The first step is to write down the two, sensory-rich *Big Messages* that seem to summarize the issue. These two *Big Messages* go next to the Big Numbers ❶ and ❷.

For example, let's prepare a presentation on something stupid like peanut butter (see **Figure 7.3—Peanuttiest Peanut Butter Presentation N2T**). My sensory-rich, two *Big Messages* are ❶ *Peanut butter puts a smile on your face* and ❷ *Peanut butter puts fat on your heart.*

Next, I think of two things that will support each of my *Big Messages.* The idea that peanut butter *tastes great* and is a *kid's food* supports *Big Message* One, that *it puts a smile on your face.* To make the case that *peanut butter puts fat on your heart,* I want to tell my audience that we *eat too much* and it's *high in fat.* These sets of two supporting ideas go under each of the Big Numbers ❶ and ❷ as subpoints ① and ② (see below).

❶ Peanut butter puts a smile ❷ Peanut butter puts fat
 on your face on your heart
 ① Tastes great ① Eat too much
 ② Kid's food ② High in fat

Finally, each of the subpoints (*tastes great/kid's food* and *eat too much/ high in fat*) get subpoints of their own labeled Ⓐ and Ⓑ (see below).

The final *Nichols' Two-Things* for peanut butter looks like this:

❶ Peanut butter puts a smile on your face
 ① Tastes great
 Ⓐ Nutty flavor
 Ⓑ Crunchy and smooth
 ② Kid's food
 Ⓐ PB & J sandwiches at school
 Ⓑ Recapture childhood feelings

❷ Peanut butter puts fat on your heart
 ① Eat too much
 Ⓐ Dense food
 Ⓑ Loaded with calories
 ② High in fat
 Ⓐ As much as butter
 Ⓑ Heart disease

Figure 7.3 Peanuttiest Peanut Butter Presentation N2T

Nichols' Two-Things N2T

Topic **Peanut Butter**

1 Puts a smile on your face

 1 Tastes great

 Ⓐ Nutty favor

 Ⓑ Crunchy and smooth

 2 Kid's food

 Ⓐ PB & J sandwiches at school

 Ⓑ Recapture childhood feelings

2 Loads fat on your heart

 1 Eat too much

 Ⓐ Dense food

 Ⓑ Loaded with calories

 2 High in fat

 Ⓐ As much as butter

 Ⓑ Heart disease

The *Nichols' Two-Things* lets you keep adding layer upon layer, subpoint after subpoint of information and ideas until you believe you've covered the subject well.

Sample Presentation

"Let's think about a great, fun food: peanut butter. Perhaps you haven't given this all-American food much thought

lately . . . but, if you think about it, two major ideas are sure to pop into your head: peanut butter is fun to eat, but it can be dangerous. It *puts a smile on your face,* but *it loads fat on your heart.* Before we consider peanut butter's potential danger, let's talk about how much fun peanut butter is to eat.

Peanut butter *puts a smile on your face* for two reasons. It tastes great, and it's a kid's food. Why does it taste great? Most people tell us it's peanut butter's great nutty taste, and "it tastes like fresh roasted peanuts," as the TV commercials tell us. Also, it's the flavor of peanuts at the ballpark. Peanut butter tastes great because of its texture, or what food scientists call "mouth feel." Peanut butter comes with a choice of *mouth feels:* crunchy or smooth. What is your favorite? That's why peanut butter is fun: It tastes great.

Peanut butter is a great, fun food for lots of reasons. It rekindles memories of your childhood because peanut butter is kids' official food. The PB and J . . . or peanut butter and jelly sandwich is by far kids' favorite lunchtime food (a close second is "tooney-fish"). PB and J was one of your favorites as a kid, too. Am I right? That is why, today, peanut butter is a fun food; it lets you recapture your feelings of childhood. It *puts a smile on your face.*

With all the stress, pressure, shrinking resources at work, and the crime and chaos in the streets, it's only natural that we would, for a few brief moments, retreat to the memories and feelings of childhood. Look at the growth of cookie sales as Boomers and Generation Xers alike rekindle the milk-and-cookies-after-school experience. Peanut butter is another great way to have some fun as you did when you were a kid.

But it's not all "good" news for peanut butter. Peanut butter can be dangerous. *It loads fat on your heart.* While we agree that peanut butter is fun, we must consider its darker side (etc. etc. etc.)."

Big Messages emerge—As you work your way through this outline, you may discover that other *Big Messages* emerge. For example, perhaps you'll find one of your supporting ② is a better *Big Message* than the one you have under Big Number ①. If you have mastered your subject matter, you'll find this structure is a wellspring of inspiration and organization that will help you quickly and easily organize your ideas into an impressive oral presentation.

The final format—presenting as a team member

For decades, advertising people, engineers, architects, and sales-people have made formal presentations to clients and senior management in teams. Teams of workers and managers make plans, diagnose problems, and make recommendations. Teams might be composed of people from customer service, quality control, accounting, purchasing, engineering, and marketing. Together they present their ideas and plans to their coworkers, and sometimes to senior management.

I imagine you've had the opportunity to make a presentation as a member of a team. If you haven't yet, I predict you will soon.

Benefits of team presentations

A team presentation is different from a solo act in one important way: In a well-designed team presentation, each individual plays a specialized role. Three benefits spring from this strategy:

1. The audience has a strong, clear perception of each individual player, and thus communication is enhanced.

2. Synergy from the heightened "sense of team" is transmitted to the audience.

3. Like any specialist, the team member can concentrate on his or her individual role and responsibilities, and deliver a better message with superior skill.

Specialty roles

Host©—In advertising and sales presentations, the *Host* role is usually assigned to the senior executive, who is often the best presenter. The job of *Host* is to project the positive, warm attitude of a winner to the audience. Because he or she is concentrating on the audience and on the team's *Big Message*, the Host actually presents a quite small volume of data. The *Host* demonstrates confidence in the team by letting the "junior members" take responsibility for the presentation. Here is the Host's list of duties, in the order performed:

First	*Host* states goal or purpose of presentation: *"As the result of what you hear today, we believe you'll agree that teal is the right color for your team's logo and uniforms."*
Second	The *Host* introduces the team using the **Wingman** technique (see **Chapter 6—Making People Believe You:**

Persuasive Communication). *"One of the smartest people in advertising, Diane Tinsley, came up with the break-through insight that led to the solution we're recommending today . . ."*

Third *Host* shares the sensory-rich two *Big Messages*: *"You need to project an image of* the great outdoors *and* tropical *imagery."*

The *Hand-Off*©

Finally, the *Host*, with pride and joy, hands off to the first presenter: *"Now, Bill Burrell will take you through the color palette used by other players in your industry. Here's Bill."*

The *Hand-off* makes the pace of the presentation faster. With a quick introduction, the next presenter is immediately free to begin his or her presentation. Without the *Hand-Off*, the speaker must introduce herself: *"Hi, I'm Sarah Rego, and I am in charge of financial analysis. I've looked at your financial reports for the first three years, and . . ."* This slows the presentation. Most business presentations are brief—or should be brief. The precious time saved may be small, only 20 to 30 seconds, but the psychological impact on the audience's perception of time is significant. The presentation seems faster.

When making short presentations (less than 45 minutes), I recommend that the *Host* not present data or evidence; that must be left to the team members. If you decide the *Host* must present evidence, perhaps, due to the superior expertise of the *Host* or the fact that the team only has two members, let the *Host hand off* to the first presenter, then return later as a presenter. If the *Host* performs the *Host's* duties and then launches into presenting the data, the pace of the presentation really slows. However, in longer presentations (one hour to a full day), you may want a slower pace. Here, the *Host* may give the introductory message and then proceed to presenting evidence.

Wingman in team presentations

The *Host* introduces the presenters (who carry forward the bulk of the persuasive messages to the audience) in glowing terms, building their credibility, as does the *Wingman*.

When it's your turn to be the *Host*, you build credibility by introducing your teammates with glowing affection and respect; you'll cite their credentials (expertise, trustworthiness, and caring). The idea is to let your team sell the ideas; you sell the team. Incidentally, through the halo effect, your teammates' heightened credibility will reflect back on you, and thanks to the *association effect,* your credibility rises along with theirs because you're on the same team. So, you'll get the benefit of high credibility without having to say a single word on your own behalf.

Presenter(s)—The presenter's job is to execute the team's communication mission effectively. You have asked for important people's scarce time because you have important ideas that they must hear. The team's communication strategy is to persuasively sell two *Big Messages* (see **Nichols' Two-Things Presentation** p. 155).

Each presenter begins by clearly and cleverly stating the major idea he or she is going to support. The Host has already introduced the Two *Big Messages*; now it's the presenter's job to deliver the supporting evidence and visual information.

The presenter illustrates the *Big Messages* with sensory-rich examples, evidence, data, and visual storytelling.

Important—The presenter must tie in the examples, evidence, data, and stories to the *Big Messages*. The listeners will not make the link unless you literally show them how the data and *Big Messages* fit together. The manner in which you make the link can be subtle and brief, and it can be oblique, but it must be done.

Finally, the presenter will *hand off* to the next presenter, or if the presentation is ending, to the *Host*.

Host **closes**—The *Host* closes the presentation using the *Tell 'em*[3] technique (please see *Tell 'em what you just told 'em* in the section **A Classic Presentation Format—*Tell 'em*[3]**). Also, go back to **The *Cold Closing*, A solid-gold, works-every-time closing**, for suggestions on ending the presentation.

Lucy©, **key team member**—The team member with the most critical role during the presentation is the *Lucy*, aka the projectionist. *Lucy* operates the projector and changes the team's slides.

Why *"Lucy"*?

The *Lucy* role was named back when presentations were made using overhead projectors and transparencies. *Lucy* would place the slides on the projector's glass, and then "pull the slides off"—much like in the comic strip *Peanuts,* in which *Lucy* would hold the football for Charlie Brown and then pull the football away. The late, great Charles Schultz gave me permission to use the name of his character Lucy Van Pelt. I was, and am, thrilled by his generosity.

You know that computer-generated slides, LED computer projection devices, and television projectors dominate professional presentations. Some folks prefer to use tearsheets on easels, photographic slide projectors, or black or white boards. The Chicago office of the great advertising agency Foote Cone Belding's "New Business Team" uses prepared cards, hand-lettered by agency artists, to provide visual evidence. However, this practice is not common.

Lucy is the conductor—Like the symphony's conductor, *Lucy* must know the entire presentation better than anyone else on the team— since *Lucy* controls the presentation's pace and timing by moving faster or slower through the slides. Of course, the presenter may indicate with a nod or a quick word to *Lucy* when they are ready for the next slide.

Equipment function—Equipment function is *Lucy's* responsibility too. The *Lucy* must check the projector and make sure that a replacement is available.

Visual sweet spot—The critical information on the slide must be projected in the upper two thirds of the screen, or above the centerline. People sitting in the back of the room may have their view blocked by other audience members, or by the projector itself.

Be invisible—A final word on the considerable *Lucy*. For all of *Lucy's* considerable responsibilities, the role works best when unnoticed. *Lucy* should sit behind the projector, not blocking the audience's view. The audience should only be aware of the presenters and the visual evidence projected on the screen.

Communication Toolbox

Message Packaging—Strategies for Formatting Presentations: How You Say It

Key Ideas

- *What you say* and *how you say it* makes your communication effective.

- *Presentation clock formats* allow you to make good presentations even when you feel lousy or don't have sufficient time to prepare. Formats also let you really soar when you feel good and have time to prepare.

A classic presentation format—*Tell 'em³*

Tell 'em₁ Tell 'em what you're gonna tell 'em.

Tell 'em₂ Tell 'em.

Tell 'em₃ Tell 'em what you just told 'em.

The *Nichols' Two-Things* presentation

Your goal is to communicate **two ideas** to your audience. People will forget more than two ideas.

Principle One	Use *repetition* of *Big Messages*.
Principle Two	*Make links* between the evidence and facts you offer and the *Big Messages*.

Principle Three	*Visualization* Your *Big Messages* and evidence should use sensory modalities, appealing particularly to your listeners' visual senses.
Remember Sense Memory	Effective communication is creating pictures in your listeners' minds.

How you open the presentation is critical. Ensure that you capture the listeners' attention, take control of the meeting and the room, and build a good feeling of rapport with your listeners.

Question Opening—Your listeners focus their attention on finding the answer to your question. Because you begin to have a conversation with your audience, your anxiety will ease.

The *Cold Closing*—Your closing is important. People remember the last thing you tell them. To do a *Cold Closing*, quickly summarize what you've told them. Make a strong, positive prediction of what good things will happen in the future if the listeners follow your ideas.

Team Presentations

Benefits of team presentations—The audience gets a clear perception of each individual player. You get synergy from the heightened "sense of team." Individual team members can concentrate on their individual messages and deliver them with superior skill.

Specialty roles

The *Host* is usually the senior team member. The *Host* projects the positive, warm attitude of a winner. However, the *Host* usually presents little data, unless the team has only two members. When you have smaller teams, say, three people, the *Host* also presents. Otherwise, with larger teams, the *Host* demonstrates confidence in the team by letting the "junior members" take the presentation.

Lucy is the conductor. Equipment function is *Lucy's* responsibility.

Chapter 7 Summary

Message Packaging—Strategies for
Formatting Presentations: How You Say It

Communicator's Checklist

Opening the presentation

☐ Introduce yourself.

☐ Say the purpose of your talk.

☐ Deliver the two *Big Messages*.

The *Question Opening—*four steps

1. Ask your audience a question.

2. You must want them to answer.

3. They answer either aloud or in their minds.

4. You must wait for the answer.

Checklist for successfully executing the *Question Opening*

☐ Ask a question you want answered.

☐ Pick a question that causes the audience to consider the issues at hand.

☐ Pick a question that causes the audience to use their sensory memory to find an answer.

❑ Act like you really want an answer.

❑ Use *Question Openings* that are *open-ended*, i.e., begin with "How," "What," "Where," "Why," or "When" to produce the best response.

❑ Avoid questions that begin "How many?" as in, "How many of you are left-handed?" followed by the audience raising their hands.

❑ Do the *Cascading Question* technique. Ask a series of questions beginning with a global, general question followed by more specific questions.

❑ Pause and wait for the audience's answer.

❑ Respond affirmatively when the listeners answer the *Question Opening*.

Cold Closing checklist

❑ Stop thinking about the past, pause for a beat, and bring yourself to the present moment.

❑ Think about the future.

❑ Get ready to give the floor back to your listeners. Your *Cold Closing* turns it back to the audience.

❑ Tell your audience something you want them to experience in the future.

❑ Feel an emotional shift, as if you're saying "Good-bye" to a friend you won't see for a while.

❑ Don't say "Thank you," signaling to the audience you're finished, and it's time for them to applaud.

❑ **Warning: Don't ask for questions.** If your audience has questions, they will ask them. In fact, they will probably ask you questions throughout your presentation.

Specialist checklist

The *Host*

❑ States goal/purpose of presentation.

❑ Asks the *Question Opening*.

❑ Introduces the team using the *Wingman* technique.

❑ Shares the *Big Messages*.

The *Hand-Off*

❑ Introduces the next presenter by telegraphing what he or she will say. The *Host* and presenter hold their places (do not move), until the *Hand-Off* is finished. When they cross, the presenter walks in front; the *Host* walks behind the presenter to his or her seat. The *Hand-Off* makes the pace of the presentation faster.

❑ *Presenter(s)* begin by stating the *Big Message* they are going to support.

❑ *Important:* The presenter must tie in the evidence, data, examples, and stories with the *Big Messages*.

❑ *Host* **closes** the presentation using the *Cold Closing* technique.

❑ **Visual** *sweet spot.* The critical information on the slide must be projected in the upper two thirds of the screen, or above the centerline.

❑ *Be invisible. Lucy* is best when unnoticed, not blocking the audience's

8

Message Delivery

Performing the Presentation

It's time to talk about how to act during a presentation. This is the part of the book you've looked forward to reading. Everybody I train in my Effective Communication Workshops is concerned with their appearance when they stand before an audience and present their ideas (I am too); they want to look confident. Worrying about how you appear to an audience can be a major cause of communication anxiety (see **Chapter 4—When You're Afraid to Communicate: *Understanding Anxiety and Fear***). Now you're ready to learn what behaviors and attitudes will guarantee that you'll give a superior presentation.

Have fun—Here is my first piece of advice: Don't worry about making a fool of yourself (even though I know you probably do—it's only natural to feel that way). Of the thousands of businesspeople I've coached, 99.9% are concerned about acting like a dimwit or "saying something stupid." I am not concerned that you'll come off like a fool. I *am* worried that you'll be too stuffy, creating a distance between you and your listeners, and bore people. Your challenge, as you prepare your presentation mental state, is to loosen up, have fun. Think about the great business presenters you've seen, the business gurus such as Tom Peters, the president of your company, or the leaders you admire in your industry. Do they have a sense of humanity, of fun and enjoyment, when they are speaking? Most great speakers do. Deep inside

you is a sense of playfulness and fun that all great speakers share. Our task here is to help get that kid that's inside you out.

You're in showbiz—entertain 'em

Your goal is to persuade the audience. To persuade, you must first entertain your listeners. Please see **Table 8.1—The** *Convincing Communication* **Chain of Effects**.

Why entertain—Let's walk backward through the *Convincing Communication* **Chain of Effects** so you can see why you must *entertain* your listeners. Before you can *convince* people, they must understand how your ideas will satisfy their needs (e.g., personal advancement, altruism, company growth, financial security, and sense of appreciation by others). Your listeners experience understanding via a burst of *Felt Sense* (see **Chapter 1—Effective Communication:** *It's Not About You*). This mind/body understanding happens when listeners realize that the benefits you offer are relevant to them: *Benefit Salience*.

Memory—Before your listeners can realize *Benefit Salience*, they must process your ideas in their minds. Both the emotion and evidence must be considered—your ideas must be in their *working memory* and interacting with their prior experience, which is housed in short-term (STM) and long-term memory (LTM).

Table 8.1 The *Convincing Communication* Chain of Effects

First you must entertain your audience, before they walk through the sequence of thoughts and experience that result in *persuasion*.

Before your ideas enter the listeners' *memory*, they must pay *attention* to you, and to gain *attention*, you must *entertain*. You are competing for your listeners' attention with a variety of influential and commanding sources.

Power of selective attention

Even if your presentation is fantastic, your audience is automatically thinking about something else every 30 seconds. They don't tune you out because they're undisciplined, or because you're not fascinating, or because your ideas are unimportant; it's simply human nature—the circumstances are beyond your control. For example, often the audience is tired. They may have other items on their personal and business agendas intruding into their thoughts while you are presenting.

If you don't work hard to be lively, interesting, and entertaining, your listeners will find the back of the person's head seated in front of them far more fascinating than you. You must compete with the hundreds of intrusive thoughts poised on the edge of your listeners' consciousness. The invasion is ready to launch an attack every 30 seconds. These distracting thoughts will march in and take over your listeners' minds unless you act to keep their attention.

Fight back—work to refresh their attention frequently

When I began working in radio, my mentors told me to talk about any one subject for a maximum of **10 seconds**—go longer than that, and the audience would push the buttons on their radios and switch to another station. Every 10 seconds I had to vary my tone, tempo, and vocal style, or deliver another piece of information or entertainment to keep their attention.

You must do the same thing. While your business audience will have a longer attention span than my radio listeners, don't depend too much on your audience's discipline and hunger for your ideas. A better strategy is to frequently submit evidence, offer new examples, and change the focus.

Move 'em around—Every 30 seconds or so, give a pictorial example. Every 3 to 5 minutes, give a bit of interesting information or entertainment. Tell a story, vary your tone of voice, vary your tempo, and change the rate of your delivery. Walk to the other side of the room; walk to the back of the room. Look into another listener's eyes.

You must entertain and be lively, if you are to persuade. Remember, one characteristic of a credible communicator is *dynamism*. Make your presentation dynamic, and you will win your audience over to your ideas.

Asking *questions* is a wonderful technique to keep your audience tuned in to your presentation.

Before you are introduced, see if your audience has a pulse

Be aware of the **mood the group is in** when you begin making your presentation. Are they tired from listening to other presentations? Perhaps they are restless from sitting too long in one position and need a minute to stretch. Is the audience fatigued? Or are they fresh and energetic?

Tip ✓ If your audience has been sitting for more than one hour, ask them to stand and stretch. Other speakers may have worn your audience down.

Prepare for the disaster that will never come

As you prepare your presentation, you must ask yourself, *"What is the worst thing that might happen?"* A word of caution: By now you're aware of how fearful thinking can lead to excessive speech anxiety. However, the assiduous application of "worst-case scenario" thinking to your preparations will pay big dividends. You can prepare by considering what you might do if disaster strikes. To balance this effect, you should also think about what is the *best* thing that might happen.

Let your body speak for you

How to stand before an audience—When you first stand before your audience, your initial posture and stance should be athletic—a more upright version of the stance used by tennis players waiting for the serve, football linebackers, and wrestlers: feet shoulder width apart, hands above the waist, and weight slightly forward on the balls of your feet. You want to stand upright and lean slightly toward your audience. This makes you look alert and dynamic. Because you've placed your feet in a good athletic position, you can easily move to your right, to your left, away, or toward your audience.

What to do with your hands—Keep your hands above your waist, then forget them. All professionals you see speaking, in big business meetings or on television, hold their hands above their waists. We call this *Kangaroo Paws©*. You stand there looking like a kangaroo. At first, you may feel goofy. All speakers worry about what to do with their hands. If you start with your hands unclasped and hold them above your waist, you'll be fine. You'll forget about them as you become engaged in your topic. That's when you'll start gesturing naturally. You don't want to try consciously to control your gestures. If you do, they will seem artificial.

Some people gesture a lot, some a little. Whatever is the right amount of gesturing for you will occur naturally.

Don't try to be cool—I've seen too many speakers trying to project an artificial attitude of casual confidence. Instead of filling their beings with real feelings of positive confidence, they try to fake self-assurance with body posture. These ill-fated speakers set themselves up to lose by draping their bodies across the table or leaning on the podium. At first, they do look casual—until they feel the urge to move. Now they're in trouble: They can't move, they're stuck in place, trapped by their tense muscles and the high metabolic rate that naturally occurs at the beginning of a presentation (see **Chapter 5—Managing Communication Anxiety:** *Action Steps You Can Take*). In fact, by trying to be cool these speakers feel self-conscious and have a hard time being graceful because they're frozen by muscle tension. Consequently, as they try to move from this inherently awkward position, these poor speakers find themselves stuck in an increasingly uncomfortable posture. They can't move. A look of concern crosses their faces, and the audience begins to focus on the humorous position, instead of on their words.

You must avoid this trap. Do this: Use the athletic stance during the awkward opening minutes—it's safe and looks great. After you're truly more relaxed, you can slip into any posture you want.

Projecting your attitude to your audience

Establishing rapport with the audience—Your first few minutes talking with a new group is important. They scan you intently and decide how credible you are (see **Chapter 6—Making People Believe You:** *Persuasive Communication*). They assess many factors of expertise, trustworthiness, and goodwill. Very simply, they are deciding if they like you and trust you. Now is the time to establish rapport and

earn their respect. First rule: Don't try too hard to be impressive. I've noticed that some junior executives try to overcome their relative lack of rank, experience, and recognition by acting too formal and stiff, dropping their charm, sincerity, and humanity. Here are some tips on establishing rapport.

Be interested in them as people—It's easy to think of your audience as a faceless blob. Perhaps you plan to concentrate on one or two key players who are the group's leaders and deciders. Remember that, in part, these key listeners will form their opinions of you based on how the audience reacts to you. An audience is an organism composed of individuals, and each one takes on a life of its own. If you are talking with an audience of 30 people, you're talking with 30 individuals, one at a time. Each audience member is different and will react uniquely to you. As you progress through your presentation, they will begin to form a common attitude and share the same feeling. First, you must establish rapport with and interest in each person, as an individual.

Be good-natured—Although you'll be talking about some serious subject matter, try not to be so serious. Act as though you enjoy what you're doing. Concentrate on a positive feeling. For example, if you're effective in establishing a conversational tone with your audience, they will talk back to you. When someone in your audience asks a question or makes a remark, listen and react honestly.

Expect humor—Anticipate that someone will try to joke as they answer your questions or talk with you. The audience will realize that the person is making an attempt at humor—even if they don't laugh. If you don't react with some sense of amusement, if not joy, they will think you are out of sync, not tuned in, and not really speaking with them.

Use humor—I am not suggesting that you tell jokes. Unless you have talent, don't make jokes. And if you are talented enough to base your presentation on your gift for humor, I suggest you seriously review your current career ambitions. You'll find that professional comedy pays lots more and is lots more fun. So, if you're like most of us, don't tell jokes. Use humor, wit, and observation, as they flow from your interaction with the audience. It's best to attempt humor as you discuss your topic. It's even better if someone in your audience makes the humorous remarks, and you do the laughing. This will work wonders for your credibility. Typically, the truly funny audience member is someone the group loves and respects. By recognizing this person's humor, you make yourself an honorary member of the group.

Warning: Pay attention to how the group reacts to the audience member making the humorous remarks. (If you notice that the group resents this person, or sees him or her as an outsider, don't affiliate with the person.)

Use common experiences to establish common ground—Work to find something that you share in common with your audience. Perhaps you hold the same beliefs as your audience, or have the same hopes and aspirations. Maybe you have similar ambitions, or have experienced the same things.

A sure-fire way of establishing rapport is by expressing sincere admiration for your audience. You know that members of a corporation hold certain people in high esteem. They may venerate the company's founder, or be deeply loyal to the current CEO. Perhaps they take pride in having made technical advances, or crafted new instruments, or launched new products. If you truly appreciate and admire individuals, philosophies, or products, be sure to mention this.

Show the depth of your appreciation—Be prepared to encounter skepticism as you express your appreciation. Some listeners may resist your approbation because it means so much to them, and they hear so little of it. Others may be slow to receive because of their temperament. For example, auditors, engineers, and actuaries might have a preference for quantitative data and be slow to internalize your feelings-rich approval. The best approach is to prove your sincere appreciation to the audience with overwhelming evidence. You will need to give two or three examples that show the depth and scope of your appreciation.

Be straightforward—I always recommend beginning your presentation by *futzing* around a bit. *Futzing* will establish your territory and will help you gain poise. For example, taking a drink of water, or looking and speaking informally with the audience or to certain front-row members will give you a sense of command, and also give you time to settle down (see **Chapter 4—When You're Afraid to Communicate:** *Understanding Anxiety and Fear*).

Be direct—Say exactly what you mean. Time will fly during your presentation, so you don't have *time* to be elliptical. If you're too vague, or if you "tease" them by delaying the delivery of your message, the audience will pay less attention to you and will fabricate their own message. You'll heighten the communication challenge. Time is short, and your listeners' imaginations are rampant: Tell them clearly and simply what you want them to know. Make your message short and vivid.

Have fun—By now, you fully understand why it's so important to have fun when you're presenting. If you're having fun, you will project goodwill. Your sense of fun will communicate confidence. Also, fun and enthusiasm are easy for an amateur actor to project, and fun entertains your audience. If you're having fun, you will open up communication into a two-way flow and encourage your audience to participate. And fun makes dry or difficult material more approachable.

Your audience is on your side—It's easy to think of your listeners as the enemy. You visualize the negative outcomes; you're filled with fearful thoughts. Your audience is the source of your consternation and fear. It's only normal that you'd attribute your discomfort to them.

Look at it this way. You and the audience are on the same team and have the same objectives. You and they are trapped in the presentation room for uncounted minutes during the presentation. You're holding them prisoner. The doors are psychologically locked. They want you to do well, to make the time together pleasant, even fun.

Your listeners have a selfish interest in seeing you do well. They are trapped with you, for the next 3 minutes to 1 hour. Listeners are hungry to be entertained, informed, and enlightened. They want you to be interesting and lively. Have you ever attended a meeting and hoped it would be dull? When you started a new college class, did you say to yourself, "Gosh, I hope this professor is boring" or "I hope this class is like standing in a long, slow line at Wal-Mart"? *No*, of course you didn't. You were praying that the speaker would bring something interesting and important. You remember the good speakers you've heard, people with passion and purpose. When a speaker gives you a sense of joy and enthusiasm, it is hypnotic and intoxicating. You never forget the feeling, and hope to get it each time you hear a new person speak. Because it's rare, great speaking has more value to you. Skinnerian psychologists call this *intermittent reinforcement.* It produces the strongest inducement of repeated behavior. If the rat can't predict when the food pellet will be dropped into its cage, the rat will push the bar far more often than when the food is dropped every time, or every third time. Predictable does not produce performance.

You have the audience from the beginning. Your listeners are with you from the start—during those first 2 to 3 minutes, when you're insane with enhanced metabolism, they are forgiving (see **Chapter 4—When You're Afraid to Communicate:** *Understanding Anxiety and Fear*). You have them on your side, hanging on your every word, until you get dull and lose them. Keep it interesting, have fun, be young, drink Pepsi.

Take charge of the room

When speaking before a group, at a special meeting, or in a job interview, you must assert yourself by getting a few, small things necessary to perform to your maximum ability. Make yourself comfortable. For example, make yourself physically at ease. Leave the room before your talk. Go to the bathroom. I'm serious. The natural excitement and tension will make your bladder feel fuller than it really is. You must eliminate all possible sources of extraneous tension from your body. Your clothing must be comfortable and allow you to move well. Your shoes must support your movement. Make sure that your shoes' soles are not so slick you might slip when you move. This happened to me, and it's nasty—I accidentally performed some James Brown–like "choreography," and it hurt. I don't know how the Godfather of Soul does it.

Relax your whole body by stretching. While you're out of the room, you can do some stretching exercises. If you're working in a conference facility or theatre, frequently an empty room is adjacent to the meeting room or backstage. An unwritten rule says that the speaker is in charge of the room. The audience will comply with your reasonable wishes. If you want them to stretch and take a break, they will. If you want them to move to the front of the room, they will. If you want the lights on, they go on. It's your show. If you expect it to happen, it will. If you truly communicate what you want, your request will be honored.

Technique—When I was younger, I sold water conditioners door-to-door. While doing this difficult work, I learned how to take charge when I was in somebody else's domain, such as someone's house or office. When I arrived at the prospect's home, the family would be watching television—I was calling on Americans, after all. I knew that the TV would interfere with my sales pitch and that I must get it turned off. Think of how hard that is: getting people to stop watching their television show, in their own home.

The technique—If I asked them, "Do you mind if I turn the TV off?" and then waited for an answer, the husband would look at the wife, and they'd say, "Let's leave it on." But if I moved toward the set as if to turn it off, and simultaneously asked, "Do you mind if I turn off the set?" they would always say, "Sure, no problem."

Key—Be in motion, doing what you want, when you ask permission. People will rarely stop you, nor will they resent you for doing it; it

will seem natural and okay to your audience. So, when you say to the meeting chair, "Do you mind if I step out for a minute?" while you're getting up from your chair and heading for the door, the answer will be "Of course not, go right ahead." You must take time to prepare yourself; you owe it to yourself and to your audience.

Business presentations are not storytelling

When people are put in new social settings, they tend to revert to their core personality traits. For example, a person who has learned to use humor will tend to make jokes. A critical person will tend to criticize. This normal human trait becomes even more evident when you are under pressure—such as when you have to make a business presentation. Most people have few opportunities to speak before groups, and they have little time and even less training, so they tend to rely on their core sets of behavior and experience.

Presentations learned at the dinner table—So people "revert to type," they make their presentations using techniques and strategies they have used or have seen others use in the past. This can be a big mistake. Without even realizing it, you might mimic presenters you have seen—not because they were good presenters, but because they reside in your unthinking mind and are available to you. The few times that most people have spoken to groups in the past, it was to tell a story. For example, most people have their first speaking experiences before a group at the family dinner table. Mom says, "So, Billy, what did you do at school today?" Billy then begins a reluctant, rambling narrative of his day. He may relate the events chronologically or hit highlights, if he can think of any.

Adolescent raconteur—Later in life, during your early teens, you logged lots of speaking experience before groups, for example, when you were at a party or out with friends. You would take turns sharing stories of your experience:

> "You think your family is crazy? Wait'll I tell you what my brother did. We've got this plastic pool in our backyard, you know, and it has always got this green stuff growing in it, you know. So, Jessie goes, 'I'll get it clean.' So, he uses Drano . . ."

The techniques that make for a good "social presentation" are not optimally effective in the business setting. You force your listeners to

sift through your needless, low-information buildup until you give them the punch line. A business-style packaging of the same story would be: "My brother's so lame he used Drano to clean my wading pool." Then, you'd provide the details.

Business presentations versus social presentations

The primary goal in a business presentation is efficient persuasion. Time is limited. In a social presentation, time is not limited, and the goal is to provide your companions with entertainment and to develop a relationship. The key difference between the two is that the social presenter holds her audience in suspense until she reveals the punch line: "So, the Drano eats a hole in the bottom of the pool . . . duh!" or "So, the dog says, 'I've never had $20 before.'" You hold your audience's attention, working to build up to the big punch line or story ending. Along the way to your story's ending, you may offer some interesting sidelights: "So, Jessie's wearing his usual weekend outfit, cutoff jeans and a wasted Jimmy Buffet T-shirt"—but your primary goal is to build up to the big ending. Usually, the ending is the big news, the weirdest, funniest, most surprising part of the story.

Business gives the punch line first—Dynamite business presentations are the opposite: You give away the punch line right up front; the first thing you say is the punch line. That is, you state the purpose of your presentation and what you want the audience to believe. Then, you give them facts and illustrations that support the conclusions you want them to adopt.

Your social storytelling usually unfolds in chronological order.

"So, I got up that morning and decided to go to the mall. So, I called Kathleen, and said, 'Do you wanna go to the mall?' and she sez, 'Okay.' So, I picked her up, but first I put twenty dollars worth of gas in my car. You know that car of mine is making a funny noise, kind of a chugga-chugga at stoplights. Whatta you think that is? Anyway, so I pick Kath up and we get to the mall . . ." ad nauseam.

Business presentations cut to the chase early—A business presentation is more streamlined. It begins:

"Our team believes this firm can increase market share by 1.5% and increase ROI by three points by adding sales coverage in

the Western markets. And now, to show you why we believe this, here is Bob, who will show our regional sales figures for 2008, and the 2009 projections."

Bim-bam-boom, right to the point. Set up the listeners with your conclusions right up front, and then show them why you came to those conclusions. This method is the fastest (you've only got a few minutes); it grabs and holds the audience's attention; and it is persuasion dynamite.

Tell 'em what you learned, not how you learned it—All too often, businesspeople revert to their social experience for their presentation formats and strategies. They relate how they arrived at their conclusions chronologically, like this: "Thank you for giving us some time to speak with you about our research project and plans for 2008. Our team first looked at the present sales figures in all the regions and compared them with each other. And frankly, it wasn't easy to get the figures from the East Coast; I think their software blew up or something. Right when they were trying to e-mail it to us, all they could send was garbage. It caused quite a stir in our offices, let me tell you. Anyway, we knew that if we looked at sales expenses as a function of sales revenue for comparison . . ." Of course, the underlying message the speaker is trying to convey is *"I am smart and worked hard on this."*

This type of presentation is like slow death. The presenter is challenging the audience to pay attention. The listeners must be maximally disciplined to sit through this all too common type of presentation. While the key information will eventually be presented, the audience is forced to extract the data they need; the presenter is hiding it from them by burying it in his rambling, unnecessary narrative.

Presenting PowerPoint slides

The slides are your partners—Don't force your listeners to divide their attention between what you say and what they read. Show your listeners which part of the slide you're talking about. Work in cooperation with your partner, the slide. (To learn more about building slides, see **Chapter 10—Communicating With Tables, Graphs, and Charts:** *Your Visual Toolbox* and **Chapter 11—Maximum PowerPoint.**)

Turn, Touch, & Tell

Turn to the bullet-pointed text.

Touch the text on the screen with the hand closest to the screen (upstage hand; see **Figure 8.3—Greek Theatre,** p. 187.)

Tell the listeners what those words mean to you. Describe the pictures you're seeing in your mind's theatre.

Technique: Point to the screen using your upstage hand (the one closer to the screen). If you use your downstage hand (closer to the audience), you'll turn your back to the audience and flash them *Butt Meat.*[©]

Butt Meat—Keep your back away from the audience. When you present, your goal should be to show the audience as little Butt Meat as possible. That way, you'll be facing your audience, and they can see your facial expressions.

Ideas expand to fill time

Speaking is like cooking a pot of rice: A small amount of rice cooked in a pot of boiling water swells to fill the pot. When you make the rookie cook mistake of putting too much rice in the pot, the rice grains swell with water as they cook, fill the pot, and soon push the lid off the pot, spilling rice all over your cooktop. The same is true in speaking. A few ideas will swell to fill the time allotted.

Technique: To cut hunks of time out of your presentation, do this:

Don't read a slide—Tell your audience to read the slide, and ask them if they want to talk about it. They will read it faster than you can.

Don't elaborate on every bullet point—Just read and elaborate on one bullet point per slide.

Cut material—Because you are using the *Nichols' Two-Things*, it's easy to cut down a presentation to save time, for example, when you're giving a presentation on how *Summer is the best season.*

Figure 8.1 *Summer Is the Best Season:* Cutting Time

Nichols' Two-Things N2T

Topic	Summer is the best season

1 Warm, bright sun **2** Bar-b-que

 (1) Feels good on your skin (1) Good food

 (A) Warm, healthy feeling (A) Flavorful food

 (B) Relaxing (B) Fun food

 (2) Gives you energy (2) Friends and parties

 (A) Streets full of people (A) Informal fun

 (B) Lots to do outdoors (B) Family and close friends

Long version

Nichols' Two-Things N2T

Topic	Summer is the best season

1 Warm, bright sun **2** Bar-b-que

 (1) Feels good on your skin (1) Good food

 (A) _____ (A) Flavorful food

 (B) _____ (B) Fun food

 (2) Gives you energy (2) Friends and parties

 (A) _____ (A) _____

 (B) Lots to do outdoors (B) _____

Shortened version

Tailoring from long to short

(Don't ask me why you are talking about summer—pretend you're selling lakefront vacation homes.) (See **Figure 8.1—*Summer Is the Best Season:* Cutting Time**.)

You can easily eliminate the subpoints using the *Nichols' Two-Things*. **Remember**, your goal is to have your audience remember two things you tell them. All those subpoints are just evidence, examples, and support for your two *Big Messages*. See how the *Summer is the best season* presentation can be cut down for time.

The time-shortened *Summer is the best season* has your *Big Messages* "*Warm, bright sun*" and "*Barbecue*," and only seven subpoints. The full presentation has 12 subpoints. The meaning of the message is intact. The audience will fully get the *Big Messages* in about half the time. The next time you're asked to give an hourlong presentation, and the meeting chair comes to you and says, "The marketing VP has gone over, can you cut your presentation to 10 minutes?" You'll say, "No worries," and give a dynamite presentation.

"Can you make it shorter?" Cutting down for time.

A couple of years ago, I was invited to give a luncheon keynote address before an audience of 700 architects in Canada. The group asked me to speak for an hour and 30 minutes about "Effective Communication and Design-Build Project Management." The audience would eat lunch while I talked. About 35 minutes before I was to go on, the executive director took me aside and said, "The association's president just told me he's changed his mind. He doesn't think you should have to talk while they are eating. Can you cut it to 30 minutes?" I agreed; it would be much better if they were not eating while I was talking. It was "No worries with *Nichols' Two-Things*."

I easily jumped into my PowerPoint slides, and cut subpoints. The presentation was a hit. The audience gave me a huge ovation, and lots of people came to the stage to congratulate me. Apparently, audiences don't care if your speech turns out to be shorter than planned. But you already knew that.

Put your hand in the light—Some people have a fear of moving their bodies into the projector's light. Yes, you can put your hand in the projector's light. You will stick your hand in the light when you do *Turn, Touch, & Tell*. And you can walk in front of the screen. You'll

want to cross in front of the screen to keep your presentation lively and interesting, and when you want to get closer to audience members on the other side of the screen.

Go to black—When you decide to elaborate, and talk about things not on the slide, put the slide in black mode. This will keep the slide from upstaging you. If you leave the slide showing, the audience will be distracted by the slide and not concentrating on you. When you are ready to work with the slides again, you can take the projector out of black mode.

Presenting Graphs

The moment a graph appears on the screen, be ready to talk about it. A graph is the ultimate *upstager*, particularly for quantitatively minded audience members. You and your *Lucy* will want to closely coordinate calling for graphs. *Lucy* should ensure that a graph is not put up until you're ready to talk about it. If a graph appears and you're talking about something else, your audience is listening to you with only half an ear. Most of their consciousness is focused on the graph.

When presenting a graph, the first thing you do is give the audience a tour of the graph, so they know how to read it.

The *Big-G*©: Touring the graph

The fastest way to explain a bar or line graph to your audience is to lead their eyes through a G-shaped scan (see **Figure 8.2—The *Big-G***).

The *Big-G*

First—Read the title of your slide.

Second—Tell them what the y-axis scale means.

Third—Tell them what the x-axis scale means.

Fourth—Give an example: Go to a specific data point, relate it to the y-axis scale, and tell them what it means.

Technique: Stand on the left-hand side of the chart. You'll find it's the best spot because you can reach the y-axis easily.

Figure 8.2 The *Big-G*

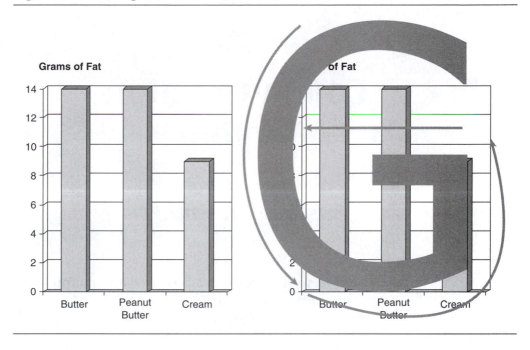

Communication Toolbox

Ten Tips and Rules for Persuasive Presentations

Tip One **Keep your communication mission simple.** Too large a payload, and your craft will crash. Sell no more than two ideas in your presentation.

Tip Two **Get on and get off fast.** Promise that you will talk for only 10 minutes, then get off after 7 minutes. The audience will love you for it. Should you go on for 12, you're spending your hard-earned relationship capital, which could go to persuasion rather than tolerance.

Remember: Great presentations seem short to the audience—either because the presenter's brilliance makes the time fly, or because the team (presenter) gets on and off fast. I recommend that you do both: Deliver a sparkling, beautifully packaged message, and do it briefly.

Tip Three **Use the power of silence ... enjoy pauses.** When you ask your audience a question, pause, and let them think about it. The pause is the difference between an empty "rhetorical question" and powerful communication.

Picture your audience's mind like sand on the beach and your ideas like water in a bucket. You present your ideas by pouring the water onto the sand. If you pour too rapidly, the sand cannot absorb the water, and it runs off the surface. If you pour at precisely the right rate, the sand can drink in the water. Pauses allow your audience to drink in your ideas.

Tip Four **Enjoy silence.** Don't fill the silences with empty mouth noises. Silence is far better. For example, as you select your next thought, don't say "uh," "uhmmmm," "er," or "ya know." Just remain silent; it's far more powerful.

Tip Five **If your teammate goes blank, fill in, and provide the key word.** As you discovered in the chapters on speech anxiety (see **Chapter 4—When You're Afraid to Communicate:** *Understanding Anxiety and Fear* and **Chapter 5—Managing Communication Anxiety:** *Action Steps You Can Take*), we often go blank mentally and fail to find the right word or make the leap to our next thought. In a presentation, the illusion that time is compressed (*Einstein's Time Shift*) may cause your teammate to panic. Don't let your teammate twist slowly in the wind while you sit there with an invisible pane of glass between you. Speak up calmly and naturally. Complete the thought, and your teammate will pick up right where he or she left off.

In fact, two or more teammates can share the stage, making verbal and nonverbal hand-offs to each other. It's a technique that I love to use when working with more talented and experienced presenters, after we have learned to work together.

Tip Six **Don't read your talk.** If you have a kind and generous spirit, and you want your audience to catch up on sleep, or to practice their doodling, or perhaps enjoy some daydreams—be sure to read to them.

However, if you're more selfish and want your audience to listen, if you insist that they hear your ideas and consider your point of view, speak from an outline. Reading is sleep-inducing, unless you're talented, trained, and have rehearsed your script. Few of us have that ability. **Don't read** a scripted address. Have your opening and closing well prepared, even memorized, but ad-lib, speak extemporaneously from an outline of key phrases and words.

Now, having said bad things about reading, sometimes you have to read a script to your listeners: (1) If you're part of a televised program, and the format is expected; (2) if your statement is likely to be legally inflammatory or risky; or (3) if you are part of a large, scripted, multimedia-driven meeting—on these occasions, you should agree to read your address. Then, you have the onerous job of making

it seem natural. Hire a coach; when you reach the point in your career where you must read a presentation, you can afford one—and can't afford *not* to get professional help.

You'll sound as if you're reciting the Pledge of Allegiance in grade school. Memorizing your presentation is not a good strategy, either. When you deliver a text you've memorized, it tends to force a singsong delivery tone to your voice. That tone of voice signals the audience that you're not directly speaking with them. As a result, they tune you out.

Tip Seven **Don't bore the listener with the saga of how you came to your conclusions.** Your listeners want your ideas, your conclusions. They are not as interested in learning how hard you worked or in the steps you took to collect your data. It is a natural mistake to spend our listeners' precious attention asking them to hear how hard we worked: *"We first examined all available secondary data with ADI CD-ROM—we did not find much, but a single article really gave us insight. Next, we called all our primary suppliers and asked them to send us a record of costs related to . . ."* (Getting sleepy?)

Key **Listeners are interested in benefits, in what they will gain from your information, from your insight.**

Tip Eight **Don't upstage your teammate.** This fascinating bit of theatre minutia has utility beyond giving you another tidbit for conversation at a cocktail party. Master actors know that the upstage position (behind your teammates) is powerful. While the downstage actor is nearer the audience, an actor who is standing upstage can easily distract the audience's attention by making small movements. The lesson is: Even when you're not actively presenting, if the audience can see you, you're still "on." So if you choose to stay in audience view—instead of stepping offstage and taking a seat while your teammates present—you must maintain your concentration, and listen to what they're saying. This can be tough, since you're probably not listening; either you're rehearsing your talk if you're waiting to go on, or if you've presented, you're thinking about how it went. So take a seat.

Figure 8.3 Greek Theatre

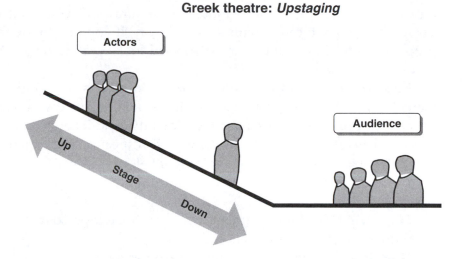

Greek theatre: *Upstaging*

In ancient Greek Theatre the audience sat on a flat plane while the actors stood on a raked stage. Today's theatre uses the opposite design in which the audience sits on an angled plane while the actors perform on a flat stage.

A bit of theatre history—According to theatre lore, the actors' terms "upstage" and "downstage" are said to come from the ancient Greek theatre. Unlike today's theater, where the audience sits on a raked plane and the stage is flat, the Greek theatre placed the actors on an inclined plane, and the audience sat on the level ground (see **Figure 8.3—Greek Theatre**). The players typically stood in a semicircular line called the "chorus." When a member of the chorus had a line to speak, the actor would move toward the audience, or literally *downstage*. The members of the chorus were *upstage* from that actor. Today, that terminology is used in the theatre. An actor who is closer to the audience is downstage from the actor (or set piece/furniture), who is farther away from the audience.

You can use the upstage power to make nonverbal contact with audience members as they look at you. First, give them a bit of your positive vibrations' charm, then look back in earnest to the presenters . . . you'll find that they follow your eyes and begin to tune in to the speaker.

> **Tip Nine** **Handling props**—From time to time, you'll want to use props to illustrate your ideas. Props are great attention getters, and audiences love them. The moment you bring out a prop, you'll notice the energy level pick up (see **Table 8.2—Working With Props**).

Warning: Your props can upstage you. They can dominate the stage; so if you don't want the audience to focus on the prop, keep it out of sight. Keep the prop behind the podium until you need it. Then, after you're through with it, put it away. If you don't hide the prop, your audience will become distracted looking at it, even after you've moved on to other topics.

Head to Heart©—In our culture, we hold objects of significant value high on our chests, between our heads and hearts. If you want to show respect and convey a product's quality, hold it between your head and heart. If you want to convey disrespect or poor quality, move the object away from you, holding it below your waist.

Hold the Baby—Hold objects you value highly as you would hold a baby.

Finger Tip It©—Hold a product with your finger tips, so that your hand does not block the audience's view.

Hide It—When you are through talking about the prop, hide it from audience view. You know it will upstage you.

Table 8.2 Working With Props

Terms and techniques to *know* and *use*:

- *Head to Heart*
- *Hold the Baby*
- *Finger Tip It*
- *Hide It*

Tip Ten **Handling the company's or client's product.** When you hold the product, show your respect, and handle it with care. Pretend that you are holding valuable crown jewels. You must communicate the product's value, even if it's a hunk of machined steel. When clients hand you their product (or brochure, etc.), take it as if you were accepting their newborn child. It's probably no less precious in their eyes.

Handling the Audience's Questions

Start by actively listening to the question and the questioner. The audience will judge you and your credibility by how you handle audience interaction, particularly how you listen to, and answer, their questions.

- Repeat the question and ask, "Have I stated your question correctly?" If not, learn what the question is.
- Respect the questioner.
- Defuse the obnoxious or hostile question by rewording it.
- Use the group to control the angry or hostile questioner.
- If you don't know, admit it . . . and promise to find out. Ask the audience; perhaps someone will know the answer.

Of course, most of the time you want to be attentive and respectful to your listeners. The audience members identify with the questioner and will feel slighted if you patronize or insult the person. On the other hand, if the questioner is a hostile idiot or a group-outlier the audience hates anyway, you can damage yourself by affiliating with the questioner, or giving him or her too much recognition or sympathy. Similarly, you can advance your cause by standing up to stupidity, bullies, and errors. You must have an iron fist inside a velvet glove. When handling questions, put out your antennae to the audience, and sense their reaction. If you sense that a question is stupid, hostile, or difficult, I recommend you first scan your audience for their reaction. Often, if you've set up the right type of rapport with your audience, certain audience members will pick up the cue from your eye scan, and answer the question themselves, or tell the person: "Shut up—that's not relevant here."

Tip ✓ Sometimes questioners are quite earnest and asking a question that will help clarify your talk, but they have trouble expressing themselves. You'll want to gently step in and provide phrases and terms to help form the question.

Tip ✓ Help the questioner: Do not treat questions as annoyances or interruptions. If you've mastered your topic, you can handle any question. You want a conversation with your listeners, not a speech directed at them. Remember, your credibility comes from showing that you understand.

Keys to good listening—While the audience member is asking the question, give him or her lots of nonverbal feedback: nod, change expression (with listener's statements), lean forward, shift your posture with the flow of conversation, tilt your head to show interest.

Key: listening actively

When you're stuck, buy some time—If you're stuck for an immediate answer, use silence—wait, and the questioner will start talking again,

giving you more time to think. To give yourself time, repeat the question and ask the listener: "Do I understand your question?" Usually, by this time, the right answer has composed itself in your head.

How to handle obnoxious or hostile questions—First, relax, and do not show fear. It's easy to become afraid; fear transmits. Remember, the hostile person is in a state of fear, and you might catch it. Keep in mind that you have superior power. You may be caught off guard by the attacking tone; it's rare that an audience member will be rude, so it can be surprising. Buy time, and then, restate the question. This gives you more time, and you can strategically restate the question in less confrontational terms. Ask the listener: "Is that your question?" He or she will probably agree with your watered-down version of the attack, and now you can go on to answer it.

Give a moderate but meaningful answer. Most of the audience will agree with a more moderate point and will probably be embarrassed by the hostile questioner.

Consider using the group to control the hostile person—If the questioner seeks to dominate, by making a speech instead of asking a question, or after you've answered one question continues to ask other, hostile questions, trying to box you in, say: "We have other questions," or "The other people have come to hear more than your interesting question." You may wish to offer to meet the questioner after the presentation for further discussion. Remember, the hostile questioner often wants your audience's attention, and when confronted with the prospect of talking only with you and not enjoying your spotlight, they'll decline the offer.

If you don't know, admit it—Tell the person you'll find out, and get back in touch; or ask the audience—perhaps someone else knows.

Meeting the audience, moving about the room—It's important that you speak within the communication space of each person in the audience (it is not easy and often is impossible). Think of a 10-foot radius around you. People within that distance receive a more detailed and powerful message than do those farther than 10 feet away.

The difference is not the words you say; it's the information from your facial expressions. Your eyes and mouth deliver volumes of information. Think of your eyes and mouth as a *Communication Triangle.* The small muscles about your eyes and mouth convey volumes of expression. We read the triangle-shaped area between the

eyes and mouth for nonverbal data. Prove it to yourself. Take note in informal conversation—notice what facial features people look at on other people's faces.

Be sure to move about the room. Work to get inside the communication space of each audience member. Remember the technique I recommended to reduce speech anxiety: Get to the room early, and welcome each person as the audience comes in. This momentary contact makes you seem like a "real person" to the audience members, and also reduces your anxiety.

Problem: Deciders may sit in the back of the room—Often, a key person in the audience—for example, your boss—will sit in the back of the room surrounded by a phalanx of subordinates, which hampers communication between you and your boss. Even a little bit of contact will help. One technique is to give each person a handout. This will give you the excuse (or motivation, as actors say) to move to the back and communicate with the boss within a communication space.

Voice Control

Great speakers share a common characteristic—they are masters at using their voices to express meaning. Let's talk about how you can learn to control and use your voice to communicate meaning, your feelings, and your attitude to your listeners.

Don't trust your ears—you don't sound like that. We all have a common handicap when it comes to training our voices: Our ears give us lousy feedback. This is a major problem in improving your voice, because you've got to have an accurate sense of how you sound if you're going to enhance your vocal skill. Remember the first time you listened to yourself on a tape recorder? Did you like the sound of your voice? Most people don't. We react with: "Is that me? I don't sound like that, do I?"

The reason we're all so stunned when we hear how flat and nasal our voices sound is because, as we are talking, we hear a different sound from our voices than do other people. Here is why: You know that sound is a vibration, and our ears are organs designed to sense vibrations and translate them into acoustic information for consumption by our brains. The vibrations our listener hears come largely through the air. The vibrations travel a path from your mouth, through the air, and into your listeners' ears. The sound vibrations you get travel largely through your bones. That's right, you vibrate

the bones in your head, throat, and chest. Your ears are mounted on the sides of your head, and the hearing organs sit nestled in a cavity of skull bone. What you're hearing is the acoustic equivalent of singing in the shower. You know how great you sound in the shower? It's because your voice is vibrating the shower's tiles, amplifying your voice, and giving it a wonderful resonance—a full, rich sound. Our listeners get only our unresonated sound. So, obviously, the trick is to make sure that we deliver important business communication in the shower. Unfortunately, by the time you're so far up in the organization that you can order people to listen to you in the shower, you will not need this book. So, as an alternative, I'll show you how to increase your resonance by using more of your body when you speak.

Bend your ears

You'll learn to listen to yourself accurately through a technique called *ear bending*. Like the old-time radio announcers, you cup your hand around your ear to scoop in more vibrating air, so your air vibration/bone vibration ratio changes. Of course, you can't do this during a presentation, but you can when you practice. Practice is important, including practice using a tape recorder. I recommend that you tape your business conversations, including telephone calls, to see how well you're using your voice. How can you listen to yourself and work to change your vocal control, when the feedback you get is highly distorted?

Radio announcer's tips and exercises to improve your vocal expression

Years ago, when I earned my living by making the right noises into a microphone, I learned how important relaxation is to effective announcing. Speech and vocal resonance come largely from skillfully articulating and manipulating the muscles in your mouth and throat. The vibration you need for speech comes from twin muscles located in your throat. As kids, we called them vocal cords in the voice box. The scientific terms are glottal folds in the larynx. By flexing and squeezing the diaphragm—a large, powerful, flat muscle that stretches across your abdomen, starting below the center of your rib cage—you force a column of air up from your lungs, through your throat. As this swift rush of air passes over the glottal folds, they begin to vibrate. When you stretch and flex your glottal folds, the air passing over them vibrates rapidly, making sounds that go up high. Then, when

you relax your glottal folds, the air passing over them causes them to vibrate slowly, making lower, deeper sounds. Next, the vibrating air passes over the articulators in your mouth: your lips, tongue, and teeth. You use the articulators to shape the vibrating air into words. The articulated vibrations move from your mouth and through the air, until they contact your listener's ear. If the vibrations move rapidly, they hit your listener's ear hard and sound loud. If you move the vibrations slowly, by whispering, the impact is soft upon the ear and sounds quiet. When you whisper, you're hardly moving your glottal folds at all; most of the sound is air rushing past your articulators.

Reducing the vocal tension

Failing to relax affects your breathing, too. As you know from **Chapter 4—When You're Afraid to Communicate:** *Understanding Anxiety and Fear*, it's hard to take a deep breath when your upper body's "fighting muscles" are tense. When that region is held in spasm, you can't stretch out the intercostal muscles between your ribs. Your ribs have to expand for you to take a deep breath. So you end up taking short, gasping breaths that increase the tension in your throat. Another problem with this "clavicle breathing" is that you can't move enough air past those tight glottal folds to make them vibrate properly, the way they vibrate during normal speech. When you're talking with business associates, you can tell when things are difficult for them, by the tightness in their voice. This is because generalized, upper body tension causes the delicate glottal folds to become tight, and makes it impossible for them to convey the rich, lush vibrations that communicate that the speaker is relaxed. So what do you want? You want to relax your speaking muscles: glottal folds, abdomen, and intercostal muscles. You should work to get rid of upper body tension (see relaxation exercises in **Chapter 5—Managing Communication Anxiety:** *Action Steps You Can Take*).

Humming and other vocal exercises

While those relaxation exercises in Chapter 5 will help you take control of the larger muscles, they will only indirectly reduce tension in your glottal folds. The next exercise will allow you to directly stretch and relax your vocal cords, without having to stick your hand down your throat. Relax your vocal cords directly by humming. When you hum slowly, especially tunes that have lots of low parts,

such as gospel music, you give your glottal folds a mini-massage with those pleasant vibrations. By humming a little tune, you can stretch out the tension. And it's a lot easier than reaching down your throat and trying to massage them directly.

Humming phrases you can use

First, hum. I recommend any song with lots of slow, low parts (think Barry White). This will relax your vocal cords. Another good exercise is to singsong the following phrases. Be sure to take as long as possible to say them. As a musician would say, keep the "sustain on"—really drag it out.

Here's how you do it. You sing the first word high, then sing the second word low:

- king—kong
- ding—dong
- ping—pong

Avoid needless embarrassment: Find a place where you can do these exercises by yourself.

More vocal exercises

Stretching your speaking instrument—Privately, before you go on to speak, or before the meeting starts, take a few seconds, and stretch your muscles as prescribed in **Chapter 5—Managing Communication Anxiety:** *Action Steps You Can Take.* Then, add these new, voice-specific exercises to your routine.

Professional baseball players always stretch their game muscles as part of their pregame warm-up—even the Chicago Cubs. Your speaker's game muscles are your face, your abdomen, and the intercostal muscles. Open your mouth as wide as you can, and while stretching your eyes wide, raise your eyebrows up high. You'll be doing the "silent scream"—you're screaming without making any noise.

Make room for more air: Stretch your bellows

Take a long, slow, huge, deep breath, and hold it. You're inflating your chest and stomach like a giant weather balloon. While you're holding your engorged breath, you'll find within a few seconds that you can take in more air, because the abdomen and intercostal

muscles between your ribs have stretched. Now suck in a few extra million air molecules. Slowly let the air out. Repeat this exercise a couple of times. Be careful, because you're really loading lots of extra oxygen into your system. You can hyperventilate, and get dizzy and disoriented; this is the last thing you want to do to your brain before you have to face your audience. So take your time and don't rush these exercises. Stop just before you get slightly dizzy. You'll develop a far smoother, lower, more relaxed voice, because you're not holding as much tension in your body. As a bonus, because you have a body full of oxygen, you'll get a wonderful feeling of well-being.

Now that you've got your instrument warmed up, let's practice some "vocal scales."

Speaking exercises

If you've ever studied a musical instrument, you'll remember practicing "scales." You probably spent hours playing these nonmusical exercises to improve your technique. The next section gives you some vocal scales that will greatly improve your ability to articulate difficult sounds. After you've practiced these, you'll find that you've developed an enhanced vocal control. You'll take command of your audience with your increased vocal power. I can't promise that your listeners will march off a cliff like lemmings under the hypnotic spell of your voice, but listeners will gain greater meaning from your words, give you a higher credibility rating, and listen to you for a longer period.

When practicing the drills, first go for accuracy, and then, when you can say them perfectly, go for speed. Do not try to go fast at first. You're building new muscular coordination and establishing new neural networks in your brain, and this takes time. It's far better to practice a new skill perfectly, in small increments.

Instructions—Say these aloud. At first, do these exercises in private. Then, as you gain proficiency, ask someone to listen to you. (You'll find that doing these in front of somebody is a totally different experience from your solo performances.) Work on one sentence at a time. Slowly repeat these three times. Then, repeat and increase your pace.

- She says she shall sew a sheet.
- He saw six slim, sleek, slender saplings.
- We're your well-wishers.
- Toy boat.

- Some shun sunshine. Do you shun sunshine?

- Bugs' black blood.

- The sea ceaseth, and it sufficeth us. (Joel's note: I've never been able to say this one, but maybe you can.)

The above sentences are filled with the building blocks of sound: words built from these basic tones. When you make these sounds well, your speech has greater articulation. For example, consonants have a crisp, sharp sound. Be sure to emphasize your **T**, **H**, and **S** sounds.

Tip ✓ Be sure to record your exercises, and listen to the tape critically. Once you've made your tape, you can practice these exercises in your car—playing the tape back as you drive.

Tip ✓ Here is an old radio announcer's trick. When you say certain "s" sounds, they sound even better when you "buzz" them . . . put your teeth together, and make a buzzing sound. For example, in "He saw six slim, sleek, slender saplings," when you say "saplings," buzz the final "s." Practice by saying the word "jazz" with and without the buzz sound. It gives your voice a clean, dynamic sound.

Vocal traffic cop

Like a busy traffic cop, you want to direct your listeners' attention to the parts of your ideas that deserve special emphasis. Some parts of your sentences are more important than others. Here is an exercise that will help you learn how to communicate your attitude by emphasizing different words to your listener. Instructions: Read each sentence, placing expressive emphasis upon a different word each time.

- I have some news for you.

- The return on portfolio "B" may become more attractive over time.

- That is the ugliest dog I have ever seen. (Joel's note: This one is my favorite of the emphasis exercises; try it doing a southern accent.)

Chapter 8 Summary

Message Delivery: *Performing the Presentation*

Key Ideas

🗝 **Have fun.** Don't be too stuffy. You'll create distance between you and your listeners, and worse, you'll bore people. **You're in showbiz, so entertain your audience**. Remember the *Persuasion Chain Effect.*

Keep refreshing your listeners' attention. **Your listeners' brains are busy**. You're competing with the hundreds of intrusive thoughts running through your listeners' minds.

🗝 Efficient persuasion is the primary goal in a business presentation. Remember, time is limited. Your goal is to give information that helps your listener make a decision. Business presentations "cut to the chase" early. Tell your listeners what you learned, not how you learned it.

The goal of social communication is different than that of business communication—In social communication, you largely want to entertain your companions and develop a relationship. You use good storytelling to delay getting to the punch line. In business communication, you use a small amount of entertainment to enhance the delivery of information and to facilitate decision making.

🗝 Prepare for the disaster that will never come. *"What are the worst things that might happen?"*

Delivering Your Message

Communicator's Checklist

❑ **Prepare yourself.** Leave the room before your talk. Go to the bathroom. Wear comfortable clothing so that you can move well. Select shoes that support your performance movement. Relax your whole body by stretching.

❑ **Start to speak** with your feet shoulder width apart. Keep your hands above your waist (*Kangaroo Paws*). Bend your knees, keeping your weight slightly forward on the balls of your feet.

❑ **Project a good attitude toward your audience.** Be interested in them as people. Be good-natured. Use humor and common experiences to establish common ground. Fill yourself with admiration and respect for your audience. Have fun; remember that the audience is on your side.

❑ **Present with PowerPoint slides.** The slides are your partner. Watch out for flashing *Butt Meat*—avoid turning your back on the audience.

Turn, Touch, & Tell

Turn—to the bullet-pointed text on the screen.

Touch—the text on the screen with the hand closer to the screen (the upstage hand).

Tell—the listeners what it means.

Put your hand in the light—When you do *Turn, Touch, & Tell*, stick your hand in the light; walk in front of the screen.

Go to black—When you decide to elaborate and talk about things that are not on the slide, put the slide in black mode. Put the screen in black when you do your *Cold Closing*, too.

❑ **Cut material for time.** Don't read a slide; tell your audience to read the slide, and ask them if they want to talk about it. They will read it faster than you. Don't elaborate on every bullet point. You can easily eliminate the subpoints using the *Nichols' Two-Things*.

❑ **Present with graphs.** A graph is the ultimate upstager. Quantitatively minded audience members will ignore you as they fixate on the graph. You need to coordinate closely with *Lucy*, when calling for graphs.

The *Big-G*

First—Read the title of your slide.

Second—Tell them what the y-axis scale means.

Third—Tell them what the x-axis scale means.

Fourth—Give an example: go to a specific data point, relate it to the y-axis scale, and tell them what it means.

Technique: Stand on the left-hand side of the chart. You'll find that it's the best spot, because you can reach the y-axis easily.

❑ **Work to refresh the audience's attention frequently.** Move about the room. It's important that you speak within the communication space of each person in the audience (it is not easy and often is impossible). Think of a 10-foot radius around you.

Talk about one subject for a maximum of 30 seconds. Give a pictorial example. Use *questions* to keep your audience tuned in to your presentation. If they've been sitting for more than one hour, ask them to stand and stretch.

❑ **Handle props—Warning:** Your props can upstage you.

Head to Heart—To show respect, convey a product's quality: Hold it between your head and heart. To convey disrespect or poor quality: Move the object away from you, holding it below your waist.

Hold the Baby—Hold objects you highly value like you hold a baby.

Finger Tip It—Hold a product with your fingertips, so your hand does not block the audience's view.

Hide It—When you are through talking about the prop, hide it from audience view or it will upstage you.

Handle the company's/client's product—When you hold the product, show your respect; handle it with care. Pretend that you are holding the crown jewels.

❑ **Manage audience questions.** Respect the questioner. Listen actively to the question and questioner. The audience will judge your credibility (goodwill) by how you handle questions, particularly how you listen to, and answer, their questions.

Repeat the question and ask, "Have I stated your question correctly?" If not, learn what the question is. If you don't know the answer, admit it . . . promise to find out. Ask the audience; perhaps someone will know the answer.

❑ **Buy time when you're stuck.** If you're stuck for an immediate answer, use silence—wait, and the questioner will start talking again, giving you more time to think. To give yourself time, repeat the question, and ask the listener, "Do I understand your question?"

❑ **Handle obnoxious or hostile questions.** First relax, and do not show fear. Restate the question in less confrontational terms. Ask the listener, "Is that your question?" The listener will probably agree with your watered-down version of his or her attack, and now you can go on to answer it.

Defuse the obnoxious or hostile question by rewording it. Use the group to control the angry or hostile questioner. Give a moderate but meaningful answer. Most of the audience will agree with a more moderate point and will probably be embarrassed by the hostile questioner.

❑ **Practice voice control.** Reduce vocal tension by stretching out the intercostal muscles between your ribs. Relax your vocal cords directly by humming. Take a long, slow, huge, deep breath, and hold it.

Eight Rules of Persuasive Presentations

1. Keep your communication mission simple.

2. Get on and get off fast. If they ask you to speak for 15 minutes, talk for 10.

3. Use the power of silence—enjoy pauses.

4. Don't fill the silences with empty mouth noises.

5. If your teammate goes blank, fill in, and provide the key word.

6. Don't read your talk.

7. Don't bore the listeners with the saga of how you came to your conclusions. Listeners are interested in benefits, what they will gain from your information, from your insight.

8. Don't upstage your teammates.

9

Writing E-mails and Memos With High Communication Factor

If you send it, will they read it?

Writing e-mail or a memo is two jobs:

1. Writing your ideas.

2. Getting someone to read what you've written.

Note: The techniques you'll learn in this chapter work equally well in e-mails, memos, and reports. Rather than asking you to frequently read the words "e-mail, memos, and reports," which would be tedious, I'll just say "e-mail." May I ask you to mentally insert the word "memo" or "report," too?

Today, people are bombarded with things they are supposed to read. Think about the ton of reading material you wade through every day. You get dozens, if not hundreds, of e-mail messages, including

spam; you get snail mail, magazines, brochures, memos, reports, professional publications, textbooks, self-help books, and instruction manuals. Admit it, you can't read it all.

Do you have a Palm Pilot or BlackBerry? Tell me you've read the manual cover-to-cover and know how to wring out every feature these amazing machines offer. I know you haven't; I haven't, either. I can make phone calls with my BlackBerry, and that's about it. I'm still trying to get my calendar synced. Wish me luck.

So, what's the point? It's no different for your readers. Just as you're buried under an avalanche of daily reading, your readers are buried, too. What makes you think they'll read your e-mail message, just because you sent it?

Solution: Use techniques to grab your readers' eyes and motivate them to read your e-mail.

Busy people scan

Smart professionals manage the paper landfills on their desks by scanning and speed-reading. In this chapter, you'll learn how to communicate better by using the visual tools at your disposal:

- Typeface
- White space
- Psychological levers
- *Motivation sentences*©
- Subheads

These techniques will attract your readers and compel them to read what you've written. You'll get attention and be heard.

Stop sending out rough drafts

I'm sure your written communication reflects your intelligence and education. You spell-check and proofread your written communication before you send it, right? If you do, you're still sending out rough drafts, unless you package your messages for readability. Think about this: As a professional communicator, you have two tasks to accomplish before you hit *send:*

1. Write your message.

2. Package it for readability.

You send a rough draft unless you add visual elements designed to grab your reader's eye and drive your message home. But you're not alone. Most people send rough drafts.

Advantage to written communication

One of written communication's great advantages over oral communication is that you can *engineer* your message through iteration. You can edit and rewrite until your words are polished. You can show your drafts to other people to get their reaction. We call this ***engineered communication:*** a process of iteration by which you test and rewrite your words using your brain's built-in writing machine (see the **Brain incubation** box below).

You can't refine your oral message in the same way. When you're speaking, after the words have left your lips, you can't take them back.

Once spoken, words can't be erased. Picture this—You're in a courtroom, and the witness says, "He's a drunken bum. Everyone knows that." The defense attorney jumps to her feet and shouts, "I object," and the judge says, "Sustained. The jury will disregard the witness's last remarks." What a sham. You know the jury will not forget what the witness just said. No matter how hard they may try, they'll remember that the "defendant is a drunken bum."

Brain incubation

Use your brain's power of incubation. First, write a rough draft, and then put it away. You've input your ideas into your unconscious mind. You let an interval of time pass to let your brain go to work, perhaps while you work on something else, or get a good night's sleep. When you return to your writing, you begin by editing it, looking for spelling or grammatical errors. The moment you begin to work, your brain reports a brilliant flow of new words that greatly enhance and improve your writing. This is your brain continuing to work, unconsciously, while you attend to other things. A polished draft is hard to produce in one sitting. I recommend you don't even try. Do this instead: Approach your writing in a series of stages. Get some ideas on paper, rest, write sentences and complete thoughts; rest, polish, rest, and polish again; rest, and polish a final time. By the fourth iteration, you've probably got something really good, something that communicates your brilliance to your reader.

Three ideas to get your e-mails and memos read

1. Use typeface and white space.

2. Prep the reader's brain.

3. Motivate your reader to read.

It's all about readability—how well your readers understand your message and how fast they can read it. Follow these ideas and your writing will become easier to read and easier to remember.

Idea One—Use typeface and white space

Recommendation for selecting the right typeface—For maximum readability, use a 12-point, proportional type with serifs. For example, Times and Times New Roman typefaces are proportional typefaces with serifs. Note: Don't look in your computer's font set for a typeface called "serif." No typeface is named "serif"—it's a group or class of typefaces. Times is the family name, of which Times and Times New Roman are members. Below is a sample of 12-point Times New Roman

This is a sample of 12-point Times New Roman.

The right typeface—Studies show that choosing the right typeface increases your reader's speed, ease, and comprehension. Gallup, Inc. found that serif typeface was more readable than sans serif (see **Figure 9.1—High-Readability Typeface**) (Ogilvy, 1985).

Pick a high-readability typeface—Times, Times New Roman, and Garamond are good proportional serif typefaces.

Don't use a slow, low-readability typeface—Arial, Helvetica, and Futura are sans serif typefaces and hard to read in continuous text (more than two paragraphs).

Why are serif proportional typefaces easier to read?—The answer is *pattern recognition.* Your brain is an amazing pattern recognition machine. It sees symbols and translates them into meaning rapidly. The more times your brain sees a symbol, the faster it can make the translation. Over the years, your brain has seen billions and billions of words with serif typefaces, because nearly every book, magazine, and newspaper you've read in your life is set in serif type.

Figure 9.1 High-Readability Typeface

Your brain's pattern recognition machine has been trained to quickly recognize the more familiar serif type. As a result, the brain's decoding process happens far faster when reading serif type than sans serif type, because we have seen more of the widely used serif proportional type than the less popular sans serif.

You'll be blamed if you use the wrong typeface—Your readers are not going to say to themselves: "Wow, this sans serif typeface is really slowing down my eye—it's hard to read and I won't remember as much." Nope, they'll think: "This writer (you) does not make sense, is not too smart, does not express himself (or herself) well." This effect is preconscious.

When to use sans serif typeface

When to use sans serif—you'll want to use this cleaner typeface for faxes, Web pages, and other noisy, analog channels. Have you ever noticed the little dots and dusty-looking stuff on your faxes, or how fuzzy the letters and lines look? What you're seeing is the result of noise and error from the phone line.

Message from Japan—To test this idea, we faxed the same message, in two versions (serif and sans serif), back and forth between the United States and Japan. Readers in both countries said they could read the sans serif far more easily than the serif type. It arrived with fewer errors and distortions.

Small type—When you must use undersized (smaller than 9-point) type, sans serif is easier to read.

Why people like sans serif

Clean, modern look—Sans serif is used routinely, but not exclusively, for display-type applications such as signs, headings, and other

situations demanding clear meaning but without the need for continuous reading. Many designers, including engineers and architects, like the way sans serif looks. They find that sans serif's modern, simple look reflects their taste and image. It's true that serif does look old school. I recommend that you use sans serif type only for brief text—no more than a paragraph or two. If you have more text than that, you will fatigue your reader with sans serif type. Do not use it when you want the reader to plow through more than a half page of text. It will seem tedious—even for engineers.

Pick proportional type

Proportional type is easier to read than non-proportional type. Here is why: Each individual word appears more readily, because there is more white space between the words than between the letters. This white space acts like a frame around a painting. Each word stands out on the page. Non-proportional type puts too much white space within the word. The reader must spend extra milliseconds seeking out the word. Over thousands of words, this becomes fatiguing and requires more effort on the reader's part.

For example, notice the difference between the two sentences below. The first is in proportional type; the second is in the harder-to-read, non-proportional type.

Times New Roman 12-point—proportional

Education is vital to success in today's rapidly evolving, high-tech business world.

Courier 12-point—not proportional

```
Education  is  vital  to  success  in  today's
rapidly evolving, high-tech business world.
```

As you can see by studying the examples above, proportional type is easier to read and uses less space than non-proportional type. Notice how the second identical sentence, set in Courier type, takes up more than one line—the proportional type packs more information into less space and is easier to read.

Don't use Reverse Typeface

On occasion, designers like to use white typeface set against a black background. This technique is called *Reverse* or *Knockout* type **(Figure 9.2—Reverse Typeface: White Type on Black Background)**. This design is harder to read. Here's why: Your eye is accustomed to

reading black type against a white background; like you're reading now. Designers like it because it's unusual and stands out. But you suffer a penalty: The reader has a harder time reading the text. While you will stop the reader's eye and gain their interest, you'll make the reader work too hard to get the message, if they decide to read it at all. Do not use reverse typeface when you want your reader to read your message.

Caution—When your primary reader is older or partially sighted, reverse type may be easier for them to read (Arditi, 2006). In the United States, 16.5 million adults age 45 and over report some form of vision impairment (The Lighthouse, Inc., 1995). This group will grow larger as the Baby Boomer segment ages. For excellent guidance on designing Web sites and other written material for partially sighted readers, visit The Lighthouse International's Web site: http://www .visionconnection.org/.

Figure 9.2 Reverse Typeface—
 White Type on Black Background

Another point on selecting typestyle: Avoid using reverse type—that is, white letters set on a black background. People find this very hard to read. While it will stand out and grab attention (because it's so seldom used it will be an attractive oddity), your text will not be read because it is too hard to decode and read.

White space directs the eye

When you use lots of white space, your writing becomes easier to read. White space—like margins and the space around paragraphs, tables, figures, and graphs—sends a message. When you see white space, it tells you: "Don't look here." It directs your eye to "look at" the text.

Lots of white space says to your reader: "This is going to be easy to read" (see **Figure 9.3—No White Space—Hard to Read** and **Figure 9.4—Easy-to-Read White Space**).

Here's why: Your readers will begin reading by looking at the left margin (see **Advertising Fact: Line of Space Attracts More Readers** box on page 210). If you indent, your readers will have to skip from the left margin over to the indented word. It might seem like a small adjustment, but it's easier to read if you use a line of space instead of an indent, and begin your paragraph where the reader is looking: on the left margin.

Recommended—Use a minimum 1-inch margin.

Recommended—Use white space between paragraphs; don't indent; double-space between paragraphs.

Figure 9.3 No White Space—Hard to Read

No margins

Hard to read

Paragraphs indented

On the fields of hesitation bleach the millions, who, at the dawn of his resting, died. Died where they rest that they may not have intended to take an eternal rest. So, I say to you, don't sit to st with you have one drop of energy left. Better to spill your last drop of energy in effort to sustain your goals than to rest and end up dead.

On the other hand, Sun Tsu, the great Chinese military strategist, advised that "rest is a weapon too." Tsu predicted that rested troops fight better than fatigued troops. Perhaps there is something to be said for rest and we should caution ourselves about work, work, work, i.e., pressing on when the body is too tired and the brain is fogged by fatigue. I mean, really, what's the probability that you'll die if you rest. Ha! I say that you'll probably be more likely to die if you don't rest. So, forget about that "fields of hesitation" bit.

It's just overstated nonsense that really does not stand up to reason. Drop that idea about press on at all costs. Grab a nap when you can. You'll probably look younger and live longer. Dreams can be sweet and time flies when you sleep. A great use of energy. You are not polluting the atmosphere, consuming more than your fair share of resources, or being annoying. Definitely, get all the rest you can. Naps are good. Snoozes are better. And, there is nothing like a really deep sleep. Like the sleep that you are probably getting ready for as your eyes get heavy, your breathing slows down, your head starts to get very, very heavy, so heavy you can't even hold it up. There, let it drop, shut your eyes and just listen to the sound of my voice...

Advertising fact: Line of space attracts more readers

Advertising studies have shown that ads using a line of space to indicate a paragraph attract 20% more readers than ads using indents to start a paragraph (Ogilvy, 1985).

Figure 9.4 Easy-to-Read White Space

On the fields of hesitation bleach the bones our s millions, who, at the dawn of history, s resting, died. Died where they res that they may not have intended to an eternal rest. So, I say to you, don't si one drop of energy left. Better to spill your la drop energy in effort to sustain your goals than to rest and end up dead.

On the other hand, Sun Tsu, the great Chinese military strategist, advised that "rest is a weapon too." Tsu predicted that rested troops fight better than fatigued troops. Perhaps there is something to be said for rest and we should caution ourselves about work, work, work, i.e., pressing on when the body is too tired and the brain is fogged by fatigue. I mean, really, what's the probability that you'll die if you rest. Ha! I say that you'll probably be more likely to die if you don't rest. So, for that "fields of hesitation" bit.

It's just overstated nonsense that really does not stand up to reason. Drop that idea about press on at all costs. Grab a nap when you can. You'll probably look younger and live longer. Dreams can be sweet and time flies when you sleep. A great use of energy. You are not polluting the atmosphere, consuming more than your fair share of resources, or being annoying. Definitely, get all the rest you can. Naps are good. Snoozes are better. And, there is nothing like a really deep sleep. Like the sleep that you are probably getting ready for as your eyes get heavy, your breathing slows down, your head starts to get very, very heavy, so heavy you can't even hold it up. There, let it drop, shut your eyes and just listen to the sound of my voice...

Labels: Margins · Easy to read · Line of space (leading) · Paragraphs flush left

Drawing attention to key words

Sometimes a certain part of your message has greater meaning, and you want to emphasize it. If you were speaking, you'd feel more emphatic, and your attitude would be more energetic. You'd speak more loudly, with more gesticulation.

When writing, you add emphasis with bolding, italicizing, or underlining. Be careful when selecting a typographic element to make your writing more emphatic. You can slow the reader down if you use the wrong technique.

Calling attention to words

- Bolding is best.
- Italicizing is second best.
- Bolding and italicizing is okay.

For maximum readability, use bold or italics to direct the reader's attention to a particular word or to add emphasis. **Underlining is rotten.** Avoid using underlining, because it adds to the visual clutter, making it harder for the reader's eye to sort out the words from the background noise. You may underline entire sentences or paragraphs with minimal reduction of readability. However, never underline single words or phrases. If you have to underline, underline an entire sentence or paragraph. Do not underline single words for emphasis.

Demonstration—Notice how your eye processes the following paragraphs:

Hard to read

For maximum readability, use <u>bold</u> or <u>*italics*</u> to direct the reader's attention to a word or to add emphasis. <u>Avoid using underlining,</u> because it adds to the visual clutter, making it <u>harder for the reader's eye to sort out the words from the background noise</u>. You may underline entire sentences or paragraphs with minimal reduction of readability. However, never underline <u>single</u> words or phrases.

Easier to read

For maximum readability, use **bold or italics** to direct the reader's attention to a word or to add emphasis. **Avoid using underlining**, because it adds to the visual clutter, making it **harder for the reader's eye to sort out the words from the background noise**. You may underline entire sentences or paragraphs with minimal reduction of readability. However, never underline **single** words or phrases.

If you're like most people, you will find the first paragraph harder to read than the second.

Caution—When you're cooking, if you add too much spice, you can ruin your creation. Similarly, if you use too much bolding and italicization, you'll add clutter and noise to your documents. Rather than communicating better, you make your writing harder to read. Give

your writing just an occasional pinch of emphasis. Avoid dumping handfuls of bolding and italicization into your documents. You know your passion and deeper meaning is best communicated by speaking. Writing is a poor vehicle for your passions. If you feel the urge to CAPITALIZE, **bold**, <u>underline</u>, and *italicize*, be aware that this is a sign that you should speak to your listener too, and not just write.

Caution—The same is true of exclamation marks. Please consider what my old journalism teacher (and Pulitzer Prize winner), the late Buddy Davis, taught me. He said: "Joel, you get to use one exclamation mark a year. Make it count. The rest of the time, use words: Verbs and adjectives are good."

Idea Two—Prep your reader's brain

Prime your reader's mental pump: subheads—You can make your e-mail and memos far easier to read by inserting mini-headings called *subheads* before important sections. Subheads tell the reader, in two or three words, the essence of the paragraph that follows—like a miniature headline. When you start a new idea—for example, a new paragraph or set of paragraphs—it should be preceded by a subhead.

Design your subhead to communicate—Think of what the readers are looking for in your report; then consider what your section contains. Write a brief subhead that tells the readers what they are about to read, and what information and perspective they are to gain, presented from a mutual frame of reference shared by you and your readers.

Best format for subheads

Follow a few simple rules, and your subheads will go to work for you (see **Table 9.1—Subhead Format** and **Figure 9.5—Subheads Increase Readability**).

Table 9.1 Subhead Format

• Two or three words long	• Capitalize first letter and proper nouns
• Flush left	
• Left justified	• Do not use underlines or italics
• Bolded	• Do not use colons, numbering, or bullets
• Use one line of space below subhead	
	• Use two lines of space above subhead

Figure 9.5 Subheads Increase Readability

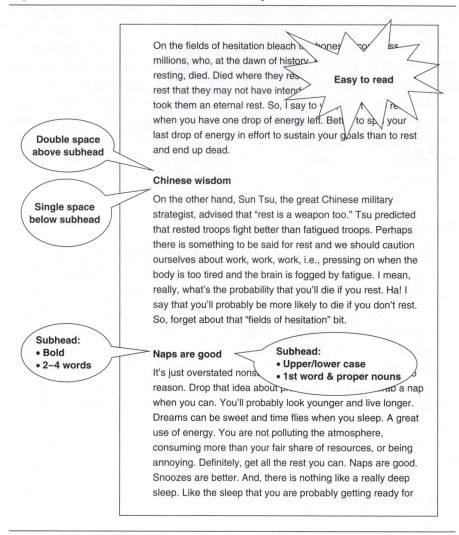

Bullets—When should you use bullets?

Bullets are great tools. Here's when you should use them. Say, for example, you're writing an analysis of your company's competition. You want your words to flow smoothly, but they don't. Your writing is becoming choppy and disconnected, and you're having a hard time linking the ideas together. You notice that you've stated lots of isolated ideas or facts. In this case, it's probably because you're writing a list. You're talking about three or more different ideas in a single paragraph—so you're ideas are packed too tightly and condensed. This is a clear signal that it's time to use bullets.

Tip ✓ **Bullets hit your target.** Most businesspeople write messages composed of highly concentrated information. Bullets allow the skilled communicator to keep the information in a concentrated form and make it highly readable.

For example, consider the following:

The goal of this project is to identify customers, determine their spending levels, number of employees, and study their projected budgets and level of satisfaction with their current supplier.

It's easier to organize your words like this:
The goal of this project is to

- Identify customers
- Determine spending levels
- Find number of employees
- Study projected budgets
- Measure satisfaction with current suppliers

Tip ✓ Make your bullets easier to read by adding 6 points of paragraph space between each bullet. Look at these bullets (below). Notice how just a little space between each line makes them stand out. The command in Microsoft Word is **Format; Paragraph; After = 6 pt.**

The goal of this project is to

- Identify customers
- Determine spending levels
- Find number of employees
- Study projected budgets
- Measure satisfaction with current supplier

Tip ✓ Make your bullets parallel. Start each bullet with a verb. For example:

Wrong	**Right**
- Increase market share	- Increase market share
- Salespeople training	- Train salespeople
- Customers will be profiled	- Profile customers

Tip ✓ Put your short bullets in columns (like the ones you see above). It's a great use of white space and will keep your documents shorter.

Bullet FAQs

Question How long can a bullet be? Can a bullet contain a couple of sentences?

Answer Bullets can be a single word or phrase. Your bullet can indeed be a sentence or two long. Remember, shorter is better.

Question How much space should I place around a set of bullets?

Answer A minimum of double space before the bullets, and triple space after your bullets.

Question Should you indent bullets?

Answer No, don't indent bullets; start bullets in the first column. Indent the text after the bullet symbol.

- Bullets should start here
 - Bullets **should not** start here

Second-order bullets should be a different shape. For example, if your first-level bullet is a dot, use an open circle for the second-order bullet. Second-order bullets are placed under the first letter in the first-level bullet:

- This is a first-level bullet
 - This second-level bullet uses a square and is indented beneath the first letter in the first-level bullet. Notice how the text wraps around (is indented).

Question When should I use numbers rather than bullets in a list?

Answer Use numbers when the items or ideas listed have an order, ranking, or count—for example, if you want to say that there are five steps to dressing well (I've been watching *Queer Eye for the Straight Guy*) or name the top five travel destinations in the United States. If the set has no numerical order or meaning, use bullets. Most of the time, you'll use bullets rather than numbers.

Communication Toolbox

E-mail Techniques

Everybody gets a huge volume of e-mail. We don't want most of it. Just think about the deluge of spam that's dumped in your inbox. Add to that the number of times you're copied by well-meaning people who think the world needs to know what they are doing. It builds to a high volume of messages. How do you decide which ones to read? The people you write have to make the same decision. To make sure that your important messages are read and acted on, you've got to do two things:

1. Capture your readers' attention: *Read me.*

2. Motivate them to optimally receive your ideas.

Starting your e-mail—what to write first

Busting through the clutter—Your message has to compete for your readers' attention. As we say in advertising, "You've got to break through the clutter." Your message has to stand out and yell: "Read me; I'm important."

Table 9.2 Write a Subject Line

Subject Line

- Headline for your message
- Write a unique Subject Line
 - o Don't hit reply
 - o Stand out from spam and clutter
 - o Set attitude
 - o Send information

Subject lines

Your subject line can attract or repel your reader. Before you send your e-mail, take a moment to look at your subject line. **It should be a mini-sales pitch, compelling your reader to stop and read your message** (see **Table 9.2—Write a Subject Line previous page**).

Scan-*ability*—A good subject line contains the essence of your message—your reader can go back later, scan quickly through his or her e-mail inbox, and find your message.

Make a fresh subject line when you hit Reply—I know that when you're answering your e-mail, it's easy to hit the reply button and get an automatic subject line ("**RE:** The sender's subject line"). Don't do it. People who use the automatic subject line are missing prime opportunities to intrigue their readers, capture their attention, and affect the recipient's mental mood. A good subject line ensures they'll receive the message in the most optimal way possible.

Write a unique subject line, one that will grab your reader's eye, help communicate the essence of your message, and set the reader's attitude and expectations.

Essential elements

When you write a friend, you can be casual; you don't need to format your e-mails. The strength of your relationship assures that your e-mail will be read. You don't have to establish your credibility through proper formatting. You already enjoy credibility. However, if you don't have high credibility, or lack an established relationship with your reader, your e-mail must reflect your education and professional ability. Important e-mail must have the same essential structural elements that you'd use in a letter (see **Table 9.3—Elements You Must Have**).

Idea Three—Motivate your reader to read

Sometimes your readers are not expecting to receive your e-mail, or may not be familiar with the ideas you have expressed, so they're not particularly motivated to read it. You must motivate your reader to invest time in reading. Do this: After you've written your message, return to the top and write a sentence or two—right at the start of the e-mail—to motivate the reader.

Table 9.3 Elements You Must Have

Elements you must have

- Salutation (Dear; Good morning; Hello)
 - Person's first name or last name (not both)

- *Motivation Sentence*
 - "You," not "I" or "We"
 - *Other-orientation*
 - On topic
 - Not extended salutation, e.g., "How you doin'?"

- Closing (Sincerely, Best regards, Thank you)

To motivate the reader, put yourself in his or her shoes and write to the reader's interest and motivations. Some suggested approaches:

- Talk directly about the benefits the reader will receive.
- Ask the reader a question to draw him or her in.
- News—offer the latest information; report changes in the environment or share ideas for change.
- Who—will it affect; who says so; who's the information from?
- What—does it describe or define?
- When—is the time frame; what's the data's date; is time running out?
- Why—is it important; what are the causal factors?
- Where—is the location; scope; relevance?
- How—will things proceed, what process, with what impact?
- Impact upon the reader:
 - How will it affect the reader?
 - How will it help the reader reach his or her personal or professional goals?
 - Show how you're responding to the reader's request.
 - Summarize what the reader can expect to learn or find out by reading your memo.

Make it about the reader, not about you

The best way to guarantee that your message will be read, and that it will get the best possible audience, is to write the *Motivation Sentence* from the reader's point of view. When you start your message

with, "I'm pleased to announce that the . . ." you are writing from your point of view about something that interests you (see **Table 9.4— Be *Other-Oriented*—Motivate Your Reader**).

Rules for motivating people:

- Use **You** instead of **I.**
- Use **You're** instead of **I'm.**
- Use **Your** in place of **My.**

It works wonders—when you write using those second-person pronouns you've got the magic key that grabs the reader's attention and opens his or her mind to your point of view. After all, it's the reader's point of view, too.

You can expect this technique to be difficult at first. Writing from your reader's point of view is hard to do. Like most people, you've spent your entire lifetime experiencing and expressing life from your point of view, from your frame of reference. To make a 180-degree switch to the other person's side of the table takes a lot of practice. Don't expect to be able to write a good *Motivation Sentence* easily or quickly. You'll find that, over time, it gets easier. But in the beginning, most people find it difficult. The rewards make it worth it.

Features to benefits—Skilled salespeople call this "translating *features* into *benefits*." A feature is something a product has or does. A feature is the product seen from the seller's point of view (*self-oriented*). A benefit is what the product does for the customer. A benefit is the product seen from the user's point of view (*other-oriented*). For example, a car gets 35 miles per gallon of gas and can cruise 450 miles on a single tank—that's a feature. The benefit is that you can drive to your weekend vacation spot without having to stop for expensive gas. To really motivate your reader, write about benefits, not features—be *other-oriented*.

Sample *Motivation Sentence*

You have probably noticed a trend in the marketing faculty at DePaul University. You might have observed a steady improvement in the quality of professors in terms of teaching ability, intelligence, kindness, and concern for students. However, you also have seen a trend toward short faculty members. As one subject told us, "They're getting pocket-sized."

Table 9.4 Be *Other-Oriented*—Motivate Your Reader

Self-oriented	*Other-oriented*
I changed the file from Apple to PC format.	See how this file opens on your PC.
I got your letter.	Your letter arrived.
I forgot to include the attachment.	You're probably wondering where the attachments are; sorry . . .
I'd like you to remove the $35 annual fee.	If you're able, please remove the $35 "Annual Fee" from our account.
I'm pleased to announce that Fern Quiggley has been appointed . . .	When you see Fern Quiggley, congratulate her on her new appointment . . .

Memo writing rules

1. Memos range from one to three pages, single-spaced.

2. The data must be presented in narrative form; tables are optional. Use the required format for including numerical data in your text (see **Chapter 10—Communicating with Tables, Graphs, and Charts:** *Your Visual Toolbox*).

3. Use tables or graphs, if you have data.

4. Write a subhead for each section and subsection.

5. Make your subhead like a headline for the following text; it should be information-rich, summarize the text, and convey an attitude. Below is an example of a suggested memo masthead for your memos:

TO: D. Joel Whalen, Ph.D., Associate Professor of Marketing
FROM: Ms./Mr. Your Name, Title, or Department
DATE: June 14, 20XX
RE: (Topic of Your Memo)

Note that the memo masthead is bolded, followed by a line to give it a crisp loo.

Writing With High Communication Factor

Common grammatical errors

Pay close attention to grammar, spelling, and sentence structure. Common grammatical errors include:

- Using the word *which* when the proper choice is *that*. (Which is used only parenthetically; the word, which, must appear between two commas—a nonrestrictive clause.)
- Dangling prepositions (at, in, with, through). The end of your sentence is not where you want your prepositions (at).
- Subject/verb agreement, for example:

 He and his friends are in the computer lab (good subject/verb agreement).

 He and his friends is in the computer lab (bad subject/verb agreement).

More interesting to your readers

You can lull your readers into a dull-minded state. Wake them up:

- Offer your reader a variety of words; use words the way a cook uses spice. Do not use the same key words (i.e., verbs, adjectives, and descriptive nouns). Edit out repetitive words or phrases.
- Vary the length and structure of your sentences. Check the content of paragraphs and see if long paragraphs can be broken down into smaller, more readable paragraphs.
- Spell out numbers nine and lower; use digits for numbers 10 and greater. This is the Associated Press style used by most magazines and newspapers.

- Draw conclusions. Bravely take a stand and defend it confi-
 dently. Remember that in business, you state your case, make
 your recommendation, make a promise or prediction, and
 then proceed to back it up with facts and reasoning.

- Type your paper and draw your tables with superior attention
 to detail. Remember, presentation counts. Form is as important
 as content.

- Get to the point. Business writing is not storytelling. You don't
 want to keep the client or your firm's senior people in suspense
 while you build up to a big surprise ending. You may win
 a prize for literature, but you'll never be promoted on the
 strength of your report writing.

- The shorter the better. Because it's far harder to write briefly,
 you should distill your thoughts through three iterations.

Editing tips

Tip ✓ Write your memo or report over a minimum of three sessions.
Consider each version a rough draft, and work to make it
better each time.

Tip ✓ Proof your paper so that you don't have any heads or sub-
heads that are widows or orphans.

Tip ✓ Follow the page format instructions given in this document
exactly. You'll give your paper strong "eye appeal."

Tip ✓ Eliminate or reduce the number of prepositions (in, to, into,
through, about, on, between, beside, down, during, from,
over, toward, until, up, with) and conjunctions (and, but, for)
in your writing.

Here's why: If you are a skilled verbal communicator, you proba-
bly use lots of prepositions. Your first draft will be littered with prepo-
sitions. Prepositions place objects in semantic space. They allow you to
communicate with greater facility because you're tapping into your
audience's visual sense. However, the same number of prepositions in
a written sentence causes confusion. In oral communication, preposi-
tions give the listener a visual grip on what you're saying; in writing,
they just clutter up your sentences and make them too complex.

The same is true of conjunctions. These words are used to string
phrases and simple sentences together. Edit out excessive preposi-
tions and conjunctions.

Technique—Try to say the same thing with fewer words. Make sure that each word contributes to your message's clarity and meaning. If a word fails to add meaning, drop it.

Technique—Read your copy aloud. This will give you the benefit of a more objective reading, and most important, increase the conversational tone and move away from a dull, formal voice.

Writing the *Motivation Sentence*

Write the *Motivation Sentence* last, after you have written the rest of your e-mail or memo. If you try to write your introduction first, just because it's the first section of your paper, you are setting yourself up for a serious case of writer's block. It's just too hard to write the introduction first. *How can you describe a journey before you have taken it, grasshopper?*

Chapter 9 Summary

Writing E-mails and Memos with High Communication Factor

Key Ideas

🔑 Writing an e-mail or a memo is two jobs: (1) Writing your ideas; and (2) getting someone to read what you've written. As a professional communicator, you must package your message to increase its readability.

You have more than words at your disposal: Typeface, white space, psychological levers, *Motivation Sentences*, and subheads are tools you will use.

Engineer your communication—Don't hit *send* till you're ready. Use iteration and rewrite until your message is lean and smooth. Show drafts of your message to other people to get their reactions before you send it. Write an important message one day; review it the next day, before you send it.

🔑 **Use your subject line** as a mini-sales pitch, compelling your reader to stop and read your message.

Communicator's Checklist

❑ *Typeface. For maximum readability,* use a 12-point proportional typeface with serifs.

 Pick a high-readability typeface—Times, Times New Roman, and Garamond are all good, proportional serif typefaces.

 Don't use a slow, low-readability typeface—Arial, Helvetica, and Futura are sans serif typefaces and harder to read in continuous text, that is, more than two paragraphs.

❑ **White space.** Use a minimum 1 inch of margin. Use white space between paragraphs; don't indent.

❑ **Paragraphs.** Double-space between paragraphs.

❑ **Call attention to words.** Bold is best. Italic is second best. If you have to underline, underline an entire sentence or paragraph. Do not underline single words for emphasis.

❑ **Best format.** Subheads should be uppercase and lowercase and set flush left; rarely longer than one half to two thirds of a line of text (two to five words long).

 Bold the entire subhead.

 Uppercase the first letter of first word in subhead and proper nouns.

 Place two lines of space above the subhead, and one line of space below. If you can afford the space, you may use more lines of space to make the subhead stand out.

❑ **Bullets.** May be a single word or phrase, or a sentence or two long. Shorter is better.

 Make your bullets parallel (start with same type of word, e.g., a verb). Use numbers when the items or ideas listed have an order, ranking, or count.

 Begin at the left margin. Don't indent bullets. Indent the text after the bullet.

 Make your bullets easier to read by adding 6 points of space between each bullet. Put your short bullets in columns. Double-space before the set of bullets, and triple-space after your bullet set.

❑ **Motivation Sentence.** The first sentence or two of your message is designed to get the reader to read. It sets the reader's expectations and attitudes. Use a *Question Opening*.

Rules for motivating people

- Use **You** instead of **I.**
- Use **You're** instead of **I'm.**
- Use **Your** in place of **My.**

Talk directly about the benefits the reader will receive. **What's the news?** Offer the latest information, report changes in the environment, or share ideas for change:

- **Who** will be affected? Who says so? Who's the information from?
- **What** does it describe or define?
- **When** is the time frame? What's the data's date? Is time running out?
- **Why** is it important? What are the causal factors?
- **Where** is the location? What is its scope, relevance?
- **How** will things proceed? Describe a process.

Impact upon the reader—How will it affect the reader? Will it help her reach her personal or professional goals? Show how you're responding to the reader's request. Summarize what the reader can expect to learn or find out by reading your memo.

Memo Writing Tips

❑ **Memos range from one to three pages, single-spaced.** The data must be presented in narrative form; tables are optional. Use the required format for including numerical data in your text. Bullets are good. If your memo contains data, be sure to use a table or graphs. Write a subhead for each section and subsection.

❑ **Be more interesting to your reader.** Offer your reader a variety of words. Vary the length and structure of your sentences. Spell out numbers nine and lower; use digits for numbers 10 and higher.

Draw conclusions. Get to the point. Business report writing is not storytelling.

Say the same thing with fewer words. Eliminate or reduce the number of prepositions (in, to, into, through, about, on, between, during, from, over, up, with), overused (very, really), and needless words (*the fact that*). Do the same for conjunctions (and, but, for).

Read your copy aloud. Write your memo or report over a minimum of three sessions.

Type your paper and draw your tables with superior attention to detail. Remove heads or subheads that are widows and orphans.

Write the *Motivation Sentence* last.

10

Communicating With Tables, Graphs, & Charts

Your Visual Toolbox

You will want to be adept at using advanced visual tools—such as tables, graphs, and charts—in your professional writing for two good reasons:

1. Your documents will be easier to read, and because your readers will understand more quickly and easily, they will think you are smart.

2. The process of creating and writing will become easier.

Here's a secret few people know—Designing tables and graphs is an important part of analysis. When you decide how you want your table to look—think of what to place in the columns, what to place in the rows—you're conducting high-level analysis; you're making sense out of chaos; and you're mastering an essential task in creating professional reports.

Tables

Tables let your readers see your ideas at a fast glance. Readers like that. Tables are great for showing an analysis comparing two or more variables. For example, imagine you are analyzing competitors in a product category on these variables:

- Market share
- Geographic distribution
- Strengths
- Weaknesses

Rather than writing an extensive, multipage narrative, you can capture all this information, and present your analysis, using a table. Let's say you want to compare your firm with three major competitors: Alpha Corp., Beta, Inc., and Delta, LLP. You can build a table that will allow you to present these multiple variables across the competitors.

Building a table—The *factors* (competitors) go in the rows, and the *variables*, or measurements (product quality, market share, geographic distribution, strengths, weaknesses), go in the columns. The *values* go in the cells (percentage of market share; number of states with 30 percent or higher share; brief text on strengths and weaknesses).

Factor	Competitors
Variables	Market share, strengths, weaknesses, etc.
Values	Percentage of market share (high, medium, low)

Table Element	*Specifications*	
Type size	Text in cells	10 pt to 12 pt
	Labels	12 pt to 14 pt
	Row and column labels	12 pt to 14 pt
	Headers	16 pt to 20 pt
Bold	Header	
	Row and column labels	
	Do not bold text in the cells	
Typeface	May use sans serif type in tables (very small amount of text)	
Shading	Be careful with dark shading; when it's copied, it may *black out* your text. Don't apply shading	

to too many parts of your table. It's better to use shading with a purpose: drawing your reader's eye to a special element in your table.

Lines/borders Use line weight to organize your table's contents and lead your reader's eye. The outside lines (frame) are heavy and become lighter in weight as you move into the table (cells).

Table 10.1 Competitive Analysis

Competitors	Market Share	States > 30%	Strengths	Weaknesses
Our Company	38%	40	• Oldest brand • Highest share of mind • Privately held	Packaging seen as old-fashioned
Alpha Corp.	20%	2	• Popular in Southwest • Experienced sales force	• Publicly traded • Emphasis on cost cutting • Limited marketing
Beta, Inc.	10%	0	Good quality products	Emphasis on regional markets
Delta, LLP	3%	0	Aggressive	Low volume = lower margins

SOURCE: Actual data that Dr. Whalen made up

Graphs—pictures, not words

A well-designed graph tells a rich story that a table full of data cannot. See for yourself. Look at the table below, and then see what happens when the data are presented in a graph (see **Table 10.2—U.S. Supermarket Sales Growth Rate** and **Figure 10.1, a graph of the same data**).

The meaning is easier to understand when these same data are put into a well-designed graph (see **Figure 10.1—U.S. Supermarket Sales Growth Rate**, p. 232).

Table 10.2 U.S. Supermarket Sales Growth Rate

Sales	2003	2004	2005	2006	2007
Real growth	−1.1	0.5	1.5	0.8	1.5
Real growth per sq. ft.	6.75	7.22	7.09	6.85	6.37
Growth	5.3	3.1	2.2	3.3	4.4
Same store	3.7	0.3	1.0	1.9	3.3
Real growth same store	−2.6	−2.2	0.3	−0.5	0.4

NOTE: *Real growth* is adjusted for inflation.

Figure 10.1 U.S. Supermarket Sales Growth Rate

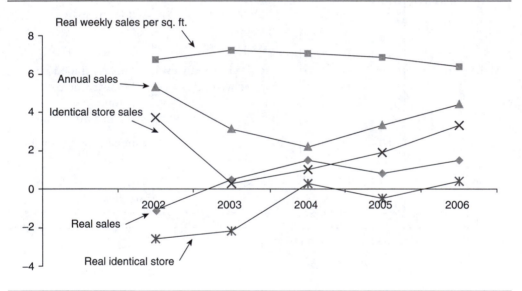

NOTE: *Real sales are adjusted for inflation*

SOURCE: FMI Supermarket Data

How to make tables and graphs

Graphs and chart types

Bar—The most commonly used chart. Bars are great for making a comparison and for showing differences between two *factors:* for comparing the magnitude between phenomena, i.e. "which is bigger" (see **Figure 10.2—Bar Graph**).

Figure 10.2 Bar Graph

Caution—If you make more than three comparisons in a single chart, it becomes increasingly hard for the viewer to understand. For example, the clock speed in hertz between three different computer processor chips; the income of college graduates (bachelor's degree) and those with MBAs; or reasons that customers switched brands.

Line—Excellent for showing change over time (see **Figure 10.3—Line Graph**). Use line charts when you have multiple observations over time. They may be used to show the change in a single variable over

Figure 10.3 Line Graph

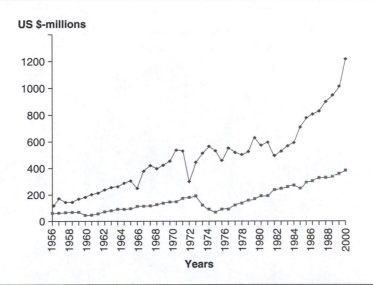

time, for example, the annual inflation rate in the U.S. over 10 years. And, they may be used to compare two or more variables, for example, to show the salary trends for male MBA holders and female MBA holders over 10 years.

Tip ✓ Financial data and data that run across time are best shown in line graphs.

Pie—Used only to illustrate the relative magnitude of all component parts of a complete set or universe, for example, the percentage of men and women in a group, or the market share of all competitors in a category. Pie charts are rarely used.

Making pretty pie charts

When students first start making graphs, they love using pie charts. There is something appealing in the pie. However, in actual business applications, line or bar charts are used more often.

Use a pie chart when you have a complete set and want to show how it is composed (see **Figure 10.4—A Pretty Pie Chart**). Percentages, shares, and proportions are best shown in pie charts, for example, market share among all competitors, or the percentage of budget allocated across expense types. In both cases, you have 100% of all the factors presented in the single pie chart.

Figure 10.4 A Pretty Pie Chart

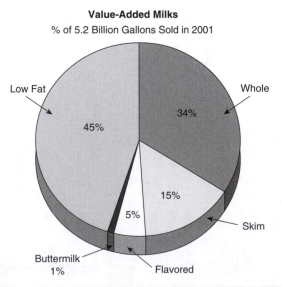

Tip ✓ Put the most important wedge at the top of the pie.

Tip ✓ Limit the pie wedges to five or fewer; avoid clutter.

Tip ✓ Rotate the pie so that it stands up straight, leaning backward only slightly (see **Figure 10.5—Rotate the Pie for Readability**).

Figure 10.5 Rotate the Pie for Readability

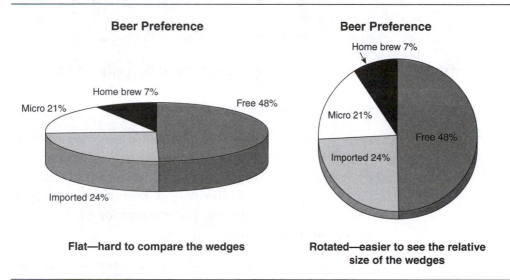

Psychology tip: the magic number = 3

When you select a key statistic, for example, the age distribution of people in a target audience, you'll want to report at least three numbers. Why use three numbers? The reason you pick the top three index numbers, although you're only actually using the biggest one, is because the two smaller numbers help sell the bigger number.

The other two numbers serve as reference points that allow the client (or your boss, or the loan committee, or whomever you're trying to persuade) to gauge the relative magnitude of the data. Psychologically, it's called *perception of contrast*. You can't see a white cat eating a dish of vanilla ice cream in a blizzard—everything's white, so nothing stands out. But when you sprinkle some chocolate chips on top of the ice cream, those chips really jump out. The smaller numbers allow your chosen index number to jump out.

Sometimes the top two or three numbers are close together (constricted range). In this case, your chart will not have the visual contrast you require. So to get the smaller, contrasting number, you may have to include four or more corresponding categories in your chart. Of course, in this case, you'll be reporting more than the usual three statistics. When possible, it's important that your table show some big numbers and some smaller numbers, to deliver a clear, persuasive presentation.

Making highly readable graphs

Graphs can frustrate your readers unless they can quickly and easily get the meaning.

Tip ✓ Within 3 to 5 seconds, your reader or audience will be looking at your graph and understanding what you are communicating. Use only the essential slide elements, and no more. Less is *more* when communicating with graphs.

Tip ✓ With a quick glance, your reader will be reading and understanding your graph. Make sure your graphs are fully labeled: *x*-axis, *y*-axis, pie wedges, and title.

Tip ✓ Sharpen your graph's professional look by examining its elements—grid lines, labels, legends—then ask yourself if the element adds information or noise. If you decide that it's communicating essential information, keep it. If not, drop it. You won't notice it's missing, and your reader will decode your illustration faster. Fast is good.

Tip ✓ Consider giving the source of your data. In professional and academic presentations, a source is mandatory.

Graph building techniques

Figure 10.6 Same Color Bars

Tip ✓ Use the same color for each variable, unless you want to point out a bar (**Figure 10.6**).

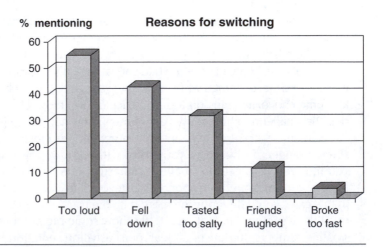

Figure 10.7 Emphasize One Variable

Tip ✓ This chart in Figure 10.7 quickly and clearly draws the reader's eye to *Fell down* as a key reason that customers switch by pointing out a bar.

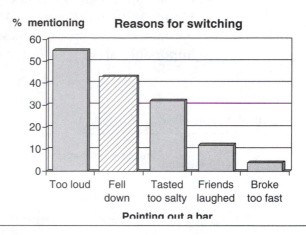

Figure 10.8 Too Many Patterns

Tip ✓ Each bar in Figure 10.8 has a different color or pattern. While this may satisfy the "artiste" in you, it makes it harder to understand. This chart is too confusing; one color or pattern is better.

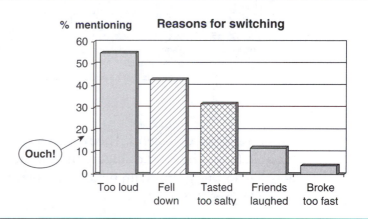

Figure 10.9 Keep *y*-Axis Label Horizontal

Tip ✓ Make all text horizontal, including the vertical *y*-axis's label. Notice how difficult it is to read this chart's *y*-axis (**Figure 10.9**). The reader has to tilt his or her head sideways to read it.

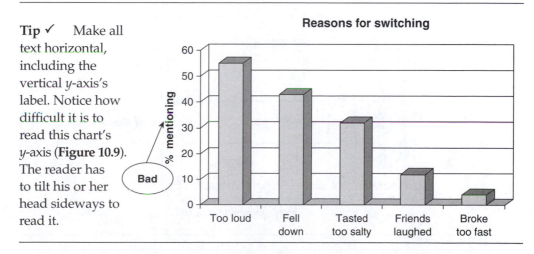

Tip ✓ Don't use a legend. Put the label in the bar, close to it, or best of all, connect the label and bar with an arrow (compare **Figure 10.10** and **Figure 10.11.**) By eliminating the legend, you can use the space to make the graph bigger. The most important part of your figure is the graph.

Figure 10.10 Legend Box

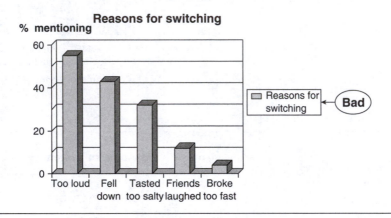

You don't need a legend. The reader can see what the bars mean without it. Notice how much bigger the bars and scale become. It's far easier to read this graph with no legend, than the version with a legend (see **Figure 10.11**).

Figure 10.11 No Legend Box

Figure 10.12 Too Many Grid Lines

Figure 10.13 Good: Few Grid Lines

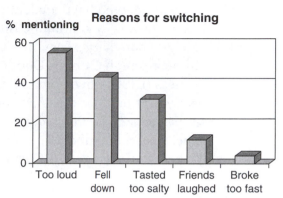

Tip ✓ Reduce the number of intervals on the *y*-axis. If you don't need to show 0 to 100 by intervals of 10 (0, 10, 20, 30, etc.), reduce it to intervals of 20 (0, 20, 40, 60).

The graph in Figure 10.12 has too many grid lines. By raising the interval between grid lines from 10 to 20 as in Figure 10.13, you make the slide cleaner and easier to read.

Tip ✓ When your *x*-axis labels are longer than seven to 10 characters, set them on a raked diagonal plane, or even better, use a horizontal format bar chart as in Figure 10.14.

Figure 10.14 Horizontal *y*-Axis Labels

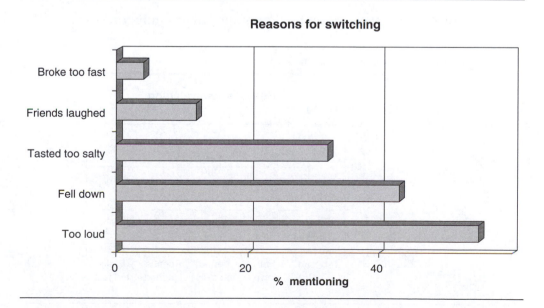

To 3-D or not to 3-D? That is the question

Readers who have a talent and liking for the quantitative side of life (engineers, accountants, financial analysts, and actuaries) really hate 3-D bar charts. They don't trust them. This type of person usually scores high C on his Dominance Influence Steadiness conscientiousness (DISC) (loves precision, follows rules, fears criticism). You'll hear your quant-jock readers complain: *"Where am I supposed to look to see the value? The front edge of the bar, or the back edge?"* When you expect a good number of quantitative, high-C types in your audience, it's best to flatten your 3-D charts.

Figure 10.15 Freaks Out Quant-Jocks **Figure 10.16** Quant-Jocks Like 2-D

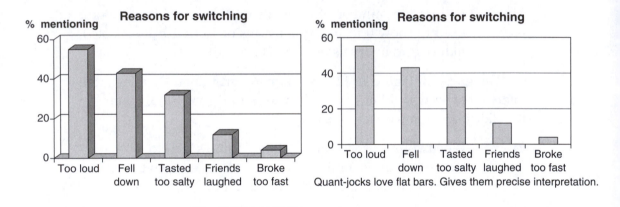

Quant-jocks love flat bars. Gives them precise interpretation.

Tip ✓ Put the data on the top of the bars as in Figure 10.17.

Figure 10.17 Data on Top of Bars

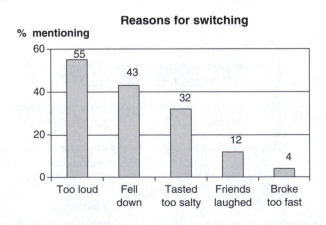

Graphs that deceive

When you make an x/y graph, either bar or line, you must design it carefully, or you may distort the data, misleading your reader. The x-axis must be longer than the y-axis, about one third longer. The ratio is 0.75. The y-axis should be three units, and the x-axis four units, like a typical television screen.

For example, the chart in Figure 10.18 is drawn with the y-axis higher than the x-axis is wide. Looks okay, but it is over-selling the rate of growth.

When the graph is drawn honestly, it looks like the graph below. It shows a less dramatic growth. Both charts were built using the same data. Only the shape of the chart is different. The honest chart is drawn in landscape, the deceptive chart in portrait.

Figure 10.18 Dishonest—Growth Distorted

Figure 10.19 Honest Graph

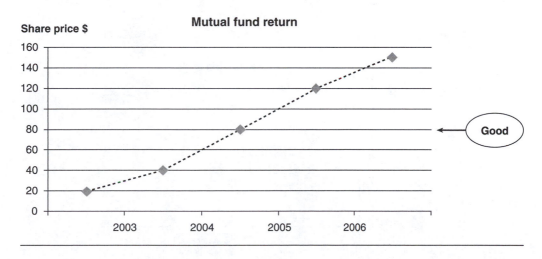

Models— Perceptual Maps

Figure 10.20 shows a poorly drawn perceptual map. Notice how the *abscissa* (*x*-axis) is longer than the *ordinate* (*y*-axis). It distorts the data, moving things to the right.

Figure 10.20 Distorted Map

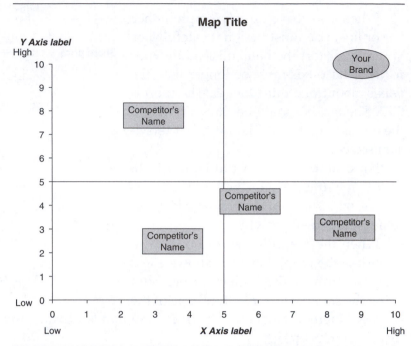

Figure 10.21 shows a well-drawn perceptual map. It's nice and square.

Figure 10.21 Accurate Map

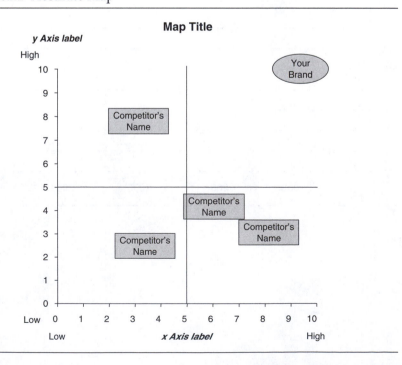

Tip ✓ When you want the quant-snobs in your audience to back off, call your *x*-axis the *abscissa* and the *y*-axis the *ordinate*. By correctly using these arcane and highly sophisticated terms, you'll be considered a member of the quant-snob club, and they might not pick on you.

Tip ✓ You want to move your product to the upper right.

Tip ✓ If a cheap price is good, reverse the scale, so a small number gets a big value.

- Keep them perfectly square.
- Each of the four quadrants should be the same size and square.
- The ideal area is the upper right.

Choose your software carefully

The most popular software has been designed for specific applications. If you try to use PowerPoint, for example, to build a graph of a large data set, you'll find that it's hard to enter and then manipulate the data. Entering your data in Excel and then pasting it into PowerPoint is much easier, and gives you more analysis options. On the other hand, if you try to use Excel to make your graphs, you'll find it harder than if you used PowerPoint. PowerPoint makes beautiful graphs easily. (See **Table 10.3 or Table 10.4—Picking the Right Software for the Job**; it's a handy reference for picking the best software for your requirements.)

Table 10.3 Picking the Right Software for the Job

Software	Good Uses	Rotten Uses
Word	Writing textFormatting textProducing tablesCreating reports (especially containing objects created in PowerPoint)	Creating figuresMaking chartsAnalyzing dataDoing calculations
Excel	Recording dataPerforming calculations	Making tablesDrawing perceptual mapsCreating graphs
PowerPoint	Making figuresMaking perceptual mapsCreating graphsDrawing organizational chartsDrawing process charts	Recording data **Tip** ✓ To make a graph with lots of date, first put the data in Excel and then paste into PowerPoint

Chapter 10 Summary

Communicating With Tables, Graphs, and Charts: Your Visual Toolbox

Key Ideas

🗝 Tables, graphs, and charts make your documents easier to read. These communication tools are also *thinking* and *analysis tools.* They will make creating and writing your report easier. Designing tables and graphs is an important part of analysis.

Communicator's Checklist

Building a table

❑ The *factors* (competitors) go in the rows.

❑ The *variables* (measurement) (product quality, market share, geographic markets, strengths, weaknesses) go in the columns.

❑ The *values* go in the cells (percentage of market share; number of states with 30 percent or higher share; brief text on strengths and weaknesses).

❑ **Charts and Graphs** Your audience should understand your graph within 3 to 5 seconds. Use only the slide elements that you need, and no more. Before you add anything to your slide, ask yourself: "Is this going to add information, or noise?"

Label graphs fully: x-axis, y-axis, pie wedges, and title. Give your data source.

Bar charts—The most commonly used charts. Bars are great for making a comparison and for showing differences between two *factors.*

Line charts—Excellent for showing change over time; for example, financial data are best shown in line graphs. Use line charts when you have multiple observations over time.

Pie charts—Pie charts are rarely used, because they show the relative magnitude of all component parts of a complete set or universe. Unless you have a complete set, use a bar or line chart.

Put the most important wedge at the top of the pie. Limit wedges to five or fewer. Rotate the pie so it stands up straight, only slightly leaning backward.

Chart-making tips

❑ Use the same color for each variable, unless you want to point out a bar.

❑ Make all text horizontal, including the vertical y-axis's label.

❑ Don't use a legend.

❑ Reduce the number of intervals on the y-axis.

❑ When your x-axis labels are longer than seven to 10 characters, set them on a raked, diagonal plane; even better, use a horizontal format bar chart.

❑ Engineers, accountants, financial analysts, and actuaries really hate 3-D bar charts. They don't trust them.

❑ Put the data on the top of the bars.

❑ The x-axis must be longer than the y-axis, about one third longer.
 • The ratio is 0.75.
 • The y-axis should be three units.
 • The x-axis should be four units.
 • A good bar chart looks like a typical television screen.

❑ **Models**—Keep perceptual maps perfectly square. Each of the four quadrants should be the same size, and square.

The ideal area is the upper right. You want to move your product to the upper right.

If a cheap price is good, reverse the scale. In this case, a small number gets a big value.

Picking the right software for the job

Table 10.4 Picking the Right Software for the Job

Software	Good Uses	Rotten Uses
Word	• Writing text • Formatting text • Producing tables • Creating reports (especially containing objects created in PowerPoint)	• Creating figures • Making charts • Analyzing data • Doing calculations
Excel	• Recording data • Performing calculations	• Making tables • Drawing perceptual maps • Creating graphs
PowerPoint	• Making figures • Making perceptual maps • Creating graphs • Drawing organizational charts • Drawing process charts	• Recording data **Tip** ✓ To make a graph with lots of data, first put the data in Excel and then paste into PowerPoint

11

Maximum PowerPoint

You must have visual support in your presentations. People really do think that "seeing is believing." If you don't have the opportunity to prepare projectable illustrations, have a teammate write what you're saying (key words and figures) on a blackboard, on a tearsheet, or on a blank overhead transparency—or write it yourself.

Pictures of numbers are vastly better communicators than digits, even with quantitatively oriented audiences. Show a picture of those numbers—for example, a pie chart or a big guy standing next to a little guy (see **Chapter 10—Communicating With Tables, Graphs, and Charts:** *Your Visual Toolbox*).

Key—If numbers are important to your presentation—show the numbers (overhead, card, tearsheet). Don't just say it. People don't hear and remember numbers accurately.

Type Size

Make sure that your visual is readable from the back of the room. Often, this is where the decision makers sit, so use at least 18- to 24-point type—or bigger. The bigger the point size, the bigger the type.

This is an example of 18-point type

The smallest size you can use on a slide.

This is an example of 24-point type

A better size for bulleted text.

Typestyle

Use proportional serif type. The text you're reading now is written in proportional serif type. (For more on this topic, and for examples of serif and sans serif type, see **Chapter 9—Writing E-mails and Memos With High Communication Factor.**) Because PowerPoint slides contain few words (see "how much information to put on a slide," below), if you prefer, use a sans serif type (Arial, Helvetica).

Keep punctuation to a minimum

For maximum readability, avoid projecting punctuation marks or expressions with details that are hard to see. These small elements look like noisy flyspecks:

- Slashes, e.g., "black/white"
- Parenthetical expressions separated by an em dash, i.e., "is definitely—hypothetically speaking"
- Exclamation points! These look like the letter "I" when projected.

How much information to put on a slide

There are no firm rules on how much data to put on a slide. But here is a good rule of thumb: Use a maximum of seven words per line and five lines per page.

Rule—Only seven *chunks* on a slide. A *chunk* is a visual element: the header, a bullet point line of text, and your logo bug in the lower corner; a graph's elements count as chunks: bars, axis values, axis labels.

Communicating with color

Advertising research shows that a full-color ad draws twice as many readers as the same ad in black and white (Ogilvy, 1985). For the

greatest readability when using color, make the background blue, and the foreground (letters, lines, and symbols) white. Use red only as an accent color (see **Table 11.1—Using Color to Increase Readability**).

The magic of color—how it works

Blue's wavelength falls just before and just behind the human eye's focal plane. As a result, the color blue looks a bit out of focus to us. Notice how blue things appear a bit softer to the eye than other colors. Blue makes the perfect background in which to nest letters. The light waves of white objects, on the other hand, fall perfectly within our focal plane. White things look sharp. When you put sharp white letters and numbers on a soft blue field, the characters jump off the screen.

Blue's the favorite color—Polls say that most people pick blue as their favorite color, so using blue as your background is a good choice. Since the background is the largest element in your slide, you're giving viewers lots of their favorite color.

Presenting with visuals

Don't let your visuals upstage you. When talking about the visual's data or words, point or turn three quarters around and look at the screen with your audience. Give your audience a clear line of sight to the visual: Don't block their view.

Tip ✓ Show the audience a minimum amount of *Butt Meat*.

Rehearse your visuals—Become comfortable and skilled in handling visuals. If you can, rehearse in the same room where you will be making the presentation.

Table 11.1 Using Color to Increase Readability

Slide Element	Recommended Color
Background	Blue
Foreground (Letters & Numbers)	White
Accent	Color Red

Certain colors work well with our eye's physiology and our mind's psychology to communicate better.

When to hand out materials

The old school of presentation is all about controlling the pace, rate, and order in which the audience receives information. Most communication trainers insist that you show a visual just when you're ready to talk about it. They are concerned that the audience will stop listening to you because the reading material—including handouts, brochures, projected slides, and props—distracts them. Did you ever have an old-school professor who lectured while standing next to an overhead projector? Did he keep the transparency covered with a piece of paper and slowly slide the paper down, revealing the text one line at a time? Did it drive you crazy? Today, that professor uses the PowerPoint animation feature that reveals text one line at a time. If his slide has five bullet points, he'll push the button five times to show them all. He's still driving some of his audience crazy, but this time with more advanced technology.

Let your audience self-feed the information—I recommend the latest thinking in regulating the flow of information. Different people have different needs for getting information. Some people read more quickly than others. Some parts of the presentation will be more interesting and will require more study than other parts. For example, your financial people may linger over the spreadsheets, while marketing people like connect-the-dots and coloring sections (just kidding). Remain flexible and let your audience consume the information at their own pace. If they want to jump ahead, or return to earlier parts of the presentation, I suggest you do this. This presentation strategy returns control to the audience. Your listeners will feel more confident and in control. Thus, they will be more able to accept your ideas. The *Nichols' Two-Things* message packaging technique your learned in **Chapter 7— Message Packaging—Strategies for Formatting Presentations:** *How You Say It* lets you put the audience in control of the information. You can ask your audience, "Two major ideas are driving this: Idea A and Idea B. Which would you like to start with?" When you restrict the flow of information, you take away their sense of power and control. Managers like power. Give it to them. In return, they'll support your ideas, and like your presentation style.

Technique—Does it bother you if your audience reads your handout while you're presenting instead of paying total attention to you? It bothers most other speakers, too. To keep your audience from thumbing through your handout during your presentation, try this: At the beginning of your presentation, say, "You've got a 10-page handout.

Will you please look through it and make sure that you have all 10 pages? If not, let me know and I'll get you a complete copy." Your audience will do as you ask; they'll thumb through each page and let you know if they have a complete copy. You've also sated their need to sneak peeks at the handout throughout your presentation. This stops the *thumbers* every time.

Sample presentation visuals

Most presentations will have a minimum of four slides, containing the following information:

1. Title slide
 - Presentation's title or topic
 - Team name, if any
 - Participants

2. *Statement of Purpose*

 Short statement of what you want your audience to believe at the end of your presentation.

3. *Big Messages*

4. Outline of presentation; key points

 This major part may require several slides.

Bullets are great—use them

Structure your presentation using bullets.

Note on using numbers or bullets—If there is a numbered sequence of steps or a ranked hierarchy, use numbers to order your key words. If there is no natural hierarchy, and therefore no meaning to the numbers, use bullets. Typically, you will use more bullets than numbers on your slides.

If there is a written report accompanying your presentation, the key words may be similar or identical to the subheads in your report. This shows your audience the logical flow of the presentation.

Tip ✓ Here's an efficient way make visuals for an oral presentation of your written report. First, read your report looking for key phrases, subheads, and short sections that summarize

or capture your ideas. Mark them with a yellow highlighter. Then, using your word processor, edit out the extraneous text, leaving the keywords or phrases. You will find that you have highlighted the essence of a good presentation.

Chapter 11 Summary

Maximum PowerPoint

Key Ideas

Pictures of numbers are vastly better than digits, so show a picture of the number you are reporting (on an overhead, card, or tearsheet).

Communicator's Checklist

❑ Use at least 18- to 24-point type (or bigger).

❑ Use proportional serif type.

Keep punctuation to a minimum

❑ Slashes, i.e., "black/white"

❑ Parenthetical expressions should be separated by an em dash, e.g., "is definitely—hypothetically speaking"

❑ Exclamation points! Look like the letter "I" when projected.

❑ Use a maximum of seven words per line and five lines per page.

❑ **Rule:** Only seven *chunks* on a slide.

❑ Make the background blue and the foreground (letters, lines, symbols) white. Use red only as an accent color.

Presenting with visuals

❑ When you are talking about the visual's data and/or words, point or turn three quarters around and look at the screen with your audience.

❑ Give your audience a clear line of sight to the visual. Don't block their view.

❑ Keep the amount of *Butt Meat* you show the audience to a minimum.

❑ Rehearse your visuals. Become comfortable and skilled in handling visuals.

PowerPoint Slide Editing

Text slides

Checklist

❑ Resize bullets (**Command:** Insert; symbols; Wingdings; 65%; select a big dot or a small square).

❑ Resize and bold subheads and bullets to match text.

❑ Organize all the visual elements to maximize the balance with white space. Use white space to lead your readers' eyes through your slide.

Graphs

Checklist

❑ Eliminate the legend—use text boxes instead.

❑ Reduce the grid lines by increasing the interval between axis labels.

❑ Use text boxes to create axis labels, not the PowerPoint data table.

❑ Use text boxes to create the header, not the PowerPoint graph.

❑ As you consider each visual element, e.g., grid lines, value labels, text, and arrows, ask yourself: "Is this element adding information, or noise?"

Test: Your readers or listeners should be able to comprehend your slide in 3 seconds.

Remember: Simple is good.

Demonstration: PowerPoint Slide Editing

Pages 260 through 265 contain some examples of typical slides created by graduate and undergraduate students at DePaul University's College of Commerce before they learned slide design techniques. On the left side you will see a slide with common errors; on the right you'll see an improved version with the recommended formatting techniques applied. At the bottom you can read a narrative of the steps I took to transform the slides.

Avoid special effects—After studying this section, I hope you take away a sense of how much time and attention to detail are necessary to produce easy-to-read PowerPoint slides. Making simple, readable text and graphs can easily take hours of effort. You don't have time to both maximize your slides' readability and include clip art, pictures, and clever screen effects (wipes, dissolves, etc.). Give yourself lots of time to edit. Good visual communication is the product of time, effort, and iteration.

The dear Dilberts at Microsoft—creators of PowerPoint's default slides, graphs, and backgrounds—are certainly geniuses at software, but they don't know beans about readability. So you can't use the slides that first appear on your screen and run with them. To make them readable, you have to do some serious editing.

Given the pressure cooker atmosphere most of us work in, I recommend focusing your efforts on an essential editing task: cutting out all but the most essential words.

Hint—Cut out excess conjunctions (and, but) and prepositions (of, through, with).

After

Who is Wile E. Coyote?
Dirty South Presentation Team

Host:
Dirk Spindler

Presenters:

Dr. Dana Fredrichs Jr.
Dr. Peg Yun

Lucy:
Del Revener

After

Before

Who is Wile Coyote

Dirty South Presentation Team

Host:
Dirk Spindler

Presenters:
Dr. Dana Fredrichs Jr.
Dr. Peg Yun

Lucy:
Del Revener

Before

Joel's editing log

- Centered the title; increased the point size for both the title & the team name from 28 pt to 44 pt.
- Proofreading: added "?" to title line and E. to middle name of Wile Coyote.
- Increased text's pt. size from 18 pt to 32 pt.
- Changed text color from blue to black.

After

Who is Wile E. Coyote?

Dumb as a Box of Rocks

Plans never work

- **Stupid blueprints**

- **Never gets the road runner**

Dirty South Presentation Team

Before

Who is Wile Coyote

Dumb as a Box of Rocks

Plans Never Work
- stupid blueprints
- never gets the road runner

Runs Into Walls
- paints the tunnel on the wall.
- goes splat

Joel's editing log

- Reduced 9 chunks of information to 5 chunks; arranging copy on two slides rather than one.

 Note: maximum chunks allowed per slide = 7.

- Reversed type (changed blue type on white to white type on blue background).

- Increased header text's pt. size from 24 pt to 48 pt.

- Increased bulleted text's pt. size from 24 pt to 32 pt.

- Put all bulleted text all on one line.

- Changed bullets to Wingding 65%.

257

Before

Struttin' with Style & Sex appeal

- **Stylish Impressions**
- **Attractive to the opposite sex**

Before

After

Struttin' with style & sex appeal

- Stylish impressions
- Attractive to the opposite sex

After

Joel's editing log

- Increased header text's pt. size from 32 pt to 54 pt.

- Because of larger typeface, broke header to two lines; made break at conjunction: "&."

- Changed "style" and "sex appeal" to lowercase.

- Because the amount of text is small, and there was lots of white space, I increased the bulleted text's pt size from 32 pt to 44 pt.

- Turned off bold on bulleted text.

- Changed bullets to Wingding 65%.

- Increased indent from bullet to text.

258

Road Runner vs. Coyote

You'll hear

- Why the chase?
- A deeper look at that wiry, fuzzy Coyote

After

Road Runner vs. Coyote

We will discuss:

1) Why are they always chasing one another?
2) Deeper look into that Wirey & Fuzzy Coyote

Before

Joel's editing log

- Reduced header text's pt. size from 66 pt to 54 pt to fit on one line.
- Dropped colon ":" from subhead — too noisy.
- Dropped "shadowed text." (not shown) — too busy.
- Edited copy: Changed "We will discuss" to "You'll hear" to put the wording into the audience's frame.
- Corrected spelling: wirey to wiry

- Cut copy to fit on one line.
- Changed numbers to bullets; use numbers for ranking or ordering only.
- Used white lettering for readability (not shown: slide used yellow letters). **Hint:** Use yellow & red as accent **only.**

259

Makes the world frown

Before

Makes the world frown

- AWFUL SMELL

- Retain moisture
- Bacteria develops

- DIRTY

- Collects grime

- Only article of clothing that you never wash

After

Makes the world frown

Awful smell
- Retain moisture
- Bacteria develops

Dirty
- Collects grime
- Only clothing you never wash

Joel's editing log

- Kept plain white background with black letters.
- Centered and bolded header.
- Increased header text's pt. size from 44 pt to 60 pt
- Changed subheads from upper to title case (upper and lower).
- Bolded subheads and dropped bullet (never used here).
- Changed bullets from side-by-side to vertical format. (This format allowed the text to be on one line. Try to avoid using more than one line.)
- Dropped "article of." (**Hint:** Look for excessive use of prepositions and conjuctions, cut from copy.)

Number of Times Smashed Per Year

Before

Times Smashed Per Year

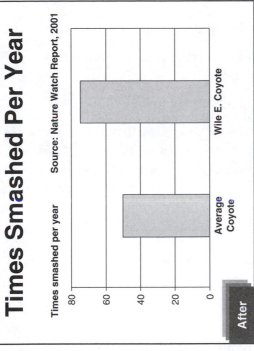

After

Joel's editing log

- Edited header copy to fit together on one line.

- Changed header typeface to black (was yellow).

- Changed axis labels from a vertical to horizontal format. Never use vertical text (too hard to read quickly).

- Dropped x-axis label "Coyote Comparison" — redundant.

- Reduced number of horizontal grid lines, lowered noise.

- Removed object depth on the bars, and floor depth of the grid. I love 3-D graphics, but quant-jocks, i.e., engineers and finance/accounting types, hate it (High "C" on DISC). Complain they can't tell exactly where bar is on the grid.

- Added "Source." You **must** cite a source for data.

Text slides

Checklist

❑ Resize bullets (**Command:** Insert; symbols; Wingdings; 65%; select a big dot or small square).

❑ Resize and bold subheads and bullets to text.

❑ Check all the visual elements on your slide to make sure that they are surrounded by the right amount of white space. Look at the top, bottom, left, and right margins. Look at the space between each chunk. Use white space to make each chunk stand out in relationship to, and with, every other chunk. You want to lead your readers' eyes through your slide.

When people first look at a slide they look at

1. Big elements

2. Bolded elements

3. Elements surrounded by the most white space

Show your listeners where on your slides they should look first. If every element on your slide is the same size, has the same bolding, and is surrounded by the same amount of white space, they won't know where to look first. They will have to make an effort to find a starting place.

On graphs

Checklist

❑ Eliminate the legend—use text boxes instead.

❑ Reduce the grid lines by increasing the interval between axis labels.

❑ Use text boxes to create axis labels, not the PowerPoint data table.

❑ Use text boxes to create the header, not the PowerPoint graph.

❑ As you consider each visual element, e.g., grid lines, value labels, text, and arrows, ask yourself if this element is adding information or noise. Test: Your reader or listener should be able to comprehend your slide in *3 seconds.*

Remember: *Simple is good.*

Appendix

If You'd Like to Learn More

Recommended Reading

Bettger, Frank. (1986). *How I raised myself from failure to success in selling.* New York: Prentice Hall.

Carnegie, Dale. (1981). *How to win friends and influence people.* New York: Simon & Schuster.

Cialdini, Robert. (2001). *Influence: Science and practice*, 4th ed. Needham Heights, MA: Allyn & Bacon.

Craig, James & William Bevington. (1999). *Designing with type.* New York: Watson-Guptill.

Duncan, Tom and Sandra Moriarity. (2001). *How to create and deliver winning advertising presentations.* Chicago: Crain Books.

Kato, Hiroki and Joan Kato. (1992). *Understanding and working with the Japanese business world.* Englewood Cliffs, NJ: Prentice Hall.

Littlejohn, Stephen W. (2004). *Theories of human communication*, 6th ed. Belmont. CA: Wadsworth.

McCormack, Mark H. (1984). *What they don't teach you at Harvard Business School: Notes from a street-smart executive.* New York: Bantam Books.

Ogilvy, David. (1985). *Ogilvy on advertising.* New York: Vintage Books.

Tufte, Edward R. (1990). *Envisioning information.* Cheshire, CT: Graphics Press.

Tufte, Edward R. (2001). *The visual display of quantitative information*, 2nd ed. Cheshire, CT: Graphics Press.

Take these training courses

Dale Carnegie & Human Relations, www.dalecarnegie.com/

Toastmasters International, www.toastmasters.org/

References

Abram, S. (2004). PowerPoint: Devil in a red dress. *Information Outlook, 8*, 27–28.

Almer, E. D., Hopper, J. R., & Kaplan, S. E. (2003). A research tool to increase attention to experimental materials: Manipulating presentation format. *Journal of Business and Psychology, 17*, 405–418.

Andersen, K. & Clevenger, T., Jr. (1963). Summary of experimental research in ethos. *Speech Monographs, 30*, 59–78.

Annett, J. M. & Leslie, J. C. (1996). Effects of visual and verbal interference tasks on olfactory memory: The role of task complexity. *British Journal of Psychology, 87*, 447–458.

Arditi, A. (2006). Making text legible—Designing for people with partial sight. Retrieved April 1, 2006, from http://www.visionconnection .org/Content/Technology/ForDesignProfessionals/MakingText Legible.htm

Aronson, E. & Burton, W. G. (1962). The effect of relevant and irrelevant aspects of communicator credibility on opinion change. *Journal of Personality, 30*, 135–146.

Baddeley, A. D. (1992). Working memory. *Science, 255*, 556–559.

Baker, M. J. & Churchill, G. A., Jr. (1977). The impact of physically attractive models on advertising evaluations. *Journal of Marketing Research, 14*, 538–555.

Bator, R. J. & Cialdini, R. B. (2000). The application of persuasion theory to the development of effective pro-environmental public service announcements. *Journal of Social Issues, 56*, 527–541.

Bell, G. D. (1967). Self-confidence and persuasion in car buying. *Journal of Marketing Research, 4*, 46–52.

Bem, D. J. (1972). Self-perception theory. In L. Berkowitz (Ed.), *Advances in Experimental Social Psychology*, Vol. 6 (pp. 1–62). New York: Academic Press.

Berlo, D. K., Lemert, J. B., & Mertz, R. J. (1969–1970). Dimensions for evaluating the accepability of message sources. *Public Opinion Quarterly, 33*, 563–576.

Berscheid, E. & Walster, E. (1974). Physical attractiveness. In L. Berkowitz (Ed.), *Advances in Experimental Social Psychology*, Vol. 7 (pp. 157–215). New York: Academic Press.

Bettger, F. (1986). *How I raised myself from failure to success in selling.* New York: Prentice Hall.

Bither, S. W. & Wright, P. L. (1971). The effect of distraction and self-esteem on mass media persuasibility. *Pennsylvania State University Working Series in Marketing Research,* January.

Block, P. (2002). *The answer to how is yes.* San Francisco: Berrett-Koehler.

Bloom, P. N. (1984). Effective marketing for professional services. *Harvard Business Review, Sept.–Oct.,* 202–210.

Bly, R. W. (2001). The case against PowerPoint. *Successful Meetings, 50,* 51–52.

Bone, P., Fitzgerald, E., Scholder, P., Easley, R. W., & McNeely, S. E. (1986). A comment on "relationship between source expertise and source similarity in an advertising context." *Journal of Advertising, 15,* 47–48.

Boyer, G. B. (1985). *Elegance: A guide to quality in menswear.* New York: W. W. Norton.

Brandon, K. (1994). We may reach out. But we don't touch much. *Chicago, Tribune,* September 25, sec. 1.1, 20.

Bridges, W. (2003). *Managing transitions,* 2nd ed. Cambridge, MA: Da Capo Press.

Brooks, P. & Zank, H. (2005). Loss-averse behavior. *Journal of Risk and Uncertainty, 31,* 301–325.

Cahill, L., Babinsky, R., Markowitsch, H. J., & McGaugh, J. L. (1995). Amygdala and emotional memory. *Nature, 377,* 295–296.

Carnegie, D. (1981). *How to win friends and influence people.* New York: Simon & Schuster.

Chaiken, S. (1979). Communicator physical attractiveness and persuasion. *Journal of Personality and Social Psychology, 37,* 1387–1397.

Chaiken, S. (1980). Heuristics versus systematic information processing and the use of source versus message cues in persuasion. *Journal of Personality and Social Psychology, 39,* 752–766.

Chaiken, S. & Eagly, A. H. (1976). Communication modality as a determinant of message persuasiveness and message comprehensibility. *Journal of Personality and Social Psychology, 34,* 605–614.

Chaiken, S. & Eagly, A. H. (1983). Communication modality as a determinant of persuasion: The role of communicator salience. *Journal of Personality and Social Psychology, 45,* 241–256.

Cialdini, R. (1989). *Persuasion and Ethics.* New York: Quill Press.

Cialdini, R. (1990). *Influence: The new psychology of modern persuasion.* New York: Quill Press.

Cialdini, R. (1993). *Influence: The psychology of persuasion.* New York: Quill Press.

Cialdini, R. B. (2001a). The science of persuasion. *Scientific American, 284,* 76–81.

Cialdini, R. B. (2001b). Harnessing the science of persuasion. *Harvard Business Review, 79,* 72–79.

Cialdini, R. B. (2001c). *Influence: Science and practice,* 4th ed. Boston: Allyn & Bacon.

Cialdini, R. B., Perry, R. E., & Cacioppo, J. T. (1981). Attitude and attitude change. *Annual Review of Psychology, 32,* 357–404.

Cialdini, R. B., Wosinska, W., Barrett, D. W., Butner, J., & Gornik-Durose, M. (1999). Compliance with a request in two cultures: The differential influence of social proof and commitment/consistency on collectivists

and individualists. *Personality and Social Psychology Bulletin, 25,* 1242–1253.

Clevenger, T., Jr., Lazier, J. T., Clark, G. A., & Leitner, M. (1965). Measurement of corporate images by semantic differential. *Journal of Marketing Research, 1,* 80–82.

Cohen, A. R. (1959). Some implications of self-esteem for social influence. In C. I. Hovland & I. L. Janis (Eds.), *Personality and persuasibility* (pp. 102–120). New Haven, CT: Yale University Press.

Cooper, J. & Croyle, R. T. (1984). Attitude and attitude change. *Annual Review of Psychology, 35,* 395–426.

Covey, S. R. (1989). *The 7 habits of highly effective people.* New York: Simon & Schuster.

Craig, J. (1980). *Designing with type.* New York: Watson-Guptill.

Craig, J. & Bevington, W. (1999). *Designing with type.* New York: Watson-Guptill.

Cronkhite, G. & Liska, J. (1976). A critique of factor analytic approaches to the study of credibility. *Communication Monographs, 43,* 91–107.

Csikszentmihalyi, M. (1996). *Creativity.* New York: HarperCollins.

Cyphert, D. (2004). The problem of PowerPoint: Visual aid or visual rhetoric? *Business Communication Quarterly, 67,* 80–84.

Dance, F. E. X. (1970). The concept of communication. *Journal of Communication, 20,* 204–208.

Deaux, K. (1972). Anticipatory attitude change: A direct test of the self-esteem hypothesis. *Journal of Experimental Social Psychology, 8,* 143–155.

Delia, J. G. (1976). A constructivist analysis of the concept of credibility. *Quarterly Journal of Speech, 62,* 364–374.

Delia, J. G. (1977). Contructivism and the study of human communication. *Quarterly Journal of Speech, 63,* 66–83.

Dholakia, R. R. & Sternthal, B. (1977). Highly credible sources: Persuasive facilitators of persuasive liabilities? *Journal of Consumer Research, 3,* 223–232.

Dinner, S. H., Lewkowicz, B. E., & Cooper, J. (1972). Anticipatory attitude change as a function of self-esteem and issue familiarity. *Journal of Personality and Social Psychology, 24,* 407–412.

Duncan, T. & Moriarty, S. (2001). *How to create and deliver winning advertising presentations.* Chicago: Crain Books.

Eagly, A. H. (1967). Involvement as a determinant of response to favorable and unfavorable information. *Journal of Personality and Social Psychology, 7,* 1–14.

Eagly, A. H. (1969). Sex differences in the relationship between self-esteem and susceptibility to social influence. *Journal of Personality, 37,* 581–591.

Eagly, A. H. (1981). Recipient characteristics as determinants of responses to persuasion. In R. E. Petty, T. M. Ostrom, & T. C. Brock (Eds.), *Cognitive responses in persuasion* (pp. 173–195). Mahwah, NJ: Lawrence Erlbaum Associates, Inc.

Eagly, A. H. & Chaiken, S. (1975). An attribution analysis of the effect of communicator characteristics on opinion change: The case of communicator attractiveness. *Journal of Personality and Social Psychology, 32,* 136–144.

Eagly, A. H. & Chaiken, S. (1976). Why would anyone say that? Causal attribution of statements about the Watergate scandal. *Sociometry, 39,* 236–243.

Eagly, A. H. & Whitehead, G. I., III. (1972). Effect of choice on receptivity to favorable and unfavorable evaluations of oneself. *Journal of Personality and Social Psychology, 22,* 223–230.

Eagly, A. H., Wood, W., & Chaiken, S. (1978). Causal inferences about communicators and their effect on opinion change. *Journal of Personality and Social Psychology, 36,* 424–435.

Festinger, L. & Carlsmith, J. M. (1959). Cognitive consequences of forced compliance. *Journal of Abnormal and Social Psychology, 58,* 203–210.

Finkelstein, E. (2004). Forty–four recommendations for enhancing PowerPoint presentations. *Sales & Marketing Management, 11,* 8–14.

Fishbein, M. & Ajzen, I. (1975). *Belief, attitude, intention, and behavior: An introduction to theory and research.* Reading, MA: Addison-Wesley.

Freese, J. (1926). *Aristotle, The 'art' of rhetoric.* London and Cambridge, MA: Loeb Classical Library, Harvard University Press.

Friedman, H. H. & Friedman, L. (1979). Endorser effectiveness by product type. *Journal of Advertising Research, 19,* 63–71.

Gallese, V. & Goldman, A. (1998). Mirror neurons and the simulation theory of mind-reading. *Trends in Cognitive Science, 2,* 493–501.

Ganzel, R. (2000). PowerPoint: What's wrong with it? Power pointless. *Presentations, Feb.,* 53–58.

Geisler, C., Bazerman, C., Doheny-Farina, S., Gurak, L. J., Haas, C., Johnson-Eilola, J., Lunsford, A., Miller, C., Winsor, D., & Yates, J. A. (2001). IText: Future directions for research on the relationship between information technology and writing. *Journal of Business and Technical Communication, 15,* 269–308.

Gendlin, E. (1976). *Let your body interpret your dreams.* Wilmette, IL: Chiron Publications.

Gendlin, E. (1978). *Focusing.* New York: Bantam Books.

Gershon, M. (1999). *The second brain.* New York: HarperCollins.

Giller, E., Jr., Perry, B., Southwick, S., Yehuda, R., Wahby, V., Kosten, T., & Mason, J. (1990). Psychoendocrinology of post-traumatic stress disorder. In M. Wolf & A. Mosnaim (Eds.), *Post-traumatic stress disorder: Etiology, phenomenology, and treatment* (pp. 158–170). Washington, DC: American Psychiatric Press, Inc.

Golden, L. L. (1977). Attribution theory implications for advertisement claim credibility. *Journal of Marketing Research, 14,* 115–117.

Goldman, D. (1995). *Emotional intelligence.* New York: Bantam Books.

Goldman, D. (1998). *Working with emotional intelligence.* New York: Bantam Books.

Greenberg, B. S. & Miller, G. R. (1965). The effects of low-credible sources on message acceptance. *Speech Monographs, 33,* 127–136.

Haiman, F. S. (1949). An experimental study of the effects of ethos in public speaking. *Speech Mongraphs, 16,* 190–202.

Harvey, J. H. & Weary, G. (1984). Current issues in attribution theory and research. *Annual Review Psychology, 35,* 427–459.

Heider, F. (1944). Social perception and phenomenal causality. *Psychological Review, 51,* 358–374.

Heider, F. (1958). *The psychology of interpersonal relations.* New York: Wiley and Sons Publishing.

Hovland, C. I., Janis, I. L., & Kelley, H. H. (1966). *Communication and Persuasion*. New Haven, CT: Yale University Press.

Hovland, C. I. & Weiss, W. (1951). The influence of source credibility on communication effectiveness. *Public Opinion Quarterly, 15*, 635–650.

Infante, D. A. & Fisher, J. Y. (1978). Anticipated credibility and message strategy intentions as predictors of trait and state speech anxiety. *Central State Speech Journal, 29*, 1–10.

Jaccard, J. (1981). Toward theories of persuasion and belief change. *Journal of Personality and Social Psychology, 40*, 260–269.

Janis, I. L. (1954). Personality correlates of susceptibility to persuasion. *Journal of Personality, 22*, 504–518.

Janis, I. L. (1955). Anxiety indices related to susceptibility to persuasion. *Journal of Abnormal and Social Psychology, 51*, 663–667.

Janis, I. L. & Field, P. B. (1959). Sex differences and personality factors related to persuasibility. In C. I. Hovland & I. L. Janis (Eds.), *Personality and persuasibility* (pp. 55–68). New Haven, CT: Yale University Press.

Janis, I. L. & Rife, D. (1959). Persuasibility and emotional disorder. In C. I. Hovland & I. L. Janis (Eds.), *Personality and Persuasibility* (pp. 121–137). New Haven, CT: Yale University Press.

Jones, E. E. & Davis, K. E. (1965). From acts to dispositions: The attribution process in person perception. In L. Berkowitz (Ed.), *Advanced experimental social psychology*, Vol. 2 (pp. 219–265). New York: Academic Press.

Kahneman, D. & Tversky, A. (1979). Prospect theory: An analysis of decision under risk. *Econometrica, 47*, 263–292.

Kalin, N. H. (1997). The neurobiology of fear: Mysteries of the mind. *Scientific American Special Issue*, 76–83.

Kaplan, S. J. (1976). Attribution processes in the evaluation of message sources. *Western Speech Communication, 40*, 189–195.

Kaplan, S. J. & Sharp, H. W., Jr. (1974). The effect of responsibility attributions on message source evaluation. *Speech Monographs, 41*, 364–370.

Kato, H. & Kato, J. (1992). *Understanding and working with the Japanese business world*. Englewood Cliffs, NJ: Prentice Hall.

Kelley, H. H. (1967). Attribution theory in social psychology. *Nebraska Symposium on Motivation, 14*, 192–240.

Kelley, H. H. (1973). The processes of causal attribution. *American Psychologist, 28*, 107–128.

Kelley, H. H. & Michela, J. L. (1980). Attribution theory and research. *Annual Review of Psychology, 31*, 457–501.

Kelman, H. C. (1961). Processes of opinion change. *Public Opinion Quarterly, 25*, 55–78.

Kenton, S. B. & Valentine, D. (1997). *Communicating in a multicultural workplace*. Upper Saddle River, NJ: Simon & Schuster.

Keysers, C., Kohler, E., Umilta, M., Nanetti, L., Fogassi, L., et al. (2003). Audiovisual mirror neurons and action recognition. *Experimental Brain Research, 153*, 628–663.

Kohler E., Keysers C., Umilta M., Fogassi, L., Gallese V., et al. (2002). Hearing sounds, understanding actions: Action representation in mirror neurons. *Science, 297*, 846–848.

LaGrossa, V. & Saxe, S. (1998). *The consultative approach.* San Francisco: Jossey-Bass.

Lancaster, L. C. & Stilman, D. (2002). *When generations collide.* New York: HarperCollins.

LeDoux, J. (2002) *Synaptic self.* New York: Viking.

Lenth, R.V. (2004). The cognitive style of PowerPoint. *Journal of the American Statistical Association, 99,* 569.

Lesser, G. S. & Abelson, R. P. (1959). Personality correlates of persuasibility in children. In C. I. Hovland & I. L. Janis (Eds.), *Personality and persuasibility* (pp. 187–206). New Haven: Yale University Press.

Leventhal, H. & Perloe, S. I. (1962). A relationship between self-esteem and persuasibility. *Journal of Abnormal and Social Psychology, 64,* 385–388.

Levine, M. (2001). Guide to managerial communication: Effective business writing and speaking. *Journal of Business and Technical Communication, 15,* 252–254.

Lighthouse, The, Inc. (1995). *The Lighthouse national survey on vision loss: The experience, attitudes, and knowledge of middle-aged and older Americans.* New York: The Lighthouse, Inc.

Linton, H. & Graham, E. (1959). Personality correlates of persuasibility. In C. I. Hovland & I. L. Janis (Eds.), *Personality and persuasibility* (pp. 71–101). New Haven: Yale University Press.

Liska, Jo. (1978). Situational and topical variations in credibility criteria. *Communication Monographs, 45,* 85–92.

Littlejohn. S. W. (2004). *Theories of human communication,* 6th Ed. Belmont, CA: Wadsworth.

Lumsden, D. L. (1977). An experimental study of source-message interaction in a personality impression task. *Communication Monographs, 44,* 121– 129.

Lutz, W. (1989). *Doublespeak.* New York: Harper & Row.

MacDonald, J. D. (1964). *Nightmare in pink.* New York: Fawcett.

Mahin, L. (2004). PowerPoint pedagogy. *Business Communication Quarterly, 67,* 219–222.

Mathieu-Coughlan, P. & Klein, M. H. (1984). Experiential psycho-therapy: Key events in client-therapist interaction. In L. N. Rice & L. S. Greenberger (Eds.), *Patterns of change: Intensive analysis of psychotherapy process* (pp. 213–248). New York: Guilford Press.

McArthur, L. A. (1972). The how and what of why: Some determinants and consequences of causal attribution. *Journal of Personality and Social Psychology, 22,* 171–193.

McCormack, M. H. (1984). *What they don't teach you at Harvard Business School: Notes from a street-smart executive.* New York: Bantam Books.

McCroskey, J. C. (1969). A summary of experimental research on the effects of evidence in persuasive communication. *Quarterly Journal of Speech, 55,* 169–176.

McGuinnis, E. & Ward, C. D. (1980). Better liked than right: Trustworthiness and expertise as factors in credibility. *Personality and Social Psychology Bulletin, 6,* 467–472.

McGuire, W. J. (1968). Personality and susceptibility to social influence. In E. F. Borgatta and W. W. Lambert (Eds.), *Handbook of personality theory and research* (pp. 1130–1187). Chicago: Rand McNally.

McLuhan, M. (1964). *Understanding media.* New York: McGraw-Hill.

McLuhan, M. & Fiore, Q. (1967). *The medium is the message: An inventory of effects.* New York: Bantam Books.

Meyers-Levy, J. & Malaviya, P. (1999). Consumers' processing of persuasive advertisements: An integrative framework of persuasion theories. *Journal of Marketing, 63,* 45–60.

Milgram, S. (1963). Behavioral study of obedience. *Journal of Abnormal and Social Psychology, 67,* 371–378.

Miller, G. R. & Baseheart, J. (1969). Source trustworthiness, opinionated statements, and response to persuasive communication. *Speech Monographs, 36,* 1–7.

Minick, W. C. (1968). *The art of persuasion.* Boston: Houghton Mifflin Company.

Mizerski, R. W. (1974). *Unpublished doctoral dissertation.* University of Florida.

Mizerski, R. W. (1978). Causal complexity: A measure of consumer causal attribution. *Journal of Marketing Research, 15,* 220–228.

Mizerski, R. W., Golden, L. L., & Kernan, J. B. (1979). The attribution process in consumer decision making. *Journal of Consumer Research, 6,* 123–140.

Morgan, S. E. & Reichert, T. (1999). The message is in the metaphor: Assessing the comprehension of metaphors in advertisements. *Journal of Advertising, 28,* 1–12.

Munch, J. M. & Swasy, J. L. (1980). An examination of information processing traits: General social confidence and information processing confidence. In K. Monroe (Ed.), *Advances in consumer research* (pp. 349–354). Ann Arbor, MI: Association for Consumer Research.

Nisbett, R. E. & Gordon, A. (1967). Self-esteem and susceptibility to social influence. *Journal of Personality and Social Psychology, 5,* 268–276.

Ogilvy, D. (1985). *Ogilvy on advertising.* New York: Vintage Books.

O'Keefe, R. D. & Whalen, D. J. (1988). The relationship between gender and information processing strategies: A validation study. In J. H. Summey & P. J. Hensel (Eds.), *Strategic issues in a dynamic marketing environment* (pp. 153–156). Atlanta, GA: Southern Marketing Association.

Orvis, B. R., Cunningham, J. D., & Kelley, H. H. (1975). A closer examination of causal inference: The roles of consensus, distinctiveness, and consistency information. *Journal of Personality and Social Psychology, 32,* 605–616.

Osgood, C. E. & Tannenbaum, P. H. (1955). The principle of congruity in the prediction of attitude change. *Psychology Review, 62,* 42–55.

Parkinson, T. L. (1974). *The influence of perceived risk and self-confidence on the use of neutral sources of information in consumer decision-making.* Newark, DE: Bureau of Economic and Business Research, University of Delaware.

Pathak, A. (2001). Teaching and assessing multimedia-based oral presentations. *Business Communication Quarterly, 64,* 63–71.

Petty, R. E. & Cacioppo, J. T. (1984). The effects of involvement on responses to argument quantity and quality: Central and peripheral routes to persuasion. *Journal of Personality and Social Psychology, 46,* 69–81.

Pitts, R. E. & Reidenbach, E. R. (1986). Not all CEOs are created equal as advertising spokespersons: Evaluating the effective CEO spokesperson. *Journal of Advertising, 15,* 30–46.

Pitts, R. E., Wong, J. K., & Whalen, D. J. (1990). Exploring the structure of ethical attributions as a component of the consumer decision model: The vicarious versus personal perspective. *Journal of Business Ethics, 10,* 43–51.

Plax, T. & Rosenfeld, L. B. (1980). Individual differences in the credibility and attitude change relationship. *Journal of Social Psychology, 3,* 79–89.

Post, P. (2003). *Essential manners for men: What to do, when to do it, and why.* New York: HarperCollins.

Poulton, T. (1997). *No fat chicks: How big business profits by making women hate their bodies—and how to fight back.* Secaucus, NJ: Carol Publishing Group.

Rackman, N. (1988). *Spin selling.* New York: McGraw-Hill.

Raudsepp, E. (1993). Body language speaks louder. *Machine Design, 65,* 85–88.

Reddy, R. (2003). Virtual scaffolding. *Intelligent Enterprise, 6,* 44–46.

Rizzolatti, G., Fogassi, L., & Gallese, V. (2006). Mirrors in the mind. *Scientific American, 295,* 54–61.

Robinson, D., Robinson, S., & Katayama, A. (1999). When words are represented in memory like pictures: Evidence for spatial encoding of study materials. *Contemporary Educational Psychology, 24,* 38–54.

Rosenfeld, L. B. & Plax, T. G. (1975). The relationship of listener personality to perceptions of three dimensions of credibility. *Central States Speech Journal, 26,* 274–278.

Sattler, W. M. (1947). Conceptions of ethos in ancient rhetoric. *Speech Mongraphs, 14,* 55–65.

Schaffer, R. (1998). *High-impact consulting.* San Francisco: Jossey-Bass.

Schrage, M. (2003a). PowerPoint redux. *Sales & Marketing Management, 155,* 28.

Schrage, M. (2003b). Please stop using PowerPoint to sell. *Sales & Marketing Management, 155,* 30.

Senge, P. (1990). *The fifth discipline.* New York: Currency Doubleday.

Senge, P., Kleiner, A., Roberts, C., Ross, R., Roth, G., & Smith, B. (1994). *The fifth discipline fieldbook.* New York: Currency Doubleday.

Senge, P., Kleiner, A., Roberts, C., Ross, R., Roth, G., & Smith, B. (1999). *The dance of change.* New York: Currency Doubleday.

Settle, R. B. (1972). Attribution theory and acceptance of information. *Journal of Marketing Research, 9,* 85–88.

Settle, R. B. & Alrech, P. (1984). *Why they buy: American consumers inside and out.* New York: John Wiley & Sons.

Settle, R. B., Faricy, J. H., & Warren, G. T. (1971). Consumer information processing: Attributing effects to causes. *Association for Advertising Research, Proceedings of the Annual Conference,* 278–288.

Settle, R. B. & Gibby, L. B. (1976). The measurement of attributed image. *California Management Review, 3,* 70–74.

Settle, R. B. & Golden, L. L. (1974). Attribution theory and advertiser credibility. *Journal of Marketing Research, 11,* 181–185.

Shaw, G., Brown, R., & Bromiley, P. (1998). Strategic stories: How 3M is rewriting business planning. *Harvard Business Review, 76,* 41–50.

Sherif, C. W., Sherif, M., & Nebergall, R. E. (1965). *Attitude and attitude change: The social judgment-involvement approach.* Philadelphia: Saunders.

Silverman, I. (1964). Differential effects of ego threat upon persuasibility for high and low self-esteem subjects. *Journal of Abnormal and Social Psychology, 69,* 567–572.

Silverman, I., Ford, L. H., Jr., & Morganti, J. B. (1966). Inter-related effects of social desirability: Sex, self-esteem, and complexity of argument on persuasibility. *Journal of Personality, 34,* 555–568.

Smith, R. E. & Hunt, S. D. (1978). Attributional processes and effects in promotional situations. *Journal of Consumer Research, 5,* 149–158.

Stanley, T. J. (1978). Are highly credible sources persuasive? *Journal of Consumer Research, 5,* 66–69.

Sternthal, B., Dholakia, R. R., & Leavitt, C. (1978). The persuasive effect of source credibility: Tests of cognitive response. *Journal of Consumer Research, 4,* 252–260.

Sternthal, B., Phillips, L. W., & Dholakia, R. R. (1978). The persuasive effect of source credibility: A situational analysis. *Public Opinion Quarterly, 42,* 285–314.

Stewart, D. W. (1986). The moderating role of recall: Comprehension and brand differentiation on the persuasiveness of television advertising. *Journal of Advertising Research, 26,* 43–47.

Stroebe, W., Eagly, A. H., & Stroebe, M. S. (1977). Friendly or just polite? The effect of self-esteem on attributions. *European Journal of Social Psychology, 7,* 265–274.

Swartz, T. A. (1986). A further examination of the relationship between source expertise and source similarity. *Journal of Advertising, 15,* 49–50.

Tannen, D. (1990). *You just don't understand: Women and men in conversation.* New York: Ballantine Books.

Tannen, D. (1999). *The argument culture: Stopping Americans' war of words.* New York: Ballantine Books.

Tannen, D. (2001). *Talking from 9 to 5: Women and men at work.* New York: Quill Press.

Thibaut, J. W. & Riecken, H. W. (1955). Some determinants and consequences of the perception of social causality. *Journal of Personality, 24,* 113–133.

Tufte, E. R. (1990). *Envisioning information.* Cheshire, CT: Graphics Press.

Tufte, E. R. (1997). *Visual explanations.* Cheshire, CT: Graphics Press.

Tufte, E. R. (2001). *The visual display of quantitative information,* 2nd ed. Cheshire, CT: Graphics Press.

Tufte, E. R. (2003). PowerPoint is evil. *Wired, 11,* 118–119.

Tufte, E. R. (2006). *The cognitive style of PowerPoint: Pitching out corrupts within,* 2nd ed. Cheshire, CT: Graphics Press.

Tversky, A. & Kahneman, D. (1992). Advances in prospect theory: Cumulative representation of uncertainty. *Journal of Risk and Uncertainty, 5,* 297–323.

Venkatesan, M. & Ross, I. (1973). *Personality and persuasibility: A test of the curvilinear hypothesis* (paper). Boston: American Institute for Decision Sciences.

Voswinckel, T. (2006). *Presentational visualization: Towards an imagery-based approach of computer-generated presentation visuals.* Research paper, submitted in partial fulfillment of the requirements toward the master of science [MSc] degree, Computer Sciences in Media. Fachhochschule Furtwangen, Hochschule fur Technik und Wirtschaft.

Walster, E., Berscheid, E., & Walster, G. W. (1973). New directions in equity research. *Journal of Personality and Social Psychology, 25,* 151–176.

Webster, J. & Frederick, E. (1968). On the applicability of communication theory to industrial markets. *Journal of Marketing Research, 5,* 426–428.

Whalen, D. J. (1986). *The effect of the attribution of bias-expectancy and receiver self-esteem on source credibility, message comprehension, and persuasion* (unpublished doctoral dissertation). Florida State University.

Whalen, D. J. (1996). *I see what you mean: Persuasive business communication.* Thousand Oaks, CA: Sage Publications.

Whalen, D. J. & O'Keefe, R. D. (1987). The receiver's attribution of open-mindedness to a spokesperson: The effect on message comprehension. In J. J. Cronin & M. T. Stith (Eds.), *Marketing: Meeting the challenges of the 1990s* (pp. 259–263). New Orleans, LA: Proceedings of the Southern Marketing Association.

Whalen, D. J., Pitts, R. E., & O'Keefe, R. D. (1991). Appealing to consumers' greed, lust, vanity & envy, or the things nice managers don't talk about. *Journal of Promotions Management, 1,* 3–20.

Whalen, D. J., Pitts, R. E., & Wong, J. K. (1991). Consumers' evaluative structures in two ethical situations: A means-end approach. *Journal of Business Research, 22,* 119–130.

Wicker, A. W. (1971). An examination of the "other variables" explanation of attitude-behavior inconsistency. *Journal of Personality and Social Psychology, 19,* 18–30.

Wiest, W. M. (1965). A quantitative extension of Heider's theory of cognitive balance applied to interpersonal perception and self-esteem. *Psychological Monographs, General and Applied, 79,* 1–20.

Wolff, A. (1997). How to incorporate multimedia in the business communication classroom. *Business Communication Quarterly, 60,* 110–113.

Women's Heart Foundation. (2005). *Stretching exercises for women.* Retrieved January 11, 2006, from http://www.womensheartfoundation.org/content/Exercise/stretching_exercise.asp

Wood, W. & Eagly, A. H. (1981). Stages in the analysis of persuasive messages: The role of causal attributions and message comprehension. *Journal of Personality and Social Psychology, 40,* 246–259.

Zanna, M. P., Olson, J. M., & Fazio, R. H. (1980). Attitude-behavior consistency: An individual difference perspective. *Journal of Personality and Social Psychology, 38,* 432–440.

Zarowin, S. (2004). The right way to use PowerPoint. *Journal of Accountancy, June.* Retrieved January 11, 2006, from http://www.aicpa.org/pubs/jofa/jun2004/gbi.htm

Zeller, M. (1970). Self-esteem, reception, and influenceability. *Journal of Personality and Social Psychology, 15,* 87–93.

Zongker, D. E. & Salesin, D. H. (2003). *On creating animated presentations.* Eurographics/ACM SIGGRAPH Symposium on Computer Animation. Retrieved January 11, 2006, from http://grail.cs.washington.edu/pub/papers/Zongker_204.pdf#search=%22%22On%20creating%20animated%20presentations%22%22

Index

About the Authors

Joel Whalen is Academic Director of the Kellstadt Center Sales Leadership Program at Chicago's DePaul University. He is an associate professor of marketing and holds a Ph.D. in Marketing Communications from Florida State University. He has been listed in *Who's Who in America* and *Men of Distinction* in Cambridge, England. He is a sales and sales management fellow of the American Marketing Association. The Ernst & Young Entrepreneurship Foundation named him Entrepreneur of the Year, and he is a member of the Entrepreneur Hall of Fame. He has received numerous awards for outstanding teaching.

After 10 years of study, experimentation, and innovation, in cooperation with companies, associations, and thousands of DePaul students, he discovered the core psychological, attitudinal, and behavioral drivers behind effective professional communication. He created a series of exercises that have helped people become more masterful communicators. During his keynote addresses and in workshops and classes—throughout the U.S., Australia, and Thailand—he gives thousands of people the tools they need.

He has an extensive background in sales and advertising. As a salesperson and sales manager, he consistently set all-time sales records. He has received numerous advertising awards for creative television and radio commercials, including an Addy Award from the American Advertising Federation for one of the first television commercials created by a computer, for the Bose Color of Sound campaign. In Florida politics, he was communications adviser to several successful statewide political campaigns.

He is the author of *I See What You Mean* (Sage Publications, 1995) and he has published articles in

- *Psychology & Marketing*
- *Journal of Business Research*

- *Journal of Business Ethics*
- *Design Management Journal*
- *Journal of Educational & Psychological Measurement*
- *Journal of Promotions Management*

He has been interviewed by the national and international press, including

- CNN
- CBS
- NBC
- ABC
- PBS
- NPR's *Marketplace*
- *Advertising Age*
- *The Atlanta Journal-Constitution*
- *Chicago Tribune*
- *Chicago Sun-Times*
- *The Christian Science Monitor*
- *Financial Times of London*
- *Playboy*
- *Time*
- The Australian Broadcasting Company (ABC)

Corey Goldstein, M.D., is an assistant professor of psychiatry and the Associate Clinical Director of the Treatment Research Center at Rush University Medical Center in Chicago. In addition, he has a private practice in medication management, psychotherapy, and consultation. His clinical interests include anxiety and mood disorders, schizophrenia, and complementary medicine.